KEYS TO DRAWING

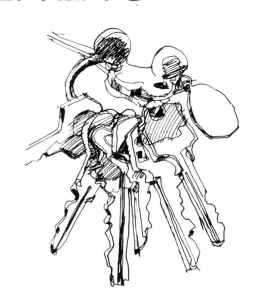

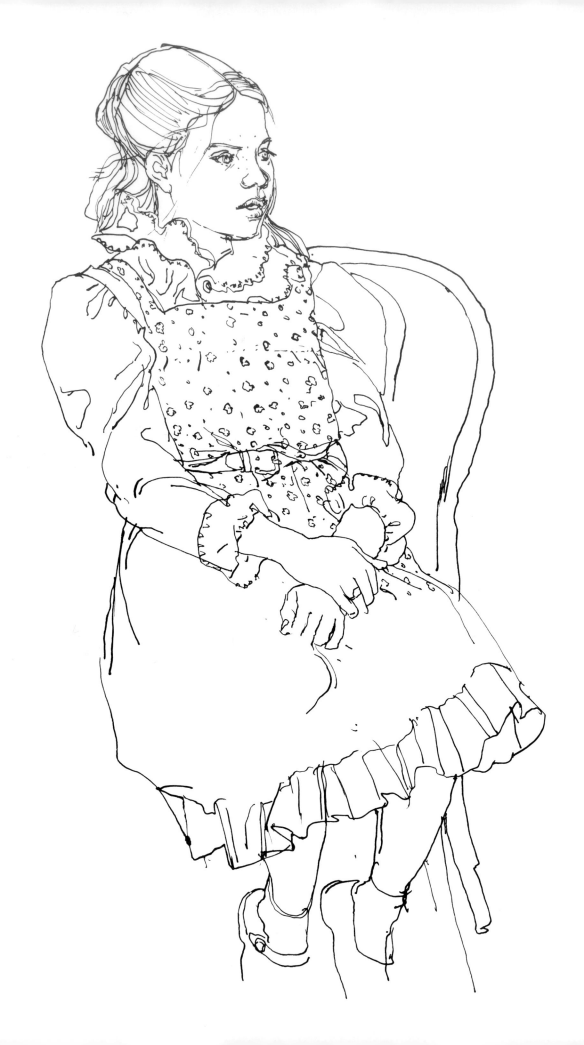

KEYS TO DRAWING

BERT DODSON

NORTH LIGHT BOOKS

Cincinnati, Ohio

Acknowledgments

I wish to express my thanks to all the artists, students, photographers, mostly friends, who have contributed their work to this book; to Fritz Henning for his kind editorial assistance; Bill Fletcher for his patient encouragement; Elihu Pearlman and Liz O'Neil for helpful advice, and most of all to my wife Bonnie for her exhaustive editing, typing and counseling.

Other fine North Light Books are available from your local bookstore, art supply store or direct from the publisher.

Published by North Light, an imprint of F&W Publications, Inc., 1507 Dana Avenue, Cincinnati, Ohio 45207. (800) 289-0963.

Manufactured in U.S.A.
First edition. First paperback printing 1990.

02 01 00 99 14 13 12 11

Library of Congress Cataloging in Publication Data

Dodson, Bert.
 Keys to drawing.

 Includes Index.
 1. Drawing—Technique. I. Title
NC730.D56 1985 741.2 85-8939
ISBN 0-89134-337-7

For Bonnie, with love and gratitude

CONTENTS

INTRODUCTION

There is a scene in an old Western film in which Danny Kaye, as the hero, is challenged by a dangerous gunslinger to a shootout in the street. As he walks toward the saloon door and out into that street, well-meaning friends give him advice on his best chances of surviving. "The sun's in the west so keep him to the east," says one old timer. "He stands up tall, so squat down low," says another. Someone else advises, "He shoots from his right, so lean to the left." Kaye desperately tries to remember these tips, but by the time he reaches the swinging doors, he is hopelessly confused, and we hear him muttering, "The sun's up tall, so lean to the west . . . he squats to his left so shoot down low . . . he's east of his right so shoot at what's left . . . "

Drawing, if approached as a set of instructions that must be remembered, can make us react very much like Danny Kaye in the scene above. No one I know draws that way because it is difficult to keep such a jumble of instructions in mind while drawing. Simply remember there are many keys to drawing which you will find in this book. With use they will be absorbed into your own system of drawing. We cannot bring to bear all our knowledge at once. What we can do is concentrate on our subject and trust our eyes. *Keys to Drawing* essentially is learning to trust our eyes and learning different ways in which we can reinforce that trust. Drawing is primarily a process of *seeing* rather than strictly an application of principles. Other keys — such as *restating, visualizing, merging* and *mapping* — are really by-products of seeing put into the language of the artist. They can be learned gradually, at a comfortable pace.

In addition to trusting our eyes, the quality that most defines any of us as artists is *curiosity*. An artist I know recently found a dead duck. He took it back to his studio and made drawings of it. He studied the arrangement of wing feathers to better understand how the bird flew. He observed them under a blow dryer. He made studies of the legs and feet, noting their location well back on the body — awkward for walking but perfectly suited and powerful for swimming. His drawings helped him *understand* ducks. For this artist, drawing is a means of satisfying *scientific curiosity*. I know other artists who will simply draw whatever strikes their eye, confident that even ordinary objects can make extraordinary subjects. Such artists are intrigued by the interplay of shapes, tones, and textures. For these artists, drawing satisfies *visual curiosity*. Whether your curiosity is scientific, or visual, or both, the mere fact that you approach the world with wonder will impart to your drawings an authority and a beauty not otherwise obtainable.

Each chapter of *Keys to Drawing* contains *projects* designed to give the reader experience with the important keys under discussion. A *review* and project *self-evaluation* section is included at the end of each chapter. The projects are narrowly focused, limiting the number of problems to be solved at any given time. Some specifically call for awkward or unusual views of objects, cluttered compositions, or

exaggerated reality. The object is not to produce handsome drawings but to introduce you to new ways of seeing and responding.

The examples included in this book embrace a variety of "types" of drawings — quick "gestures," "thumbnail" sketches, sketchbook studies, and full compositional drawings. Where photographs have been used as aids, that fact is indicated to avoid conveying any misleading impressions. Unless otherwise indicated, the drawings are by the author.

The chapters and projects are designed to be taken in sequence. However, believing as I do in serendipity, chance, and luck, I invite readers to follow any sequence which best suits them.

Fiddler's Contest
Bradford Vt.

1

THE DRAWING PROCESS

INTERNALIZING PRACTICAL DIALOGUE • TRIGGERING WORDS • DRAWING BLIND • RESTATING • SEEING vs. KNOWING • INDIVIDUALIZING • SQUINTING • SHAPE CONSCIOUSNESS • FOCUSING

An internal dialogue

The art of drawing is an act of uncanny coordination between the hand, the eye, and the mind. Each of these is subject to training and habit. For many students, improvement in drawing simply lies in breaking bad habits and replacing them with new and useful ones. For example, what do you think of as you draw? Can you remember? Perhaps your mind wanders. Perhaps you think of nothing at all. If you are like most of us though, you do, from time to time, carry on an internal dialogue as you work. This dialogue will either help or hinder your ability to draw, depending on which of two basic types it is.

Critical Dialogue

"That arm doesn't look right."
"The foot couldn't possibly turn that way."
"I never draw the legs right."
"Why do I have so much trouble drawing faces?"

Practical Dialogue

"What does that shape look like?"
"Is that shoulder line horizontal or slightly tilted?"
"Is the distance from knee to foot greater or less than the distance from knee to waist?"
"How bumpy is that contour?"

You can probably see the difference between these two types of dialogue and you may agree that the practical is preferable to the critical. Even if you already have the critical dialogue habit, it's not hard to break.

Where do you look when you draw? Do you look at your drawing or at your subject? If you're not sure, try this experiment. As you draw, have someone watch your eyes. Do they rest mostly on the drawing or on the subject? This is an important question and a key to improvement. If they focus primariy on your *subject*, you will draw better than if the focus is on your *drawing*. Why is this so? Let's go back to the two

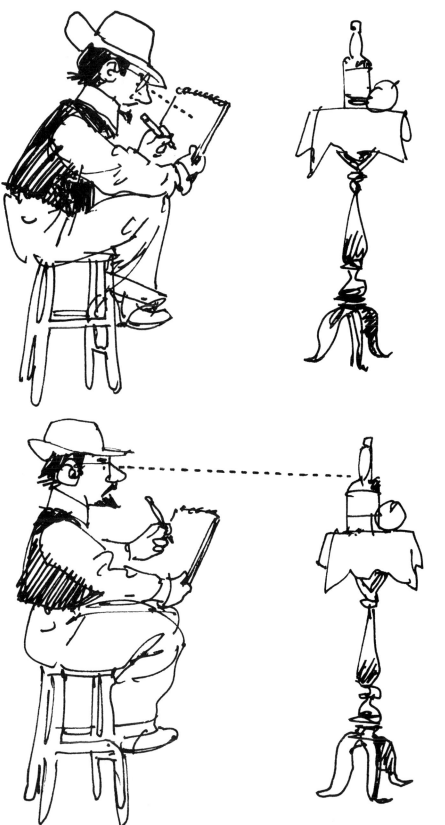

A common practice that weakens drawing effectiveness is concentrating too much on your paper and not enough on your subject.

Your drawing skills will improve dramatically if you concentrate on your **subject**, only glancing at your paper to keep your lines on track.

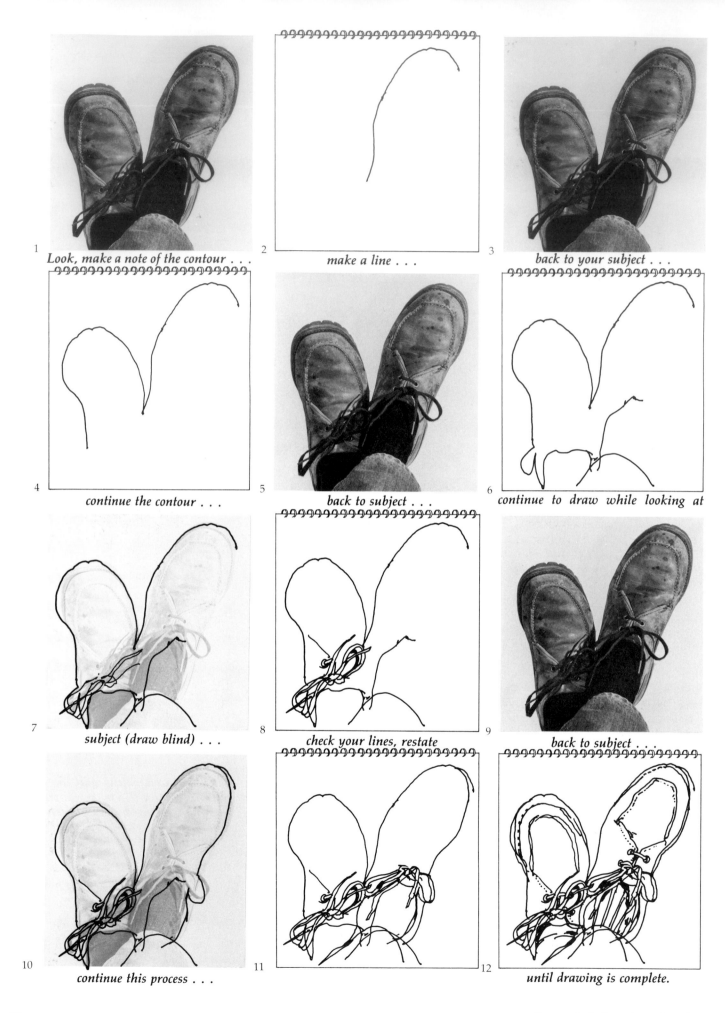

1

Look, make a note of the contour . . .

2

make a line . . .

3

back to your subject . . .

4

continue the contour . . .

5

back to subject . . .

6

continue to draw while looking at

7

subject (draw blind) . . .

8

check your lines, restate

9

back to subject . . .

10

continue this process . . .

11

12

until drawing is complete.

Photographs by Flying Squirrel Graphics

types of dialogue. When you focus on the drawing, especially in its early stages, you are *judging* your efforts. This leads to a self-involved, self-analytical, critical mode; things in the drawing are "wrong" or "just don't look right." You may be tempted to rely on formulas and techniques you already know rather than to draw what you actually see. You may become impatient. Beginning students often become lost or confused when relying on critical dialogue. It beats down on the head like Chinese water torture and, eventually, can take all the pleasure out of drawing.

Practical dialogue results when you are focused primarily on the subject. This is really a dialogue between you and the subject, giving you information about shapes, angles, and measurements that you can translate into lines on paper.

Sometimes practical internal dialogue is no more than the repetition of a single word that describes the feeling in your subject that you are trying to capture and then convey. Called *triggering* words, they help you stay in the moment. Saying a word like "angular," "sharp," "long," "rounded," "intricate," or "bristly" softly to yourself (often repeatedly) as your hand moves on the paper, keeps you in contact with your feelings about what you are seeing and makes it easier to actually create that effect.

Looking, holding, drawing a line

Drawing can be described quite simply: *look* at the subject and take note of a contour or shape; *hold* that contour or shape in your mind for a moment, and *draw* it while it's still fresh in memory. *Look, hold, draw. Look, hold, draw.* Notice we do not include "Think about it" in this sequence. In fact, drawing can be viewed as a process which usually bypasses conscious thought and knowledge. Artist and author Frederick Frank, in his book, *My Eye is in Love*, expressed it this way: "All the hand has to be is the unquestioning seismograph that notes down something, the meaning of which it knows not. The less the conscious personality of the artist interferes, the more truthful and personal the tracing becomes."

The illustrations at left depict the drawing process in sequence. We look at the subject, two feet (fig. 1), note a contour at the toe of the higher foot, and begin to trace that line (fig. 2) on the paper. Now back to the subject (fig. 3); we estimate where this line intersects the other foot and draw this (fig. 4). *Look, hold, draw. Look, hold, draw.* A natural rhythm becomes established. The speed of your hand will vary as the contours vary.

Drawing blind

It is possible to compress the look-hold-draw process into a single action which we call *drawing blind*. In doing so, your hand continues to draw as your eyes remain on the subject. This often occurs instinctively as you become engrossed. But until it becomes a habit, you should train yourself to do this.

In Figure 3, we observe the contour of the second foot. In Figure 4, we begin to draw it. In Figure 7, we look back to the subject but *leave the pencil in contact with the paper and continue drawing*. Drawing blind is a valuable way to strengthen eye/hand coordination, and the result is a more sensitive recording of contours. There is some sacrifice in accurate proportions, however, so drawing blind is best done in short bursts interspersed with look-hold-draw. It is most effective in the early stages of drawing.

Project 1 - A — Feet

Make a drawing of your own crossed feet, stressing accurate contour and detail. Use line only — a sharp pencil, pen and ink, ballpoint pen, or felt-tip marker (fine point).

Sit comfortably with your crossed feet propped up in front of you and place your pad or paper on a support in your lap so that you have a clear view of your feet. Using the look-hold-draw process discussed here, represent the feet as closely as your observation permits. Be aware of looking at the subject more than at the drawing. Try "drawing blind" at least three or four times while working. Do not erase, but have two or more "restatements" in the drawing. Allow yourself at least one-half hour for the project.

Restating

Most of us have a negative attitude about our own mistakes. To a draughtsman, such an attitude is not helpful and will need to be reshaped. Trial and error are *essential* in drawing. You make lines and compare those to the contours of your subject. Distortions will no doubt occur, and some of these you will want to correct or adjust as you go. You could erase these lines, but it is usually better to leave them for now and simply draw the more accurate lines alongside. This we call "restating," and its advantages are two-fold: (1) You don't waste a lot of time erasing which you can better spend observing your subject, and (2) the drawing actually looks more alive and energetic with all of those restatements. The Degas drawing on page 51 has numerous restatements in the arms and torso. The drawing below is a mass of restatements.

In restatements, we can see the drawing process at work, the "feeling out" of forms, the searching out of more accurate contours, and the adjusting and correcting.

Don't worry if restating lines makes your drawing look busy . . .

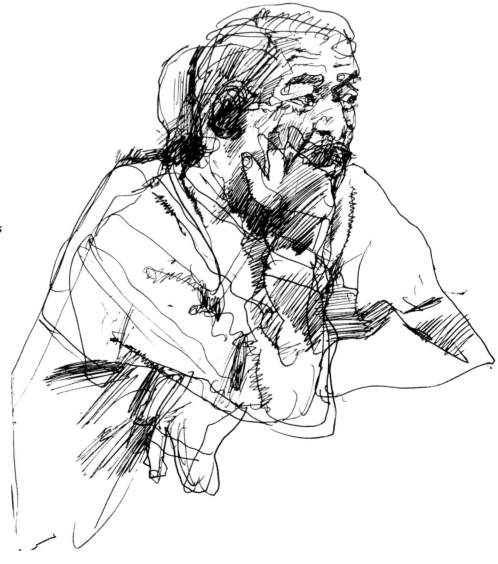

14

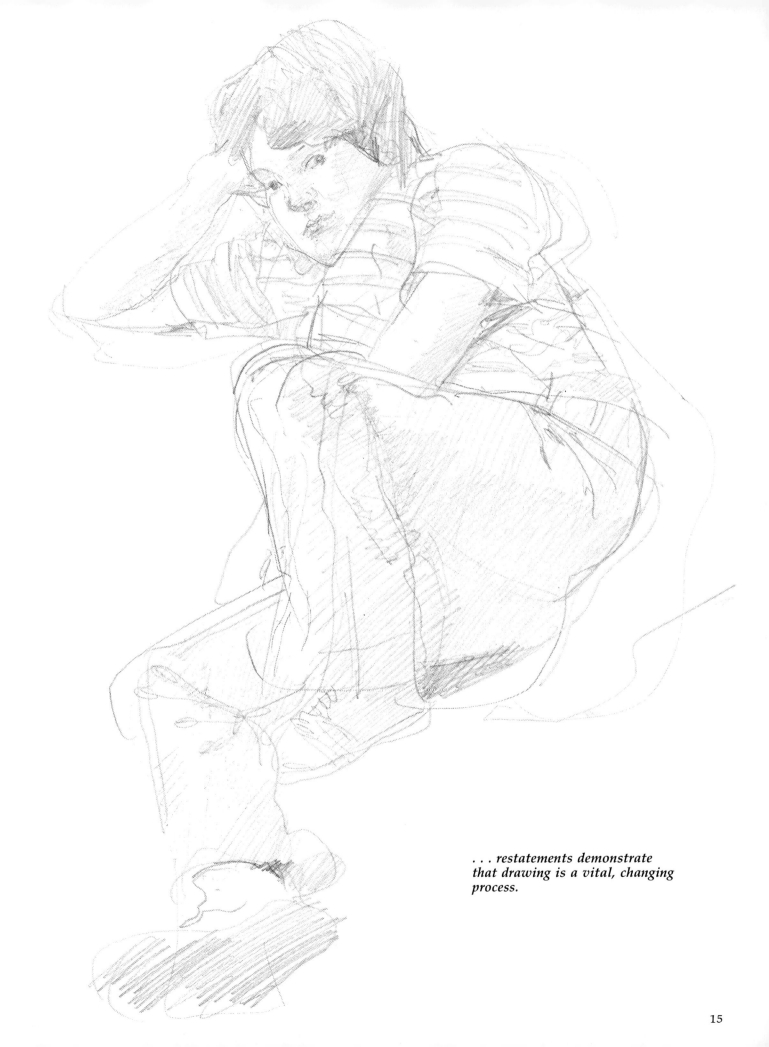

. . . restatements demonstrate that drawing is a vital, changing process.

Shoelaces drawn from "knowledge." Note mechanical criss-crossing of laces.

Shoelaces here are drawn from observation. Each lace-shape is individually drawn. This takes more patience, but the results are invariably more interesting and authoritative.

Seeing vs. knowing — a conflict

As you draw, you will often encounter conflicts between what you see and what you know. For example, in the quick sketch at right the boy's head was tipped down below his shoulders — "foreshortened" in our view. Foreshortening violates our expected view of things. The head is below the shoulders, touching the top of his trunk. Our natural temptation in this case is to "make things right" by drawing what we know instead of what we see. It's important to resist that temptation. Our goal in drawing from observation is to capture the richness and variety of *visual* experience. We should draw, for the time being at least, as if we know nothing, and were obedient only to what our eye tells us to draw. This is the key to natural, life-like drawing. To understand this is to understand that there is no such thing as knowing how to draw something. One hears, "Can you draw hands — or horses — or trees?" The answer is: we do not draw "things" at all, only lines. To reproduce objects we see on paper, we need to translate what we see into a useful language which we will call the *language of lines*. This language involves angles, shapes, tones and measurements. Any other language (the language of "things") is not of immediate use to us. Whenever we try to speak in two different languages simultaneously, the result is confusion.

The reader may argue, "OK, I see how knowledge of certain facts about something might prejudice us against seeing it clearly, but what about knowledge of drawing principles —perspective, anatomy, foreshortening, light and shadow? Doesn't this kind of knowledge help rather than

Because we know the head is placed above the shoulders, we tend to want to draw it that way.

True seeing means ignoring logic and responding to what our eyes tell us.

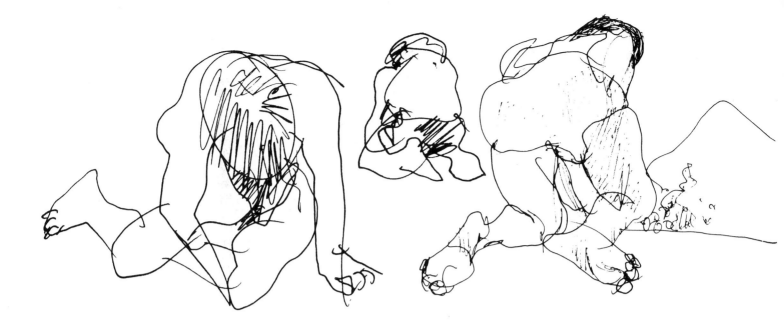

It takes courage to ignore knowledge and to respond to what we see instead.

hinder us in making a good drawing?" Indeed, these principles were developed to help us understand what we see. But they do not come first. Seeing comes first. When rules conflict with seeing, forget them and draw what you see. This is what is meant by retaining an "innocent vision." That is, to look at something as if you have never seen it before, and to be unclouded by assumptions about how a thing is supposed to look. The one simple rule to follow is: at each point of frustration or confusion, ask yourself, "What do I see?"

Squinting

If you've drawn at all, you've probably experienced times when you've been overwhelmed by the detail in your chosen subject. Squinting is an excellent way to simplify your subject and make it instantly manageable. Little wonder it's a device often used among artists. A useful habit, squinting is a key we will refer to frequently in this book.

What is it?

One of the hardest things to do in drawing is to force yourself to follow your vision when it just doesn't look right. Drawing your own hand from an end view creates such a conflict. We "know" a hand must have fingers, and that those fingers must have a certain length. Otherwise, as in this view, it "just doesn't look right." It doesn't match our preconceived hand symbol! It takes courage to stick to your vision in spite of how it looks. If you are to grow and develop as an artist, it is necessary to develop that courage.

Upon completing your drawing for Project 1B, study it a moment. If it looks a lot like a hand, you didn't keep your hand dead level with your eyes or you didn't follow your vision. (Or you are a truly excellent draughtsman.) If you gave much length to the fingers, you either held your hand too tilted while drawing it or you were drawing it from knowledge rather than from seeing. In either case, you have missed the conflict — the seeing vs. knowing — and should try it again.

Project 1 - B — Hand

Make a drawing of your own hand from the unusual end-view of the fingertips. That is, with the hand and fingers pointed directly towards your eyes. Stress accurate contour and detail. Use line only — sharp pencil, pen or fine point felt-tip marker. Tape your paper on a flat surface in front of you and hold your hand next to it about twelve inches or so from your eyes. Close one eye as you draw. Be aware of looking at the subject more than at your drawing. Try "drawing blind" at least three or four times as you work. Do not erase, but have two or more "restatements" in the drawing. Allow at least fifteen minutes for the project.

Try to keep an "innocent vision." That is, draw exactly what you see, but since this is an unconventional view of a hand be forewarned that the result will probably not look much like you expect a hand to look.

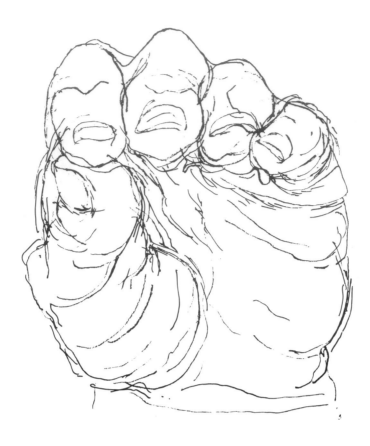

The examples on this page were done by students of varying ability and experience, but all concentrated on drawing purely what they saw. Note also the number of restatements in each.

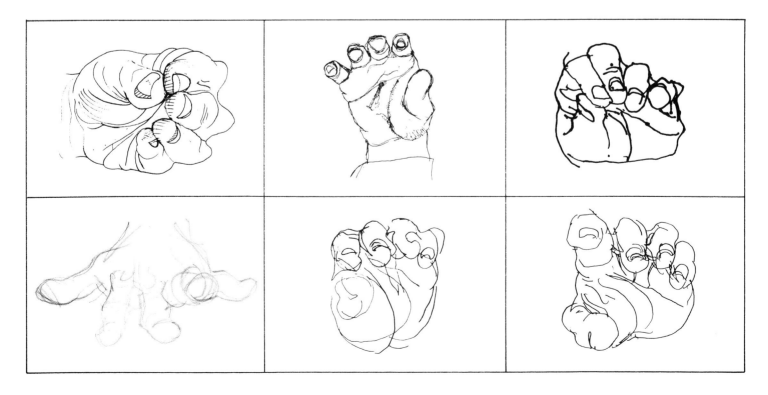

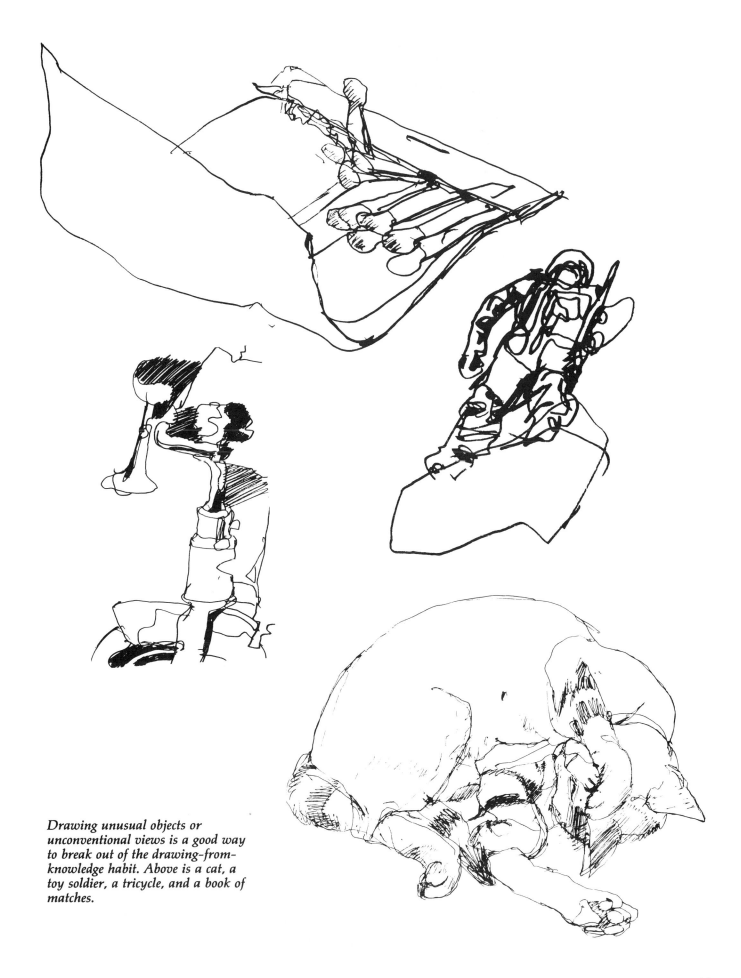

Drawing unusual objects or unconventional views is a good way to break out of the drawing-from-knowledge habit. Above is a cat, a toy soldier, a tricycle, and a book of matches.

A "symbolic apple" drawn from memory.

Seeing vs. knowing — mental images

We carry around with us mental images of the way things are supposed to look. These images are reconstructions from memory. We can easily imagine a potato or horse or the face of a good friend. Sometimes we feel that our mental image is an exact duplication of the real thing. If, however, we try to draw these mental images, we quickly realize that we don't have nearly enough information about shape, proportion, contour, or texture to do the job with much precision or character.

We can see this in these examples. The apples in the boxes are drawn from memory, the others are drawn from observation. The dramatic difference between each drawing is readily apparent and proves that mental images are really only symbols of reality. The mind couldn't possibly store all the information necessary to draw really convincing apples. Nor should it. That is a job for the eyes: following carefully each rounded contour, the maculated surface of its shiny skin, the random imperfections, the play of light and shadow. This information, which the eye alone provides, the hand can then readily follow.

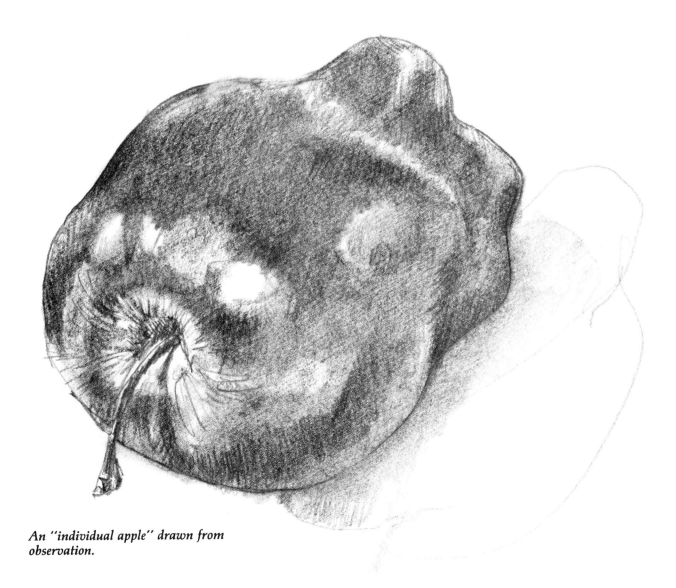

An "individual apple" drawn from observation.

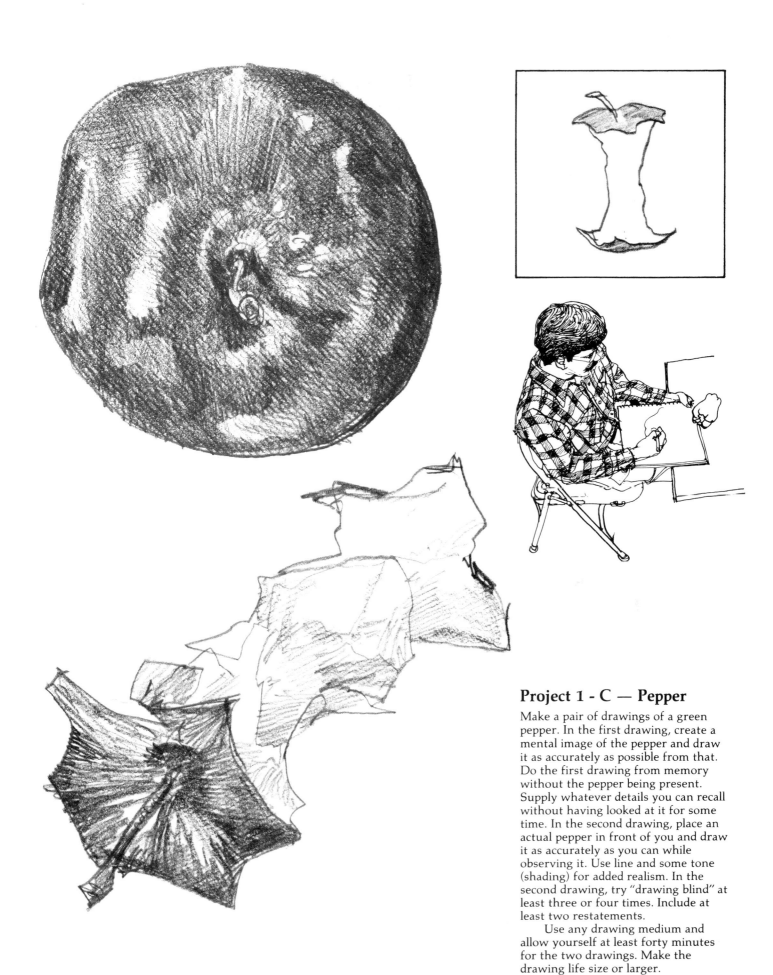

Project 1 - C — Pepper

Make a pair of drawings of a green pepper. In the first drawing, create a mental image of the pepper and draw it as accurately as possible from that. Do the first drawing from memory without the pepper being present. Supply whatever details you can recall without having looked at it for some time. In the second drawing, place an actual pepper in front of you and draw it as accurately as you can while observing it. Use line and some tone (shading) for added realism. In the second drawing, try "drawing blind" at least three or four times. Include at least two restatements.

Use any drawing medium and allow yourself at least forty minutes for the two drawings. Make the drawing life size or larger.

Individualization

How inadequate is the memory when compared to the richness and variety of direct visual experience! The shapes, tones, and textures needed to draw convincing objects are conveyed through the eyes. We individualize by drawing from life.

Try to break old seeing habits by assuming nothing about your subject. Look at it with less logic and more curiosity. Override mental images and study the subject itself. Use practical dialogue to ask questions about the subject. Shift from the language of things to the language of line and shape. To individualize in your drawing the unique qualities of your subject gives your work verve and authority.

 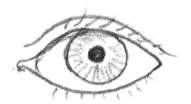

An exercise in individualizing

Try to get a mental image of your own eyes. You know that an eye is a ball set in a socket, surrounded by an upper and lower lid. The opening is almond or tear-drop shaped. Knowledge of these generalizations and a few details about iris, pupil, and lash would allow most people to draw a reasonably convincing pair of eyes, particularly from direct front view (see above).

However, unless you have practiced, it is doubtful that you could make a very accurate portrait of your *own* eyes or any other pair of eyes from memory. Moreover, when the head is tilted up or down or turned to a three-quarter view, the shapes of the eyes, lids, and brows change. Our mental images are inadequate to store all of this information.

Now stop and take a moment to view your own eyes in a mirror. As you study their shapes and contours, try to answer these questions:

- Are the two eyes *exactly* alike or are there subtle differences? If different, what are those differences?
- Are your eyes more or less than one eye-width apart?
- How much of the exposed eye does the iris cover? One third? One half?
- What is the shape of the upper lid? Is it symmetrical or asymmetrical?
- Where is the eyebrow's point of highest arch over the eye? The lowest?
- Which are the two or three most prominent character lines or folds?
- Where are the darkest shadows? The brightest light areas?
- Turn your head to a three-quarter view. Can you see how the eye shapes change to a more exaggerated tear-drop shape?

- Do you see how the difference between the two eye shapes become more pronounced?
- How much of the one eye is obscured by the bridge of the nose?
- If you wear glasses, can you see how the size and shape of the lenses are different in the three-quarter view, the near lens being a larger and more open shape?

These and countless other questions are often automatically noted and resolved in drawing from observation. What you capture on paper in this process is not merely "a pair of eyes" but a sensitive and accurate drawing of a *uniquely individual* pair of eyes.

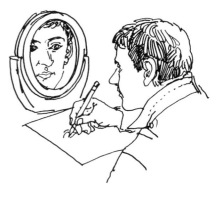

Project 1 - D — Eyes

Make a drawing of your own eyes as they are reflected in a mirror. In doing so, keep your head turned to a three-quarter view (halfway between a front view and profile). Draw as accurately as possible only the areas of the eyes, eyebrows, and the bridge of your nose. Be sure you are always drawing what you see rather than what you *know*. Use a 2B or an HB pencil and keep the point sharp.

Work primarily in line with some added tone (shading) to indicate the lights and darks you see. Allow yourself at least twenty minutes. Try drawing blind at least three or four times and include at least two restatements.

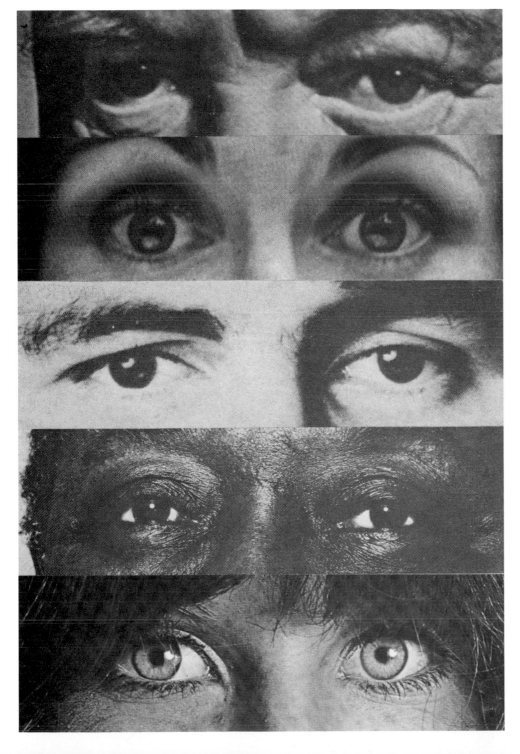

Developing shape consciousness

The painter, Edouard Manet, once observed: "There are no lines in nature, only areas of color, one against another." For any artist, the importance of this simple remark can hardly be overstated. It suggests a major key to drawing improvement. Each "area of color" has a shape — in fact, *is* a shape — for our purposes.

Drawing shapes is easier — much easier — than drawing things. Try this: Select an object in your immediate surroundings. Now, holding a pencil in your hand and closing one eye, trace the outline of the object in the air as if you were actually drawing along its outer edge. Begin at any point and continue all around the object until you meet your starting place. Did you notice that there is virtually nothing to think about? Your eye and your hand do all the work for you. It's only a slight step further to the actual drawing of the shape.

You keep your eye on the object you're drawing and only briefly glance at your paper as you work. This is working in "the language of *lines*" or, as we can now advance it, working in "the language of *shapes*." The beauty of this language is that it bypasses conscious thinking and critical dialogue and allows us to record only what we see. Our *occasional* internal dialogue is of the practical kind: "Does that

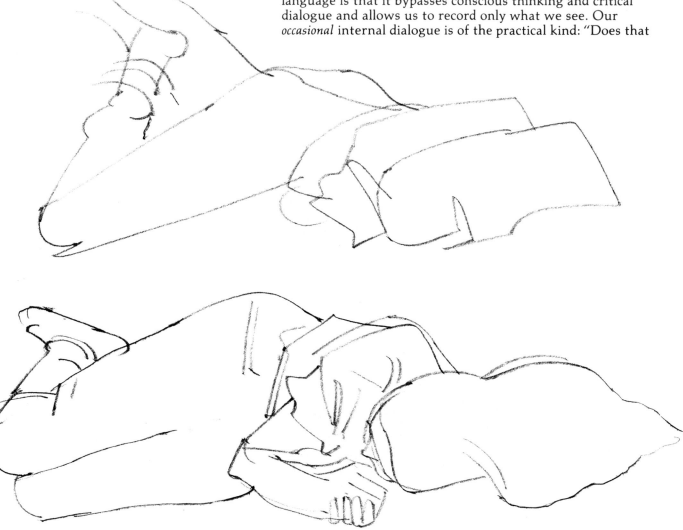

shape taper to a point?" "Is that side straight or does it have a slight curve?" "How does that shape compare with the one next to it? Is it smaller or larger?" Do you see how these questions take us out of the language of *things* ("oceans," "trees," "hands," "hair") and into the language of *shapes* ("elongated triangle," "square corner," "half moon," "oval")?

It happens that when we work in this language, our images ultimately become oceans, trees, hands, hair, etc. It's like a conjurer's trick. The more we stay in the language of shapes, temporarily shunning the language of things, the more our resultant drawings resemble the reality of the things we have observed.

That is why it really doesn't matter *what* we draw. When we learn to see things in terms of their shapes, we can draw anything well: people, buildings, parrots, landscapes, and fire hydrants all are treated equally. We are not specialists.

Four rules of shape

I've formulated four rules to help you break away from the language of things and into the language of shapes. While they are actually helpful hints rather than rules, let's call them rules so that you'll feel a greater imperative to learn them:

1. Draw large shapes first, then smaller shapes.
2. Look for enrichment shapes, including highlights, shadows, reflections, patterns, and textures.
3. Tie shapes together.
4. When you see a "trapped" shape, draw it.

These rules, once understood, will not only make drawing easier but will help you see things in a fresh and original way. Let's find out how.

Michael Mitchell

If we can get a strong sense of its shape, we can draw anything.

George Dugan

25

a. flowers and vase

b. figure and chair

Rule #1. Draw the large shapes first, then the smaller shapes.

Sometimes the hardest thing about drawing is beginning the process. The subject is before us, the blank white paper stares at us, and our pencil is poised. All we have to do is start. But where? How? Rule #1 suggests that it's easier to work from the general to the specific than the other way around. Start with the largest shape you see. Forget everything else and draw that shape. It may be the outer silhouette of a person or subject, or it may be a shape that includes more than one object. Whatever it is, that's where you start.

For example, let's say you are drawing flowers in a vase. Rather than first drawing each flower and then the vase separately, you might first draw the entire silhouette as a single shape. What you've done is capture "flowers/vase" as a *whole idea.* The drawing needn't be executed perfectly, either. This is a way of quickly getting the measure of the subject. Now you have something you can build on, restate, compare with surrounding shapes, subdivide into smaller shapes, etc.

There are no set numbers of major shapes for any given subject. Choosing which are the large shapes in your subject is up to you. If you're in doubt, squinting may help. Then draw first those shapes you see with squinted eyes.

All drawing is *process.* You make some marks on paper. Those marks help guide you to make other marks. You frequently don't know where you're going until you get there. A large shape starts that process.

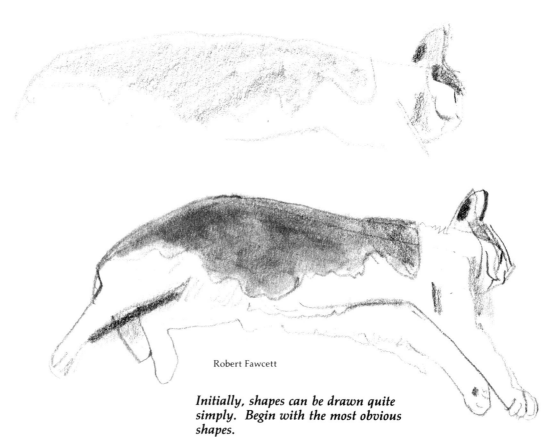

Robert Fawcett

Initially, shapes can be drawn quite simply. Begin with the most obvious shapes.

26

Rule #2. Draw "enrichment" shapes, including highlights, shadows, reflections, patterns and textures.

This rule ushers us into some of the most enjoyable aspects of drawing. Shadows, reflections and the like, those which we call "enrichment" shapes, are so named because they add so much vitality and variety to our visual experience. They do the same for our drawings.

Initially, it may be a large step for you to see them simply as shapes. Such things as a shaft of light falling across the floor, or a dark shadow on the face which is cast by the brim of a hat, or a distorted reflection in a shiny chrome bumper are, indeed, two-dimensional shapes. When you look at them in a fresh way, you'll quickly recognize that these are geometric figures in their own right — elongated triangles, wobbly trapezoids, dented circles — *shapes* with their specific contours.

Assembling these little bits and pieces of shapes is like creating a quilt. Each highlight or reflection is an added detail to enhance the whole of your work. So often what makes a drawing "real," what makes it rich and beautiful to the observer is the awareness of its enrichment shapes.

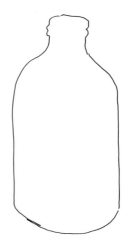

A bottle has a simple outer shape.

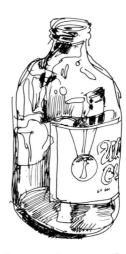

But it has complex inner shapes.

The variety of enrichment shapes in these hands gives this drawing its character and quality.

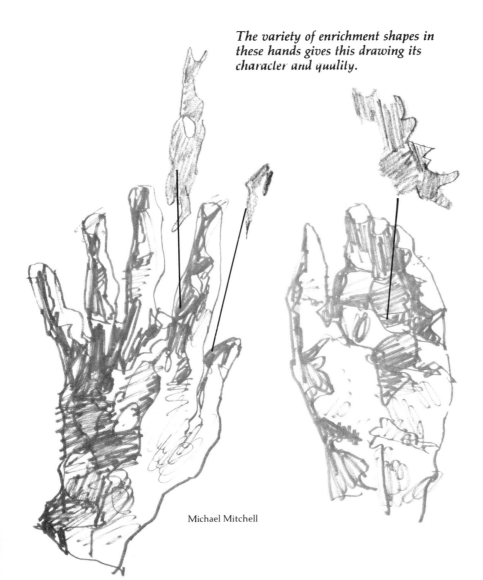

Michael Mitchell

Project 1 - E — Tinted Glass

Select a jar or bottle made of tinted glass (e.g., a soda or beer bottle). Place it on its side turned at an angle in front of you (about a three-quarter view). Draw it as accurately as you can giving special attention to the shapes you see. Draw major shapes first, then secondary shapes, and include the many reflection-shapes in the glass. If the bottle has a label, draw some of the letter shapes. Use a pencil (HB, B, or 2B) and keep the point sharp. Work primarily in line with some added tone to indicate the lights and darks you see. Try drawing blind at least three or four times. Have two or more restatements. Allow at least twenty minutes for the drawing, but don't be concerned if it takes longer. It only means you are being diligent about finding shapes. Work life-size or larger.

27

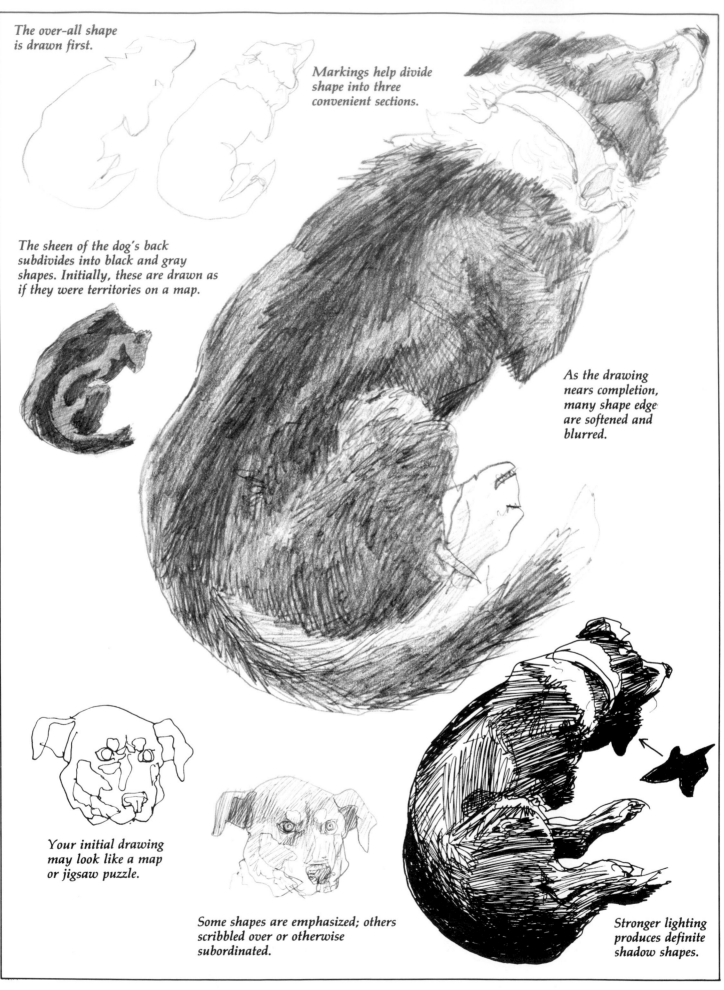

The over-all shape is drawn first.

Markings help divide shape into three convenient sections.

The sheen of the dog's back subdivides into black and gray shapes. Initially, these are drawn as if they were territories on a map.

As the drawing nears completion, many shape edges are softened and blurred.

Your initial drawing may look like a map or jigsaw puzzle.

Some shapes are emphasized; others scribbled over or otherwise subordinated.

Stronger lighting produces definite shadow shapes.

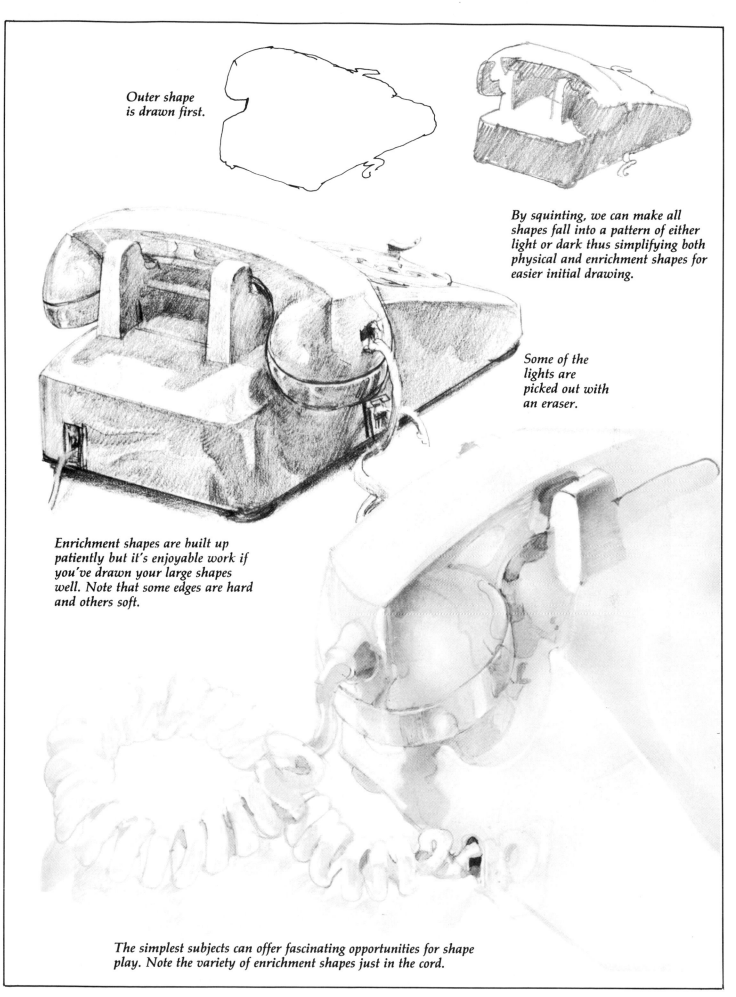

Outer shape is drawn first.

By squinting, we can make all shapes fall into a pattern of either light or dark thus simplifying both physical and enrichment shapes for easier initial drawing.

Some of the lights are picked out with an eraser.

Enrichment shapes are built up patiently but it's enjoyable work if you've drawn your large shapes well. Note that some edges are hard and others soft.

The simplest subjects can offer fascinating opportunities for shape play. Note the variety of enrichment shapes just in the cord.

Rule #3. Tie shapes together.

Rule #3 is a guide for connecting things. It's a unifier, bringing the parts together to create a cohesive whole. The drawing of cows on the lower part of the page clearly illustrates this. By running together the black shapes of their markings — that is, leaving no boundary lines between one cow and another — the artist has created a unified pattern. This is a wonderful design device: We see separate, individual cows and yet, at the same time, we see a continuous uninterrupted black shape running through the herd. This is an example of what I call a "straddle" — embracing opposite qualities simultaneously. We'll discuss straddles in more detail later, but for now let's examine the other shape mergers of the dark of the man's coat with the dark of the background. It's rare that shapes are *totally* merged in this way, but I've included it because it's so striking.

The lower drawing illustrates a more common use of shape merging. Here the two black shapes of the women's dresses are tied together — "merged" — at the knee, but are definitely separate at the shoulder. Frequently, merging the shapes in only one or two places is sufficient.

Rule #3 can be used when any two adjoining shapes are the same tones, or almost the same. We often merge the dark shapes, but white or middle-tone shapes may be merged just as effectively. We'll study merging with light and shadow shapes in Chapter 4.

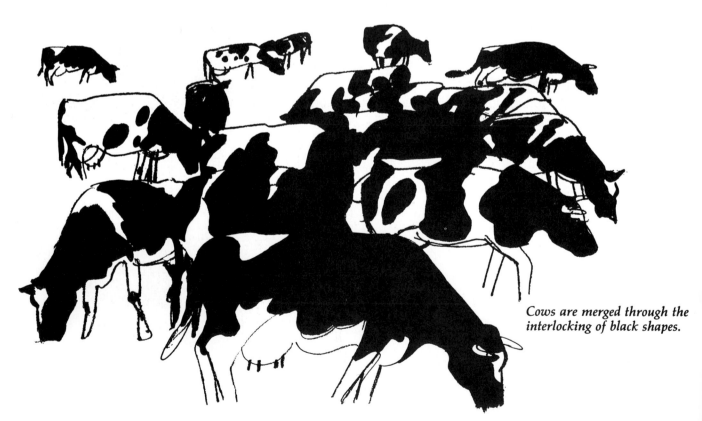

Cows are merged through the interlocking of black shapes.

Norman McDonald

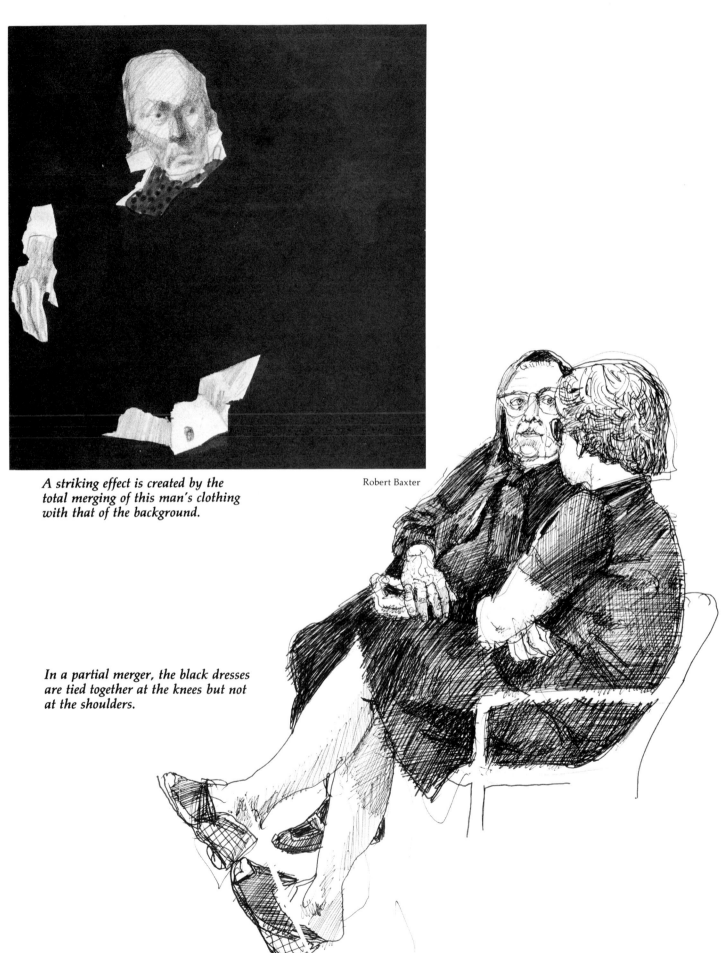

A striking effect is created by the total merging of this man's clothing with that of the background.

Robert Baxter

In a partial merger, the black dresses are tied together at the knees but not at the shoulders.

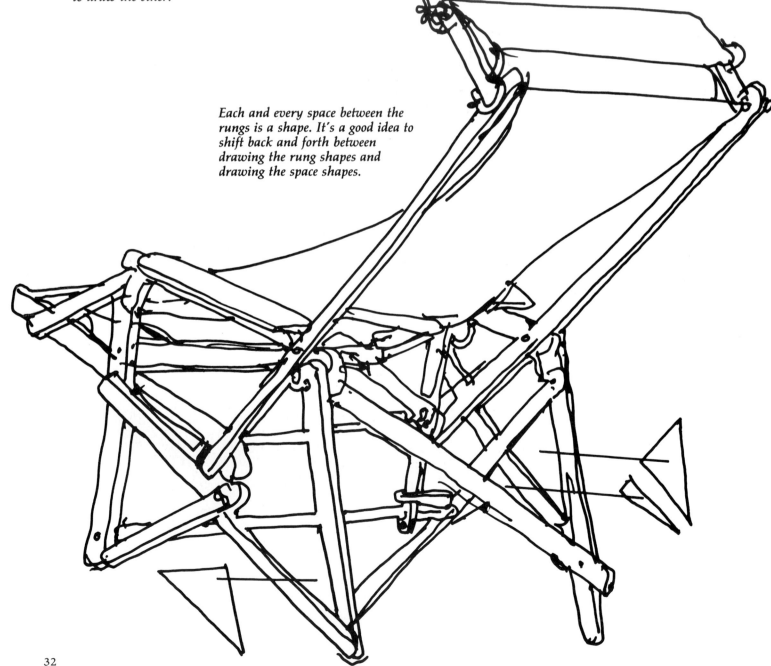

This is a drawing of two faces with a trapped shape between them or a drawing of a vase with trapped shapes on either side. To draw one is to draw the other.

Rule #4. When you see a "trapped" shape, draw it.

When you bring thumb and forefinger together to make the "OK" gesture, you have created a "trapped" shape in the little space encircled by the fingers. At first glance, it looks like an "O" but if you examine it closely, you'll notice its more specific characteristics: it's tapered near the joined fingers, there are little "points" at each of the finger joints, and it has other idiosyncrasies. If you were to draw this shape, you could probably do so accurately and with little effort because it's not a particular "thing" — just a *shape* which is, as we know, always easier to draw.

You will usually find trapped spaces or shapes in some combination of figure and background. The patch of sky between the leaves of the tree, the spaces between the rungs of a chair, the area of neck between collar and chin — all are

Each and every space between the rungs is a shape. It's a good idea to shift back and forth between drawing the rung shapes and drawing the space shapes.

trapped spaces, as are the white of the eyes and the shape within the handle of a teapot. A standing figure, hand on hip, is a shape and so is the little triangle of space trapped between arm and body. Such shapes are sometimes called "negative" or "background" shapes or merely "spaces," but they are shapes nonetheless.

Now, if it's all shape, it doesn't matter which aspect we draw; the inside of the arm and the outline of the body or the trapped shape they enclose. Since all three share a *common boundary*, to draw one is to draw the other. Since it's easier to draw shapes than things, draw the trapped shape whenever you find it. Also develop the habit of shifting back and forth between drawing objects and trapped shapes to develop a more fluid and flexible drawing approach.

In a similar vein, adjacent shapes serve as proportional checks, so, if you're having trouble with one shape, shift to the adjacent one.

I know an artist who, when beginning a landscape, looks at it upside down from between his legs. He feels this allows him to see it in a fresh way, with new eyes. Drawing trapped shapes has exactly the same "freshening" effect, disrupting our habitually logical way of seeing things. Finding new ways of observing is something we should always try to do.

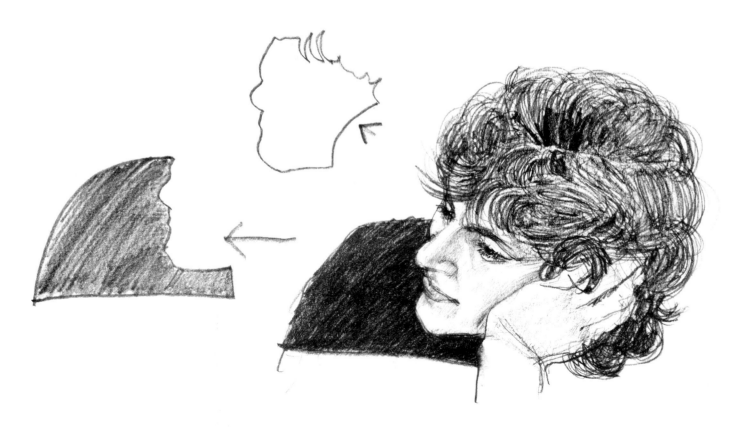

The dark shape of the blouse is a trapped shape. By drawing it, you also draw a portion of the model's profile.

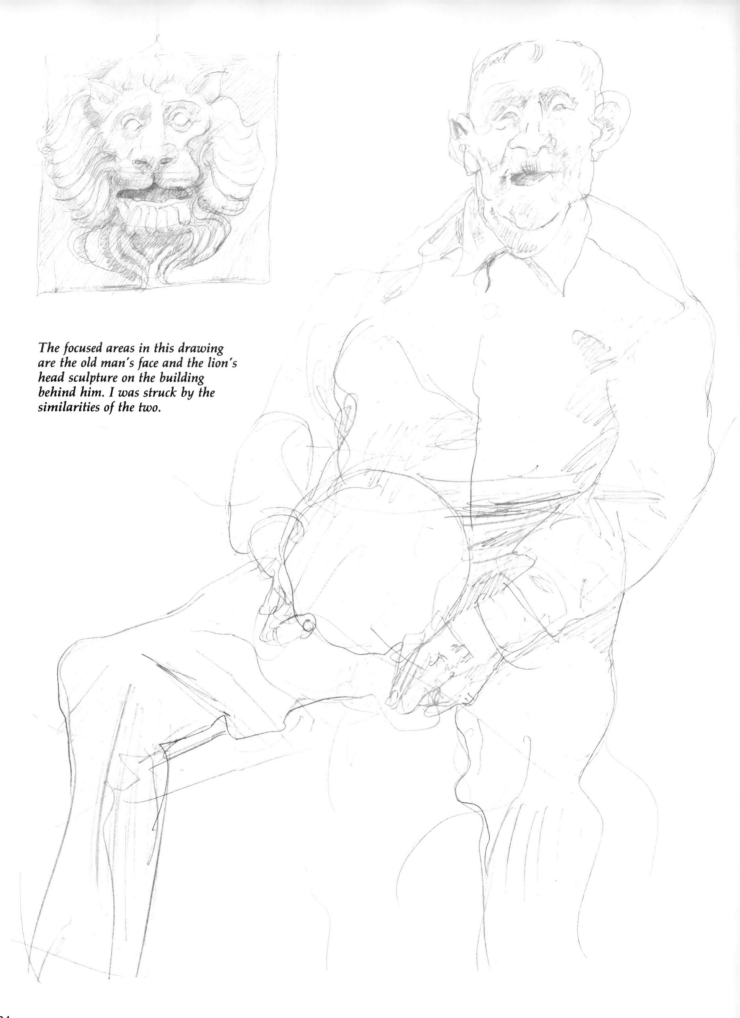

The focused areas in this drawing are the old man's face and the lion's head sculpture on the building behind him. I was struck by the similarities of the two.

Observation and fatigue

By now you have probably discovered that intense observation is hard work. (Remember, we didn't promise it would be easy!)

Fatigue is inevitable. It often comes on before you realize it. There are, however, several signs you can learn to recognize. One of these is a sudden awareness of time. Ordinarily, involvement in a drawing is like involvement in a dream. You are seldom aware of the passage of time. But, once you become time-conscious, you are probably getting tired. Other indications include an awareness of distractions and a tendency to digress into drawing from knowledge rather than from observation. At these times it's best to simply stop drawing.

The best strategy for outwitting fatigue is to develop the technique of "focusing." This is done by capturing the most interesting parts of your subject before fatigue sets in. Select ahead of time certain areas of interest in your subject and concentrate on developing those areas first at the expense of others which are only briefly considered.

"Focusing" allows you to bunch up both your energies and your time to be spent in just a few areas. For example, in a figure, the interest areas might be the head and hands. The rest of the drawing is treated with utmost simplicity.

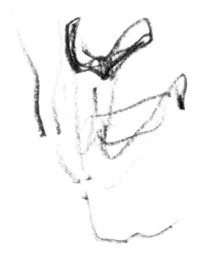

With just a few strokes, a face is suggested. The imagination fills in the rest.

Robert Levers

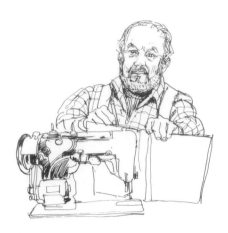

With "focusing," you are able to capture the best areas before your energies are spent. The result — leaving the viewers to use their imaginations to "fill in" or "complete" the understated forms — adds a great deal to the work.

On these pages, we can see the principle of "focusing," that is, concentrating on some areas at the expense of others, employed in different ways. Notice that focusing can be used whether the drawing is sketchy or precise. The choice of what is an "interesting" area is a purely personal one. What is interesting to one is not necessarily so to another. What matters is that some areas be selected over others.

Project 1 - F — Mechanical Objects

Make a drawing of a complicated mechanical object — an egg beater, a sewing machine, a typewriter, or a non-electric rotary pencil sharpener. Use a pencil (2B or HB) and keep the point sharp. Employ "focusing" in your drawing: Select one or two main areas and develop them in detail, treating the remainder of the drawing as simple contours and shapes. Look at the subject more than at the drawing. Search out the major and secondary shapes. (Squinting may be helpful here.) Try drawing blind at least three or four times as you work. Do not erase, but have two or more restatements in your drawing. Allow at least one-half hour. Work larger than life-size.

Bonnie Sczuka

36

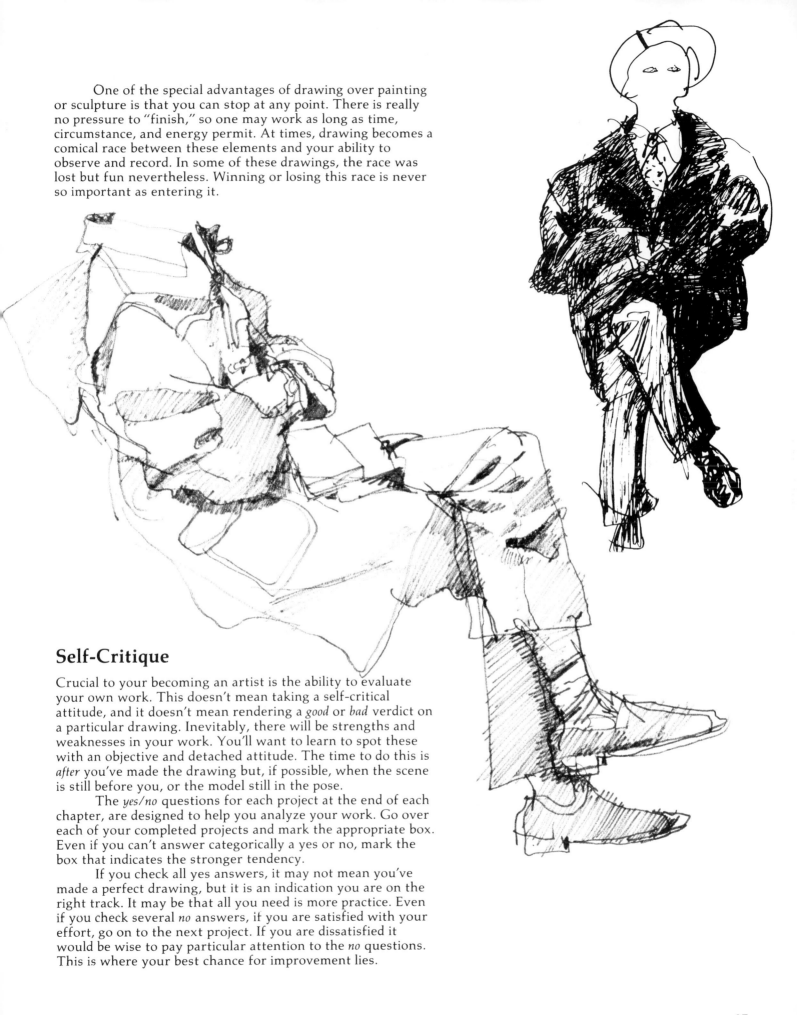

One of the special advantages of drawing over painting or sculpture is that you can stop at any point. There is really no pressure to "finish," so one may work as long as time, circumstance, and energy permit. At times, drawing becomes a comical race between these elements and your ability to observe and record. In some of these drawings, the race was lost but fun nevertheless. Winning or losing this race is never so important as entering it.

Self-Critique

Crucial to your becoming an artist is the ability to evaluate your own work. This doesn't mean taking a self-critical attitude, and it doesn't mean rendering a *good* or *bad* verdict on a particular drawing. Inevitably, there will be strengths and weaknesses in your work. You'll want to learn to spot these with an objective and detached attitude. The time to do this is *after* you've made the drawing but, if possible, when the scene is still before you, or the model still in the pose.

The *yes/no* questions for each project at the end of each chapter, are designed to help you analyze your work. Go over each of your completed projects and mark the appropriate box. Even if you can't answer categorically a yes or no, mark the box that indicates the stronger tendency.

If you check all yes answers, it may not mean you've made a perfect drawing, but it is an indication you are on the right track. It may be that all you need is more practice. Even if you check several *no* answers, if you are satisfied with your effort, go on to the next project. If you are dissatisfied it would be wise to pay particular attention to the *no* questions. This is where your best chance for improvement lies.

KEYS TO CHAPTER 1
The Drawing Process

Chapter 1 presents drawing as a highly learnable skill and stresses the role of drawing from observation in developing that skill. Important keys to remember are:

- **Use practical dialogue.** As you draw, talk to yourself in the language of line and shape rather than in the language of things. Keep your messages curious rather than judgmental.

- **Use triggering words** to direct your hand as you draw. Silently repeat a word that expresses the character of the contour you wish to capture.

- **Draw blind.** From time to time as you work, keep your eyes on the subject while continuing to draw.

- **Restate** rather than erase. When you correct errors or distortions, merely draw the new lines alongside the old ones — which you do not erase.

- **Choose seeing over knowing.** Learn to concentrate on your subject rather than on your drawing.

- **Individualize** by drawing exactly what you see. You will be able to draw specific, unique things rather than symbolized generalities.

- **Simplify shapes.** When you're in danger of being overwhelmed by the details of your subject, squinting will make them manageable.

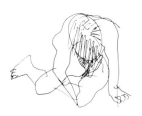

- **Look for shapes.** Learn to see your subject as a series of interlocking shapes. Draw the major ones first and then the secondary, enrichment shapes. Be alert to possible shape tie-ins and trapped shapes.

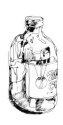

- **Focus.** Isolate the more interesting areas of your subject for special consideration while you treat the other areas in a more abbreviated way.

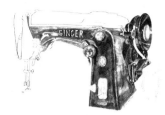

SELF-CRITIQUE OF YOUR PROJECTS

To properly critique yourself, try to answer the following questions carefully. Do not be concerned with how "good" or "bad" you think the drawings are. What is important is how well you met the stated criteria.

Project 1 - A — Feet

	YES	NO

- Did you observe the subject as much as you observed your drawing?
- Did you attempt to draw "blind" at least three or four times?
- Did you try "restating"?
- In your judgment, does the drawing contain accurate contours and details that resemble what you observed?

Project 1 - B — Hand

	YES	NO

- Did you observe the subject as much as you observed your drawing?
- Did you attempt to draw "blind" at least three or four times?
- Did you try "restating"?
- In your judgment, does the drawing contain accurate contours and details that resemble what you observed?

Project 1 - C — Pepper

	YES	NO

- Did you make the first drawing without either looking at or having just studied the fruit?
- In the second drawing, did you observe the subject as much as you observed your drawing?
- In the second drawing, did you attempt to draw "blind" at least three or four times?
- In the second drawing, did you try restating?
- In your judgment, does the second drawing contain accurate contours, tones, and details that resemble what you observed?
- In your judgment, is there a significant difference in the quality of the two drawings?

Project 1 - D — Eyes

	YES	NO

- Did you observe the subject as much as you observed your drawings?
- Did you attempt to draw "blind" at least three or four times?
- Did you try "restating?
- In your judgment, does the drawing contain accurate contours, tones, and details that resemble what you observed?

Project 1 - E — Tinted Glass

	YES	NO

- Did you observe the subject as much as you observed your drawing?
- Did you break down your subject into shapes, drawing major shapes first then secondary shapes?
- Were you able to record shapes in each of these categories: reflection shapes, shadow shapes, and label and lettering shapes?
- Did you attempt to draw "blind" at least three or four times?
- Did you try "restating"?
- In your judgment, does the drawing contain accurate shapes, contours, and tones that resemble what you observed?

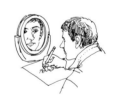

Project 1 - F — Mechanical Objects

	YES	NO

- Did you observe the subject as much as you observed your drawing?
- Did you break down your subject into shapes, drawing major shapes first, then secondary shapes?
- Did you try "restating"?
- In your judgment, does the drawing contain accurate shapes, contours, and tones that resemble what you observed?
- Did you employ "focusing" by concentrating your efforts in one or two areas while treating the other areas more simply?

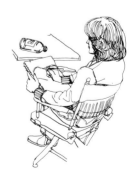

2

THE ARTIST'S HANDWRITING

SEPARATING YOUR TWO HANDWRITINGS • FREEING YOUR HAND • CONTROLLING YOUR HAND • COPYING • EMULATING • EXPLORING MEDIUMS • ERASING

In the nineteenth century, an Italian art critic named Giovanni Morelli became extraordinarily successful in attributing unidentified or mislabeled works to the proper artist. His method was simple. He analyzed the way each master handled the less significant details in paintings and drawings, and he noticed that in each the manner was consistent as well as unique. In such nonessentials as fingers and ears, he had the equivalent of a signature. Everyone who draws exhibits their "handwriting" in this way. Morelli had learned to read it.

In the same way that the masters are unique, each of us is unique. When we write, it is with a distinctly personal flair. Some like to bear down, some have a lighter touch. Some go in for looping letters, extreme slants, or tight formation. We unconsciously express ourselves in these eccentricities. Our handwriting clearly says, "This is me." Yet we write differently when we dash a note off to ourselves than when we pen one to a friend. The first might be labeled "free" and the second "controlled."

It is useful to think of drawing as involving two modes also: the intuitive and the analytical. The first is free and the second is controlled. We need our intuitive skills to grasp the essence of what we draw, to capture its spirit and feeling. Our analytical skills come into play when we want to sharpen, refine, and crystallize. I've listed some associative qualities that go with our two handwritings:

Intuitive Mode (Free)	**Analytical Mode (Controlled)**
quick, sketchy, assertive	precise, subtle, careful
nervy, sweeping	patient, judicious
impulsive, loose, connected	deliberate, fragmented

Problems occur when we try to employ these two modes at the same time. Analysis freezes and blocks the loose attitude required for intuition. Intuition softens and blurs the faculties needed for analysis. For full functioning, each must work on its own. Therefore, for the time being at least, we are going to consider that you have not one, but two handwriting styles. When you become disciplined at keeping them apart, you will find yourself using them alternatively in the course of a drawing and at appropriate times.

In this chapter, we'll examine the handwriting of six master artists to see how freedom and control combined in their work. We'll try copying and emulating them as a way of getting in touch with our own handwriting. We'll concentrate on the two types of handwriting, first drawing entirely in one mode and then the other, and finally combining the two. Since mediums play a part in the look of the handwriting, I've added some notes at the end on their use and handling.

Handwriting of the masters

When viewed up close, the strokes of master artists look as undisciplined as the random doodles any of us might make.

Giorgio Morandi

Edgar Degas

Rembrandt

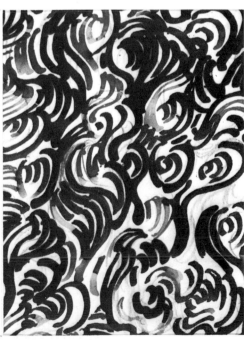

Vincent van Gogh

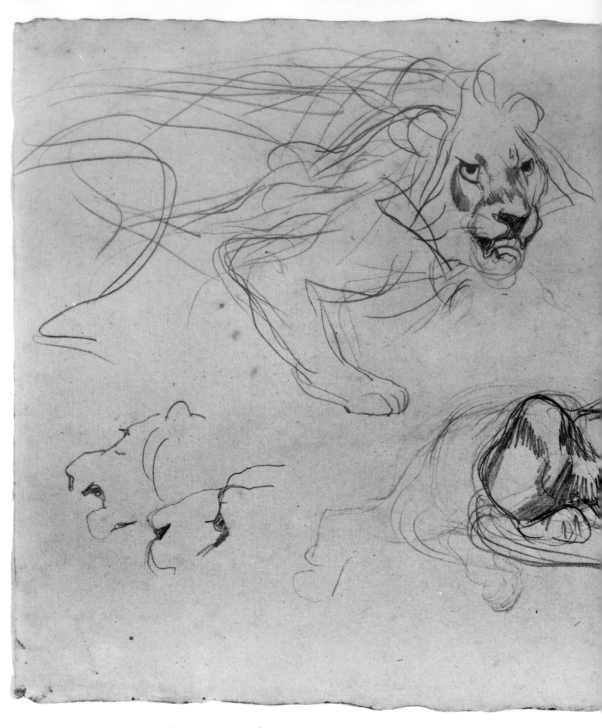

Eugene Delacroix, *Study of Lions*. Graphite.
David Adler Collection, Art Institute of Chicago.

Eugene Delacroix (1798-1863) — *Harnessing a tangle of lines*

Delacroix's *Studies of Lions* offers a close look at how the free hand and the control hand work together. Working from live, moving subjects, the artist used his *handwriting* to feel out the forms. He began with a series of almost random, free-flowing lines. As they built into busy clusters, particularly noticeable in the lion at top left, certain lines seemed to coalesce. Repeated strokes over the foreleg and haunch strengthened and reinforced the form.

We see more evidence of the control hand in the lower drawing as muscle and detail emerge in the modeling of the animal's body. These energetic strokes are darker and more decisive than those found in the other drawing.

This pair of drawings beautifully illustrates the feedback principle of handwriting. The first lines are vague and loose

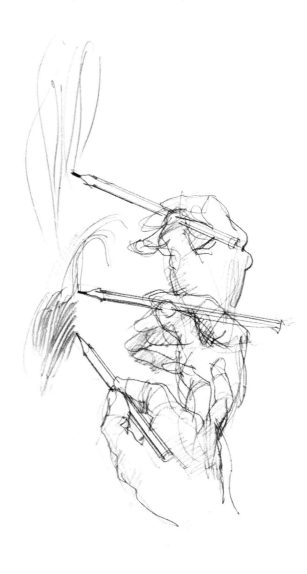

but give direction for the more accurate lines to follow. Presumably the lion moved while Delacroix drew as evidenced by the change in position of the back legs in the lower drawing. It's easier to make such changes when only a few sketchy strokes have been made than it is after a laborious investment of time. In the head of the upper lion and in the body of the lower lion, we can see the artist's strong use of focusing.

Try this: take your pencil and, without touching the page, trace over portions of this drawing in the air. Try to draw at the same speed that you imagine Delacroix used — fast for the free-flowing lines, a bit slower in the focused areas. Connect the same contours that he connects, break where he breaks, make the same restatements.

Lots of feeling-out lines, a few false starts, some close-up studies, and strong focusing provide evidence of Delacroix's impulsiveness, vigor, flexibility, and confidence.

"If it is necessary to rough cast with a broom, it is necessary to finish off with a needle."

Delacroix was one of the first artists to celebrate handwriting as a vital component of art, believing that it should remain visible not only in the drawing but in the finished painting as well. A Romantic in time and temperament, he stressed feeling over intellect. Critics have alluded to his "flying" *handwriting* and to his "demoniacal capacity for making the picture surface vibrate." Especially gifted in capturing the power and grace of animals, he often sketched them in the Jardin des Plantes in Paris for later inclusion in tempestuous and fanciful paintings.

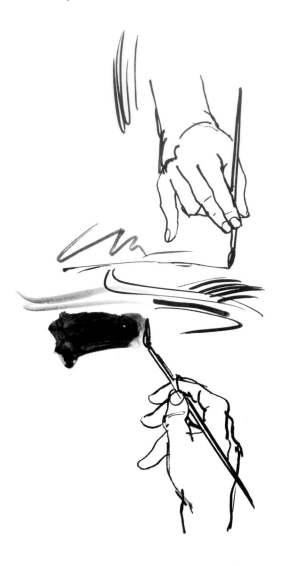

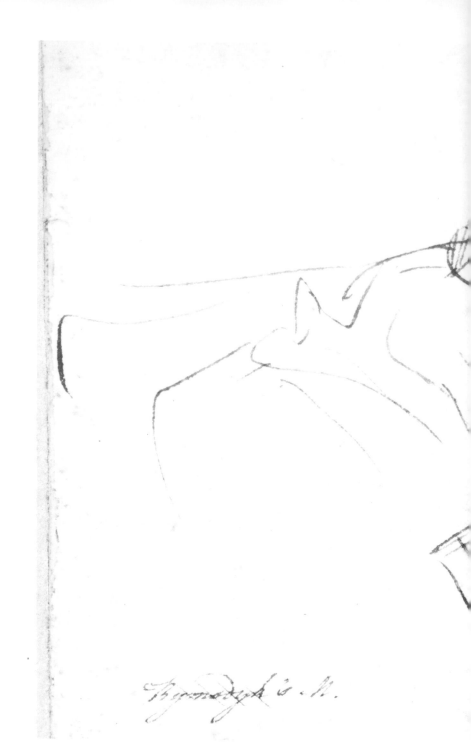

Rembrandt f.

Rembrandt was a draughtsman of great versatility. He was equally adept at rapid brush and ink drawings like this one and at precise little etchings. Rembrandt shunned artistic theories. He believed in a direct response to nature and was passionately consumed by the effects of light on form. His handwriting shows a variety of medium and short strokes, both thick and thin, spontaneous and controlled. He frequently used a partially-loaded or dry brush stroke which showed the texture of the paper.

Rembrandt van Rijn (1606-1669) — *A swift, accurate brush*

This ink drawing has much in common with the Delacroix on the previous page. Both are primarily studies, drawn as much to gain information as to produce a handsome piece of work. Although there are small areas of control, both are largely products of a free and supple hand. The changing line-weight and a certain whiplash quality add much to the vitality of this sketch. More unpredictable than pencil, ink applied with brush or pen was a medium evidently relished by Rembrandt. He may have used a combination of quill and brush here, as the stroke is quite fine in the pillow, coverlet, and facial details while it is bold and broad in the folds and shadows. Notice the thick, black accents under the head, arm and pillow. Softer tones surrounding the lower figure could have been brushed in

Rembrandt van Rijn, *Saskia Asleep*.
The Pierpont Morgan Library, New York.

with diluted ink or possibly rubbed with the hand or finger.
This presence of light and shadow, even in the sketchiest of his
works, is a Rembrandt trademark.

We can sense Rembrandt's shift to the control hand in
the area of Saskia's face and hand. He used shorter strokes
here and no doubt worked more slowly to achieve such
accuracy. Analyzed in this way, we realize that a drawing
which has every appearance of uninhibited freedom may
actually contain areas of carefully controlled focus which act to
balance vigorous strokes elsewhere.

Try retracing Rembrandt's strokes with a small empty
brush. See if you can get a feeling for the changes of pace from
careful, deliberate strokes in the face and hand to brushy
dashes in other areas. The difference in the width of the
strokes can be achieved by bearing down for the thick strokes
and using only the point for the thin strokes.

Matisse (signature)

Henri Matisse (1869-1954) —
A decorative, elegant line

"What I dream of is an art of balance, of purity and serenity devoid of troubling or depressing subject matter."

Matisse loved curving, decorative line. In his signature, we sense his love for the curve by the exaggerated size of the "s." Apparent in his handwriting is the simplicity and elegance of line. He only gets methodical when he comes to a pattern or decoration. His strokes are long, and he records as if his pen were a seismograph, charting each curve and bump of contour. He prefers a fine pen point or an even-weight pencil line, although we know Matisse was a tireless experimenter and would also try drawing with a thick brush or broad pens. His drawings were spontaneous in that he would draw in long, single lines, letting them "take him" wherever they would. He seems to have exercised control through a moderate, deliberate speed.

Matisse's drawings are characterized by their decorative charm. The pen and ink lines on the drawing at right are clean and graceful. The spontaneous elements of Matisse's work are in the long, flowing lines and apparent lack of planning. Contours were more important than correct proportions. It didn't really matter to him that the head and upper hand were drawn too small in relation to the rest of the figure. Nor was Matisse much concerned with light and shadow, perspective, or accurate features. For him, line was all. He loved decorative linear pattern such as that on the woman's dress or hair. Notice how in graceful, curving line he follows each subtle change in the contour of her arm. He didn't bother with restatements. When he put down a line, that was it. The faces Matisse drew rarely had expression or individual character. They look rather like those on Greek vases. You can see that he put more time and effort into the model's dress than on her face. And the little decorative touches on the chair or on her jewelry or hair invariably caught his eye.

Try going over a portion of this drawing holding your pen in the air. See if you can feel the speed and pressure of Matisse's long, arching pen strokes. Duplicate the fussiness of decoration in hair, jewelry, and chair ornamentation. Follow the shorthand way Matisse drew the model's features. As you do this, think of the artist himself and imagine that you are he.

Various decorative strokes.

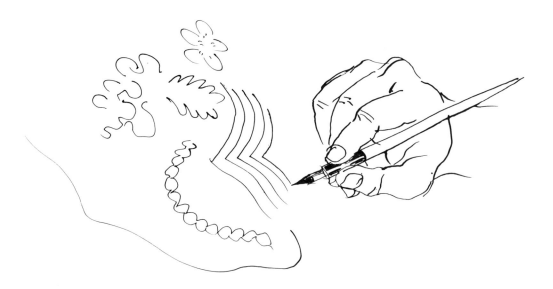

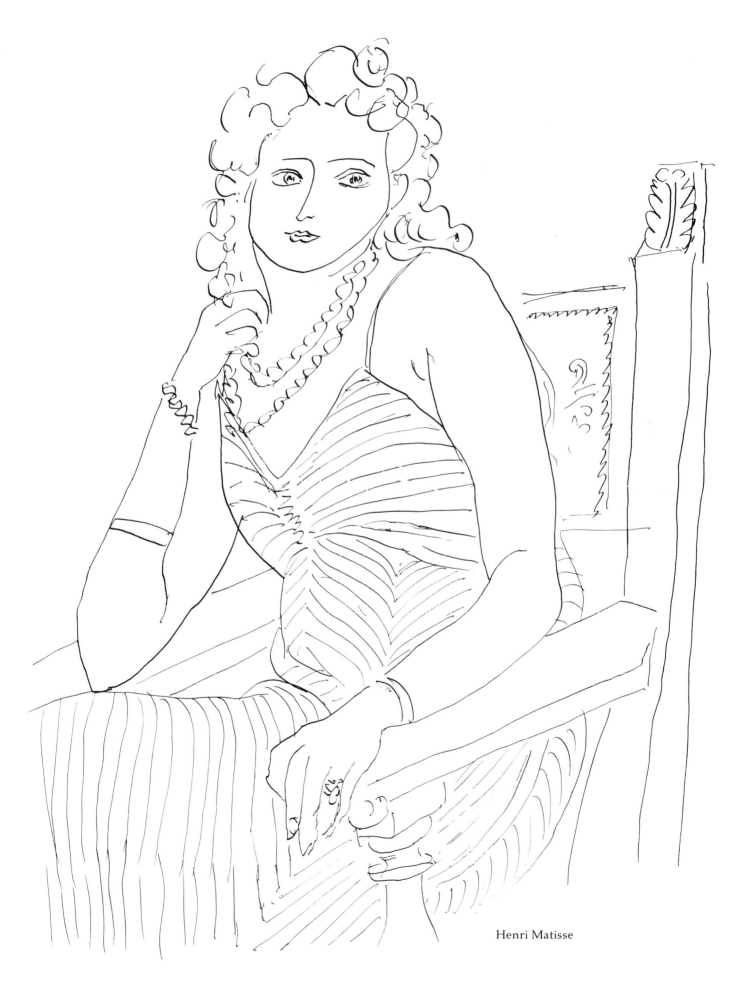

Henri Matisse

"The emotions are sometimes so strong that one works without being aware of working . . . and the strokes come with a sequence and coherence like words in a speech or letter."

Although van Gogh wasn't a natural draughtsman — his early drawings are often awkward and clumsy — he managed to create beautiful work by merging the spontaneous intensity of his vision with his control over a great variety of strokes. His later drawings are a virtual catalogue of strokes: straight parallel strokes, hatched strokes, swirling curlicues, undulating wavy strokes, and tiny stipple dots. Van Gogh usually made his drawings in pencil and worked over them with a reed pen to simulate the Japanese. He preferred a broad, flat pen point but sometimes switched to other points and even brush stokes, all in the same drawing. He also mixed in strokes of diluted ink.

Vincent van Gogh (1853-1890) —
Turbulent, swirling strokes

No artist in history is better known for infusing the emotionalism of his personality into the handwriting of his work than Vincent van Gogh. Much has been written about van Gogh's violent, tortured strokes. Even a drawing of flowers or of the postman were rendered with the thick, choppy dashes and intense swirls of a man possessed. It is true that much of the beauty of van Gogh's drawings lies in the spontaneous passion of his handwriting. What is sometimes overlooked, however, is his conscious effort to simulate various textures with a variety of strokes. He uses tight, thick swirls for the cypress trees, looser flowing swirls for clouds, short parallel strokes for wheat fields, and stipple dots for mown fields. Van Gogh was an impulsive draughtsman, to be sure, but we shouldn't forget that he counterbalanced this quality by experimenting laboriously with a variety of pen points and brush effects.

Using a pen with a thick point, simulate making each of these textures by drawing in the air over van Gogh's drawing. Try to get the rhythms and pace of each different type of stroke.

Vincent van Gogh, *Cypresses, Saint-Remy.* 1889. Reed pen and Bistre-colored ink, with preparatory pencil on paper. 24¾ x 32¼ inches.
The Brooklyn Museum, Frank L. Babbott and A. Augustus Hraly Funds.

Vincent van Gogh, *View of Arles.* 1888.
Museum of Modern Art, Rhode Island School of Design. Gift of Mrs. Murray S. Danforth.

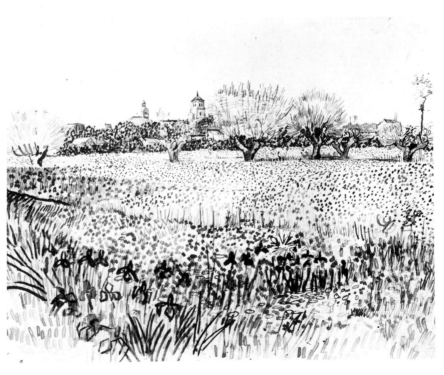

Experimenting with stroke variety.

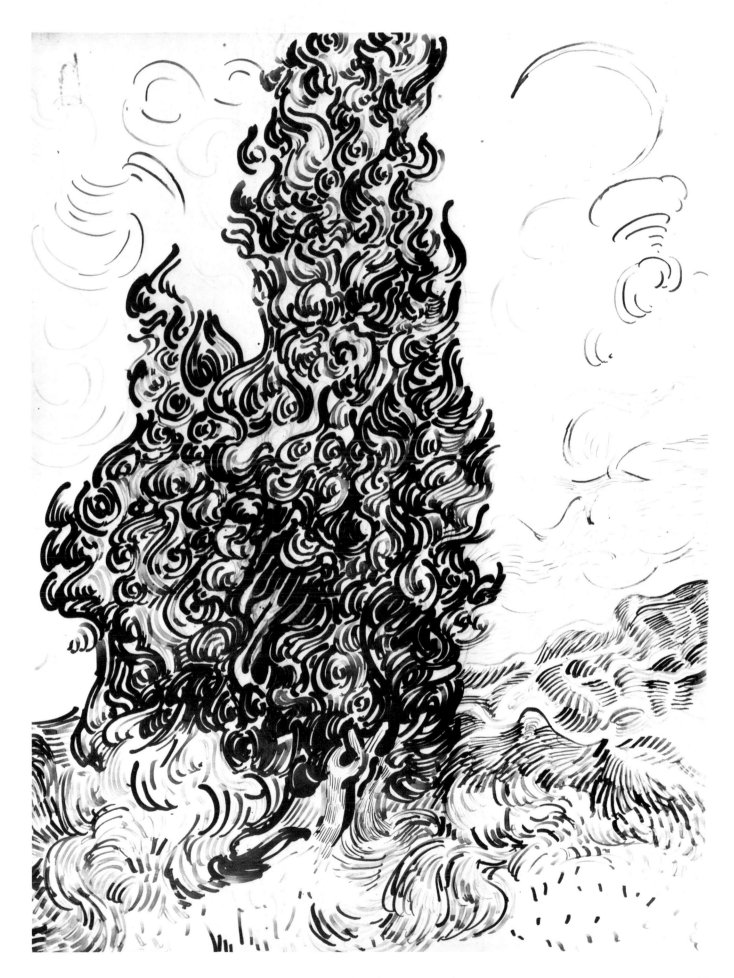

Degas

"What I do is the result of reflection and study of the old masters. Of inspiration, spontaneity, temperament, I know nothing."

Degas' statement is quite the opposite of van Gogh's. It is clear he trusted study and discipline over intuition, but we cannot take that too literally, for his handwriting reveals many "felt-out" passages.

Degas combined an accurate but graceful line with parallel "tonal" strokes. Sometimes these were done with a fine sharp pencil; others were done with a thick crayon or pastel. A typical Degas handwriting characteristic is to make numerous restatements in the quick, sketchy outline of an arm, leg or cloak, and to execute the hand or face in a precise and careful manner. Thus do we see the happy marriage of control and spontaneity.

Edgar Degas (1834-1917) —
A deft line and a controlled scribble

In Degas' work we see a handsome balance between spontaneity and control. Like Rembrandt, Degas would mix free, sweeping strokes with those more carefully handled in the same drawing. Note Degas' "tonal stroke," which is a series of quickly executed parallel marks. In the face, hair, arms, and torso, these strokes are short and evenly spaced. In the background, however, they are almost scribbled in. Also in the background, Degas changed the direction now and then by rotating his wrist. In the hatching strokes Degas used here, darkness or lightness is achieved by either varying the pressure or by varying the spacing between the strokes.

With a pencil or sharp crayon, go over this drawing in the air, duplicating Degas' tonal stroke. Feel the changes of direction he made, particularly in the background.

Degas has two invariable trademarks. One is "focusing." Note how sharply and carefully the features are drawn in relation to the rest. The other is "restating." If you will look closely, you will see numerous restatements around the singer's upper arm and lower torso. Restatements are a sure sign of spontaneity as are Degas' more scribbly tonal lines.

Degas was strongly influenced by Ingres, the great master of perfection, but he was also attracted to Delacroix, the turbulent Romantic. He was, as the critic Valery put it, "caught between the commandments of Monsieur Ingres and the exotic charms of Delacroix." This aptly describes the balance between control and spontaneity which Degas exhibited.

Back and forth scribble, shifting directions.

Edgar Degas, *La Chanson du Chien.* Lithograph.
Gift of W. G. Russell Allen. Courtesy, Museum of Fine Arts, Boston.

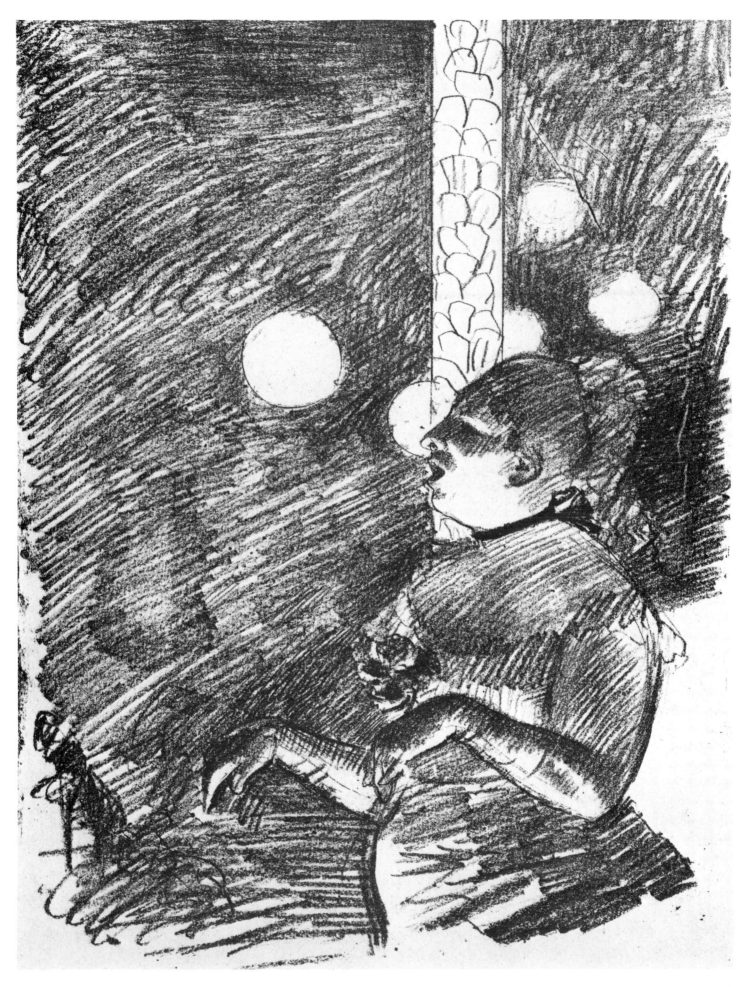

51

Giorgio Morandi (1890-1964) —
A patient crosshatch stroke

With Morandi, we begin to see a handwriting in which control takes precedence over spontaneity. He manages a methodical build-up of tone by a procedure known as *hatching*. In hatching, a light tone is produced by a series of short, parallel strokes. For a darker tone, a second set of strokes is added over the first and usually at right angles to it. This is called *crosshatching*. A still deeper tone is created by adding another set of strokes at yet another angle, and so on. Thus a picture is built up slowly and patiently, area by area. These strokes are short, rarely more than an inch long, in order to maintain control for evenness of tone.

Morandi, like most artists who work in this manner, preferred pen and ink or the etching process over all others because these mediums produce fine lines. Hatching is the handwriting of a deliberate, methodical temperament. A drawing like Morandi's would take several hours, perhaps days.

Try going over just a small section of this drawing with a dry pen. See if you can get a feel for the amount of control required.

Giorgio Morandi, *Still Life*. 1933. Etching, printed in black. Plate: 11¼ x 15⅜ inches.
The Museum of Modern Art, New York. Mrs. Bertram Smith Fund.

Morandi

Morandi's handwriting emphasizes control. He used his hatching lines to create only about four values (tones) — a light, middle light, middle dark, and dark. He avoids solid blacks. Here and there a fine pen outline can be seen. But he avoids an outlined look by letting the tones do the work. If you squint at Morandi's handwriting or view it from a distance, there is no feeling of lines at all but only of soft shades of gray.

Hatching

Crosshatching

Tones are built up patiently.

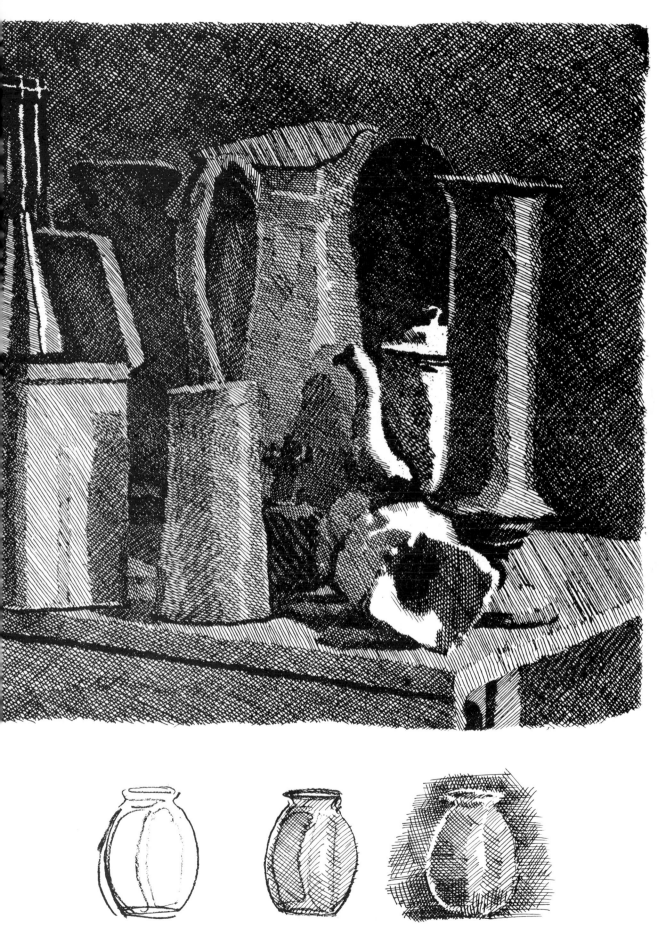

Shapes are drawn in pencil . . . hatching tones are added . . . background added, pencil erased.

Kathe Kollwitz (1867-1945) —
Soft tones and crisp edges

Although Kollwitz often made quick drawings in thick crayon or slashing ink lines, this self-portrait is notable for its subtlety and control. It seems to me to be a nearly perfect drawing — every line is right to the purpose. Incredibly, there are almost no "feeling out" strokes. When she used the side of the crayon, rather than the point, she was able to cover a lot of ground quickly. Notice how she sculpts the hollows and the creases of the face, using heavy pressure in these shadowy, dark areas, and lighter pressure elsewhere. The amount of pressure used determines the darkness of tone although here and there the tone is built up in successive layers.

Another feature of this artist's handwriting is the use of razor sharp lines to help define features within the soft modeling. This is particularly evident in the line of the mouth, the forehead wrinkles, and the edge of her face. These were achieved by using the sharp edge of the crayon. A razor or sharp knife may have been used to scrape out sharp white edges for the highlights on the nose and lower lip. Lastly, notice how the face fades into the background white of the paper. In a few soft strokes, the drawing simply ends, making the image all the more enigmatic.

To get a feel for this handwriting, try to duplicate a section of the Kollwitz self-portrait on a separate sheet of paper. You will need a stick of charcoal or Conté crayon. Bear down for the darks, ease up for the lights. Also try to obtain tonal variation by means of a gradual build-up. Additionally, the tooth or texture of the paper will affect the look by leaving (or not leaving) little white spaces in the interstices. See if you can recreate the variations of sharp lines and soft tones.

"All my life, I've carried on a conversation with Death."

In dark tones and sorrowful subject matter, Kathe Kollwitz expressed her somber preoccupation. Few artists have so successfully integrated life and art. She masterfully portrayed the victims of poverty, industrialization, war, and death in deep blacks and subtle greys. Fundamentally a dramatic artist, Kollwitz was able to evoke emotion even in the pained and reproachful gaze of her self-portrait. For her, tonality was a vehicle for mood.

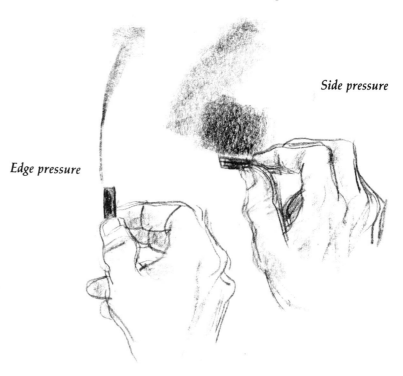

Edge pressure

Side pressure

Kathe Kollwitz, *Self-Portrait*. 1924. Lithograph.
Courtesy of the Fogg Art Museum, Harvard University Purchase Friends of the Fogg.

54

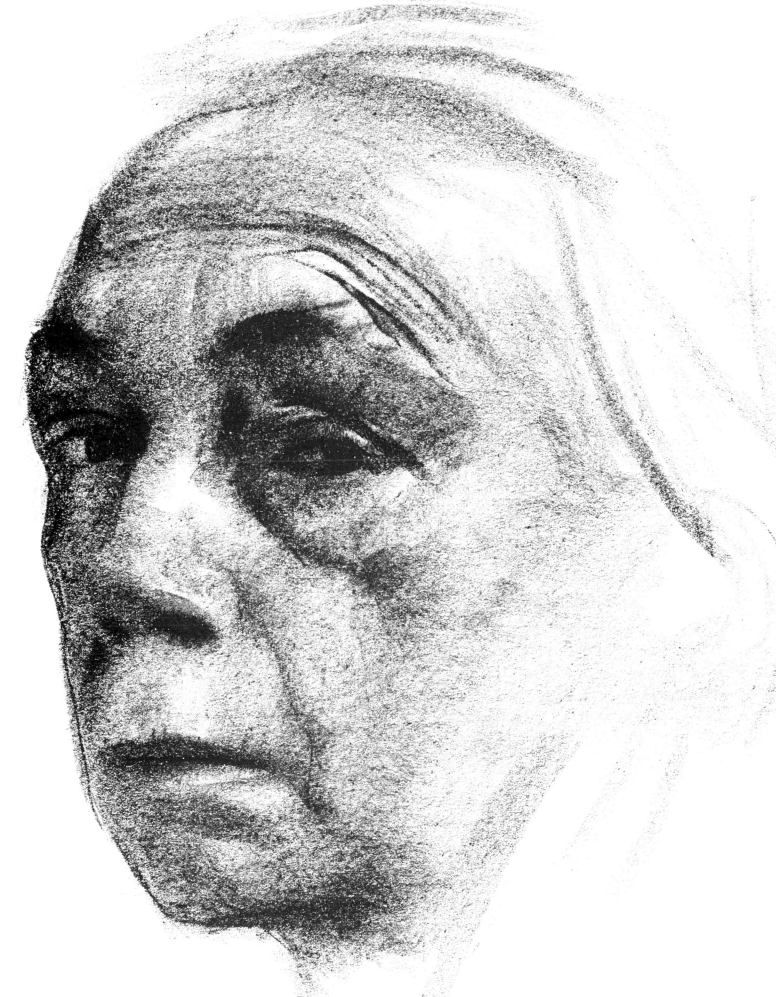

Project 2 - A — Copy a Master Drawing

Select one of the seven master drawings just discussed and copy it, using the same medium. To accurately reproduce the artist's handwriting, pay particular attention to the length of each stroke, connecting and disconnecting where the artist did. Strive for the same rhythm you imagine the artist was working in even though, in doing so, you will sacrifice some accuracy in proportions.

Work same size or larger and allow yourself 20 minutes for the drawing if you choose from among the first three artists and 30 minutes if you choose from among the last four. If you choose the Morandi, you may only want to do a portion because the crosshatch technique is very time-consuming.

When copying, try to experience the hand of the master.

Copying

A friend told me that her skiing improved dramatically when she was behind a good skier and, without really thinking about it, simply emulated her style and movements. This projection of self into another person, called empathy, provides us with a valuable key. Copying a master drawing allows you to share something of the experience of that master, to empathize with the artist. In duplicating the artist's strokes, you gain a "felt" sense of what *handwriting* really is. This sense grows in you. You begin by matching the master's drawing, stroke for stroke. This is done mechanically and laboriously. As you draw, you find that the task becomes increasingly easy. You come to know the handwriting. You make the stroke without conscious thought. This is the point of integration, that "in-the-groove" feeling that accompanies the learning of any procedure, whether it's a tennis serve or juggling method.

As a child, I loved to copy — and I always felt guilty about it. I remember drawing the Disney characters from magazine pictures, and then hiding or destroying the evidence. My neighbor Bobby Johnson was on to me, though, and whenever he found me drawing, he would cast his eyes suspiciously around the room until he spied the corner of the original sticking out from under the book or pillow where I had hurriedly stuffed it. I was humiliated, of course, and knew I was a fraud as an artist. This feeling kept me from enjoying much of the praise I received in later school years. In high school I was copying a wide variety of artists, particularly those who did the covers for *Time* magazine. In those days, most of the *Time* artists worked in very similar styles, but I could distinguish an Ernest Hamlin Baker from a Boris Chaliapin in a flash.

By now my drawing skills had developed considerably but, because they'd been achieved by what I considered to be dishonest means, I didn't trust them. I was late in accepting that I did indeed have a handwriting of my own and it had evolved in large part because of, not in spite of, my early copying. To a degree, it continues to evolve out of copying.

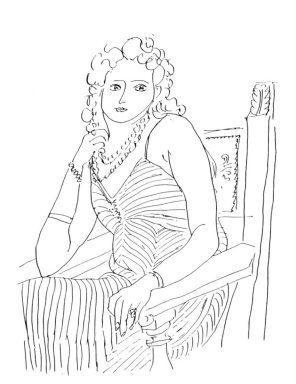

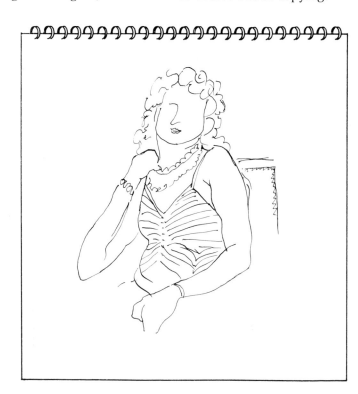

The other artists whose work is presented in this book, many of whom are friends, continue to exert an influence on my handwriting. I no longer feel guilty about it. When we know that Degas, Eakins, Cézanne, and most masters copied, we may embrace it as a key to learning.

Emulating

A step beyond copying, emulating is doing a drawing of your own in the handwriting of another. You will find it a challenging exercise. First, get acquainted with the handwriting of an artist you admire by studying it or copying it. Note the type of line, the type of drawing tool, and the mixture of freedom and control. Set up a subject similar to that used by the artist. "Be" that artist as you draw. Do whatever you think that he or she would do. Let emulating relieve some of the pressure of having to "be yourself." It's refreshing to step into someone else's shoes and let them make the decisions and take the risks. When in doubt, simply draw what you see.

From time to time, students express anxiety about losing themselves through copying and emulating. "I'm afraid if I draw like someone else, I'll never find out who I am," or, "I don't want to develop someone else's style." These concerns betray a lack of appreciation for the vitality of identity. I don't think we can ever say who we are in any fixed sense. Our own curiosity and sense of identification with others drive us constantly toward creative change.

Copying and emulating won't hurt you any more than trying to draw something exactly as you see it will stifle your creative spirit. Individuality bursts out like a weed through concrete. If you're worried about adopting too many of a certain artist's mannerisms, switch to another artist who works in a completely different style. Something of yourself will always be included. Yes, artists do eventually settle into recognizable handwriting patterns, but even those mature patterns continue to evolve over time. To be an artist is to be in a state of perpetual evolutionary growth.

Project 2 - B — Emulate a Master's Handwriting

Emulating the stroke and character you discovered in copying a master's drawing in Project 2 - A, make an original drawing of your own. Choose a similar subject and medium but work from life. Choose an animal for the Delacroix, a tree for the van Gogh, a still life for the Morandi, and pose a friend for any of the others.

The sketch at left suggests the kind of "carry over" in handling you should strive for. In this project, you will need to step completely out of your normal way of drawing and imagine that you are working with another artist's hand. Execute your strokes exactly as that artist would. As in Project 2 - A, you will sacrifice accurate proportions for quality of handwriting. Work same size again and allow 20 to 30 minutes unless you are emulating Morandi, in which case you will take longer.

When emulating, use that hand to make an original drawing.

For the distant grip used in free handwriting, pencil is held loosely, hand is away from point . . .

elbow and shoulder are brought into play . . .

Free handwriting

The way into drawing is often through *free* handwriting. Many artists have found that the best way to begin a particular drawing is not to plan or prepare but to get the pencil moving, making quick "feeling" strokes in response to the subject.

To get into the proper frame of mind, let's go over again the qualities we associate with free handwriting: quick, sketchy, assertive, nervy, sweeping, connected, impulsive, and loose. Do you catch the "I-don't-care-how-this-turns-out" attitude? Let's have no regard here for any end product. Instead, use the above words as triggering words as you try out the three techniques below. Slide your hand back on your pencil away from the point so that it practically dangles from your hand. You will be giving up control in exchange for mobility and speed. Bring the elbow and shoulder into play to get more sweep and fluidity into the line. The heel of your hand should rest lightly, if at all, on the paper. With the proper grip and a self-tolerant spirit, you are ready to try some of the free handwriting exercises.

The gesture

The gesture is simply capturing the essence of your subject in the quickest and most economical way. Gesture drawing involves a kind of "scribble" aimed not so much at what your subject *is* but at what it is *doing*. The gesture is particularly effective in capturing the animate — people and pets — but any subject which evokes a feeling in you — an old tree or a coat draped over a chair — is a good gesture subject. Use no more than one minute for each gesture drawing and keep your pencil moving the entire time.

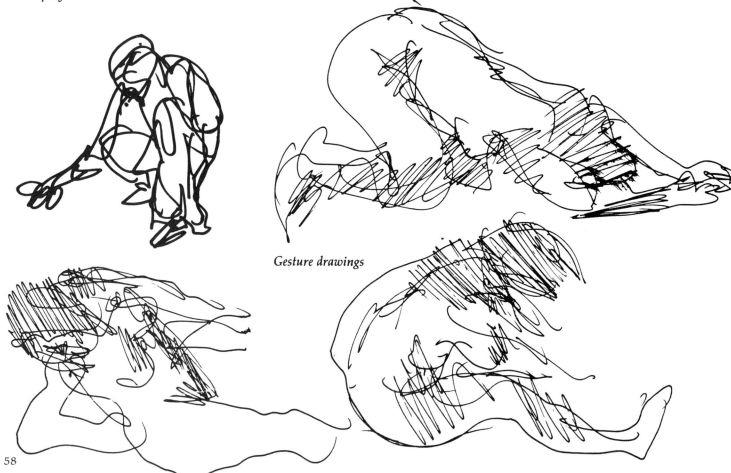

Gesture drawings

The connected-line drawing

Another quick-drawing method, connected-line drawing, is similar in spirit to the gesture but, additionally, is done entirely in one continuous line. Here again, your aim is not to be accurate but only to record the various angles and curves in a spontaneous way. This is not an outline drawing. Roam in and out of the subject, follow contours, and never lift your pencil. Take no more than two minutes for each drawing. People, cars, furniture, plants all make good connected-line subjects.

The five-minute burn

The rules for the five-minute burn are simple. Look in any direction and draw what is in front of you for five minutes *without stopping*. Give no thought whatsoever to composition, subject matter, accuracy or style. The idea is to capture as much as you can within your field of vision. The more complicated, the better. Look to the corners of your room, a cluttered table top, or a busy street. You may lift your pencil for this one.

Free handwriting involves short but concentrated bursts of energy and the putting aside of your conscious, controlling self. Make lots of these, particularly if you are the cramped, fussy type. It will teach you to capture the image quickly — very handy for sketching subjects that move, such as children, pets, people on buses, etc. You may do some interesting, even powerful drawings this way, but that isn't the goal. Don't spend time evaluating your freehand drawings and don't seek criticism or comment about them. If you view free handwriting as a long-term exercise in growth, the occasional "gem" you produce this way can be seen as a happy chance.

Project 2 - C — Free Hand Drawing

For this project, use the three approaches described on these pages to make several free hand drawings.
1) Six gesture drawings: Have a friend take six one-minute poses (bending, leaning, reaching, twisting, etc.) and capture them in a series of scribble drawings, all on the same sheet of paper.
2) Three connected-line drawings: Again, using a model, make three two-minute drawings, each without lifting the pencil from the paper until completion.
3) One five-minute burn: Find a cluttered table top or the busy corner of a room and draw it as fast as you can for five minutes straight. Do not stop to consider composition or accuracy or anything else.

For these drawings, use the distant grip and any drawing tool you feel comfortable with. Stay loose and don't worry about how your drawings will turn out. This is an exercise in understanding the mental attitude necessary to explore what your eyes and mind see while your hand follows and interprets the images in unhindered, natural handwriting motions.

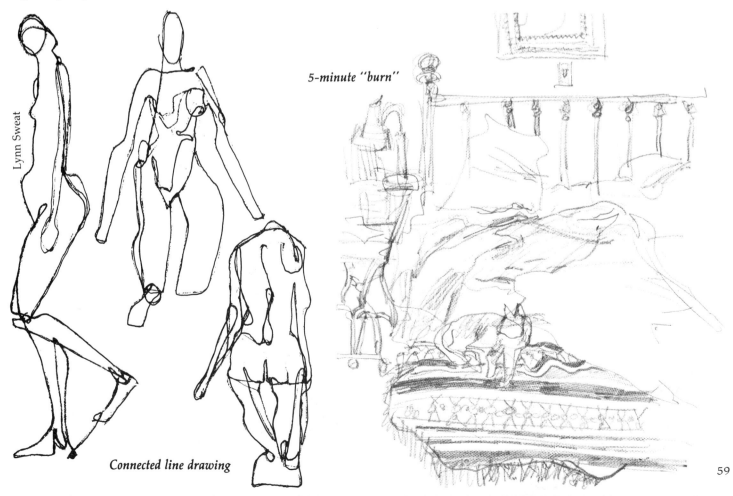

Lynn Sweat

5-minute "burn"

Connected line drawing

For the close grip, pencil is held down near the point. Fine muscles of fingers and wrist are employed.

Control handwriting

If free handwriting is the hare, control handwriting is the tortoise. It takes more time, but its leisurely pace is relaxing, and it's always there at the finish. Be prepared to spend some time concentrating on these projects. You'll be exercising your editing and fine motor skills to bring out the precise, subtle, careful, patient, and deliberate aspects of yourself. Keep these attitudes in mind as triggering words. For greater control, slide your hand down near the point of the drawing tool. You'll be making shorter, more accurate strokes. Keep your point sharp, work slowly, and evaluate your progress periodically. These exercises were designed to improve dexterity and provide you with a measurable standard. You can judge for yourself whether you've graded the tone evenly, softened edges accurately, or recorded details faithfully.

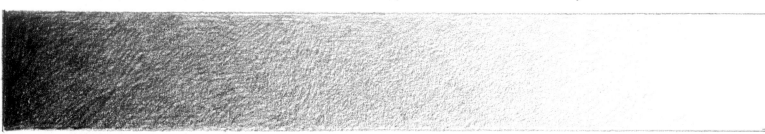

Tonal bar using pressure strokes.

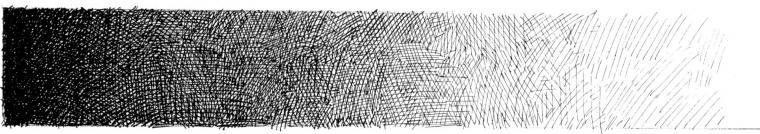

Tonal bar using hatching strokes.

Tonal bar

This exercise is valuable in controlling tone and is harder than it looks. Draw a 1 x 8-inch rectangle and create within it an evenly graded tone, moving from black at one end to white at the other. You can do this in any medium, but I recommend you try it in HB or B pencil first. Use the point or the side or both to get the results you desire. Build up to the tone slowly and watch out for the the common tendency to get too dark in the light half of the bar. Check your progress periodically by squinting and by stepping back. Your finished bar should move uniformly from dark to light. You can compare it with the examples above but don't be surprised if you do it better.

Hard and soft edges

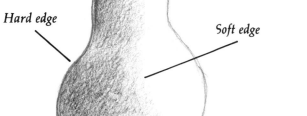

Hard edge

Soft edge

A hard edge is one with a sharply defined border; a soft edge gradually disappears. Most tonal drawings mix hard and soft edges. In this exercise, lightly draw a simple pear shape within a rectangle. The pear should be dark on one side, gradually blending (soft edge) to white on the other. The outer edge of the pear should be crisply defined all around (hard edge). The background should be a middle gray. If you want a slightly more challenging problem, make the background dark against the light half of the pear and shift to light against the dark side.

Tonal matching

The challenge in this exercise is to accurately match the tones and edges in a black and white photograph. First trace or copy a light outline of the face below. Then place your outline drawing next to the photograph and duplicate as closely as possible each tone and edge. By building up patiently and squinting frequently, you'll be able to get a good match of dark, light, and middle tones. Be particularly sensitive to the hard edges, the soft edges and those edges in between. From time to time, step back and compare your drawing with the photograph. This exercise requires at least 15-20 minutes.

 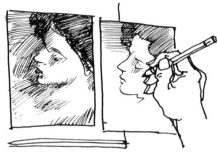

Copy or trace the outlines of the essential shapes in the photograph. Lay the two side by side and try to match the tones of the photo.

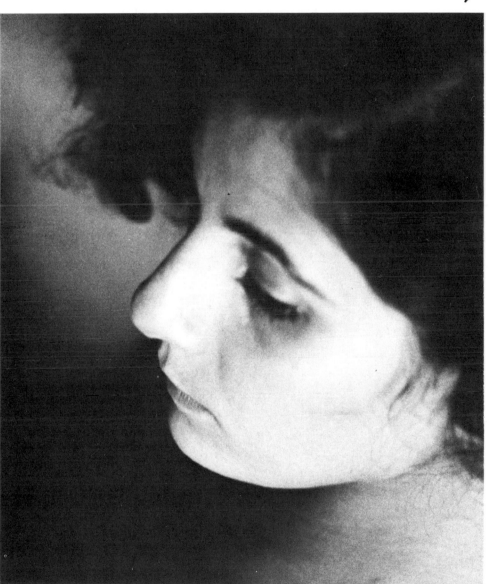

Howard Search

The precision patch

This is an exercise in tonal accuracy and fine detail. The challenge is to make a precise drawing of some small, insignificant area — perhaps a section of machinery, or a door hinge. Work slowly and strive for a meticulous rendering. Hold the drawing tool near the point and keep it very sharp.

Project 2 - D — Make a Tonal Bar

Make a 1½x8-inch panel and create within it an evenly graded tone from black to white. Use a soft pencil and build up the tone deliberately and patiently, squinting from time to time to check your progress. Strive for a smooth transition between tones and watch for "spots" of light or dark. The middle tone (50% black) should be in the center of your bar. Allow yourself 30 minutes.

If you are interested in pen and ink, try a second tonal bar using the crosshatch method. The tones will be slightly coarser than your pencil version, but when you step back, the overall effect should be the same. To create the light areas, the pen strokes must become gradually less numerous and farther apart. You may want to use the examples shown here as a general guide for both bars.

Project 2 - E — Match the Tones

As carefully and accurately as you can, match the tones in this photograph. You may want to lightly trace the main shapes first before laying the paper alongside to duplicate the tones. Build up the strokes slowly and patiently and pay particular attention to the hardness or softness of the edges. Squint frequently to compare your work with the photograph. Use a soft pencil and allow yourself 30 minutes.

In the early stages of your drawing you mostly use the distant grip.

As you begin to refine and sharpen, you shift more often to the close grip

The free hand and the control hand in combination

The relationship between the free hand and the control hand is clearly described by the sculptor Henry Moore: "I sometimes begin drawing with no preconceived problem to solve, with only the desire to use pencil or paper and make lines, tones, and shapes with no conscious aim; but as my mind takes in what is so produced, a point arrives where some idea crystallizes, and then a control and ordering begins to take place."

The free hand makes the forays over the paper and takes the risks; the control hand makes refinements and consolidates the territory. Risk and consolidation is a fluctuating process requiring a mental shift as well as a physical one. As you move between the freedom and control modes, your grip on the drawing tool will shift from the relaxed grip to the close grip and back again.

It may seem a little awkward at first, particularly the shift in grip, but with a little practice these changes in mode will take place automatically. There are artists who claim to make this shift only once — when they finish their outline sketch and begin to fill in details. While that is the general formula for drawing, more flexibility is obtained by shifting back and forth more frequently throughout.

Each shift is an unplanned event. During the free mode, a collection of loose lines begins to build. At some point, certain of these lines will seem to be especially promising, and the artist instinctively shifts to develop them. This consolidating may last only a few moments, then the hand slides back to the free mode and further new territory is staked out. Ultimately the drawing is finished in the control mode, but not before numerous shifts have been made along the way.

I've been describing in somewhat laborious fashion a process that is largely unconscious. Naturally, the first few times you try it, shifting from one mode to the other will seem awkward and mechanical, so force yourself to try this only a few times in every drawing until you get used to it. It will prove a valuable key.

Project 2 - F — Alternating Free and Control Hands

The purpose of this project is to practice shifting between your free and your control hands. Place a vase of flowers before you and begin with a free hand gesture sketch of the entire subject. Develop certain areas a little further and then shift to the control grip to delineate some of the petals, leaves, shadows, and tones therein. Leave some areas loose and undeveloped. Shift back and forth between the two hands at least four times during the course of the drawing. Work in any medium and allow 30-40 minutes.

NOTES ON MEDIA

A complete cataloguing of the different uses and properties of each medium on different surfaces would fill a large volume. For that kind of detail, I would recommend *The Artist's Handbook* by Ralph Mayer. For most of us, however, a more general exploration will suffice. For the sake of organization, I've divided the media into two rough categories, calling one Ink and the other Powder.

There is an undeniable connection between handwriting and materials. I encourage you to experience this connection by trying the experiments below in different media and then comparing them. Keep the subject the same — a little fragment or a copied photograph is enough — and keep it simple. Compare not only the end results but also how each of the different media felt in your hand. (A close-up of some of the effects can be found in Chapter 6.)

Ink materials

This group includes brushes and pens and felt-tip markers of all kinds. You will find them fluid, graceful, and sharp. Tips and points range from very broad to very fine and deliver crisp, black lines. To establish tone, ink washes or hatching is employed.

Pen and ink (crow quill point) Good line variety, thickness varies with pressure. Good for fine textures, sharp details.

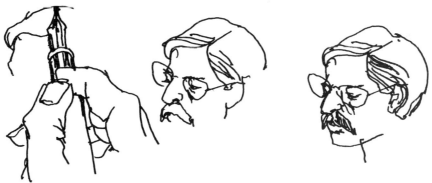

Pen and ink (cartridge fountain pen) The continuous feed of ink is very handy. Rounded tip (bowl point) allows for smooth changes in direction. Portable.

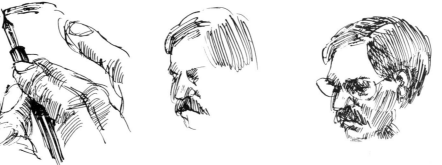

Felt tip marker (water-soluble)
Like the permanent marker but produces weaker blacks. Capable of instant tonal effects by rubbing with wet finger.

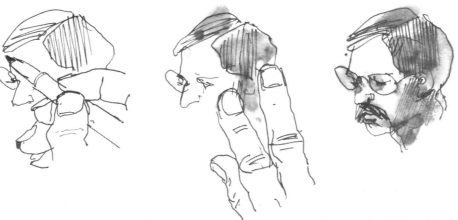

Felt tip marker (permanent)
Bold, decisive look. Nice solid blacks. Can vary line thickness by shifting from point to side.

Ballpoint pen Extremely versatile. Produces both dark and light lines, depending on pressure used. Doesn't smear. Portable.

Brush and ink
Very free. Good for explosive, unpredictable effects. Large, solid blacks obtained quickly. Interesting dry-brush effects on rough paper. Mixes easily with water for grey tones.

Mechanical pen (fine point)
Even line weight, continuous feed. Good for long, connected lines and crosshatching. Excellent for very small drawings.

Powder or dry material

This group includes pencil (graphite), charcoal (vine and compressed), crayon (usually Conté), and chalk. Generally, these materials are dry, tonal, malleable, fragile, and conducive to bold, sweeping strokes. Although all are obtainable in either stick or pencil form, I like to think of charcoal, crayon, and chalk as sticks. They are good for working large. They deliver an explosive black line or a broadside tone. In stick form they're messy and fun. There are no gold stars for clean fingernails.

Pencil is hard to classify because you can do almost anything with it. The piano of drawing instruments, you compose, think, sketch, and do finely finished pieces with it.

Pencil
The most versatile tool, equally adaptable to sharp lines, soft tone, and all ranges in between. Available in leads from soft (B series) to hard (H series). Cheap, convenient, and portable.

Vine charcoal
Very soft effects, rather grey, highly malleable, subtle, fugitive.

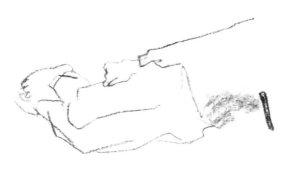 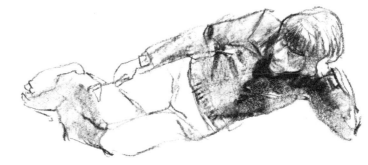

Compressed charcoal
Strong blacks, bold lines, good for working large, edges blur nicely.

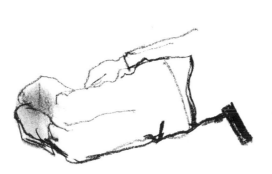 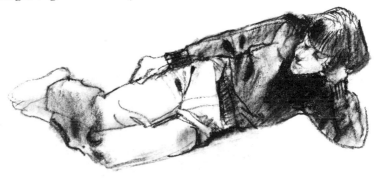

Conté crayon
Good variety of effects from use of both side edge and point. Shows tooth of paper well. Good for building tones gradually.

Rubbing procedures

An excellent feature of the Powder materials is their malleability. Smearing, smudging, wiping over, and blurring can yield remarkable effects instantly.

Using thumb or fingers . . . to soften an edge . . . or tie two shapes together.

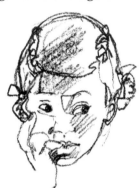
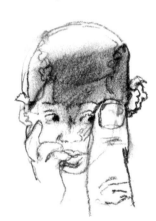
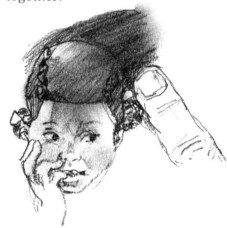

Using a paper stump . . . to soften fine details . . . or to draw with.

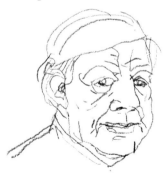
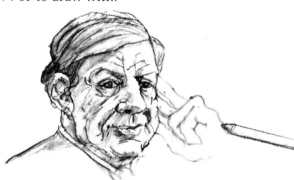

Using a hand or tissue . . . to lighten a tone . . . or to soften.

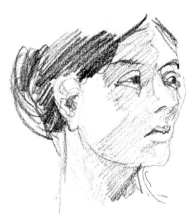

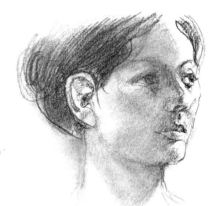

66

Erasing as a drawing method

In Chapter 1 you were cautioned against erasing, but now let's explore the eraser as a drawing tool.

Knocking back
When an area is a confused tangle . . .

reduce it without fully erasing it . . .

and your restatement will have less competition.

 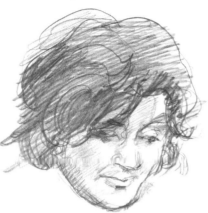

Picking out lights
Establish a tonal area . . .

pinch the kneaded eraser into a point or a sharp edge . . .

and pick out the highlights.

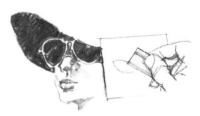 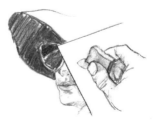

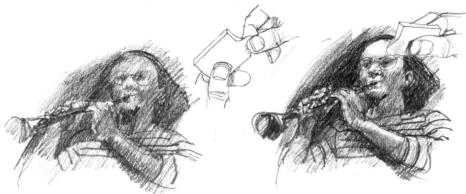

Using a Mask
When sharp edges are needed . . .

cut out the desired highlight shape from a piece of scrap paper . . .

and erase through the window.

Erasing with razor blade
Light scraping will reduce the tone.

Sharp details can be scraped out, especially in Conté.

This technique works for ink as well.

 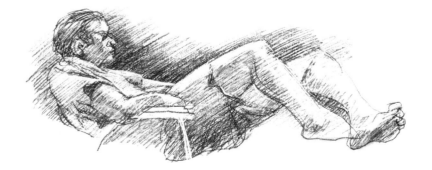

KEYS TO CHAPTER 2
The Artist's Handwriting

- **Separate your "two handwritings."** Consider that you have an intuitive "free handwriting" and an analytical "control handwriting." Each is governed by a different set of attitudes and a different drawing tool grip. Familiarize yourself with the qualities of each and practice shifting from one to the other.

- **Free your hand.** In a few swift strokes, try to capture the overall action of your subject rather than the correct proportions and accurate details.

- **Control your hand.** Working on small areas, carefully and patiently refine the lines and render the tones of your subject. Evaluate frequently by squinting or stepping back.

- **Copy.** To gain a "felt" sense of what the term handwriting means and to become more intimate with an artist you admire, choose a piece of artwork and try to duplicate it.

- **Emulate.** After copying another artist's work, see if you can do an original drawing in that artist's hand. Through the act of becoming another person, you will find yourself doing surprisingly fresh and interesting work.

- **Experiment with media and techniques.** Explore the advantages of each medium in different versions of the same subject.

- **Use your eraser and your bare hand as drawing tools.** Rubbing, smudging, wiping, and erasing are effective means of drawing. Use them to soften, sculpt, lighten, or "pick out" parts of your drawing.

SELF-CRITIQUE OF YOUR PROJECTS

Project 2 - A — Copy a Master Drawing YES NO

- Are your lines and strokes of the same length as the master drawing? —— ——
- Do your lines and strokes have a similar weight (thickness)? —— ——
- Do your lines and strokes have a similar density (blackness)? —— ——
- Were you able, at least in some of the lines and strokes, to capture a similar sweep (freedom)? —— ——
- Did the copying ever become somewhat natural and instinctive? —— ——

Project 2 - B — Emulate a Master's Handwriting YES NO

- Were you able to feel, at least at times, that you were working with someone else's hand? —— ——
- Comparing your drawing to the original master drawing, do you see in your lines and strokes a similar:
 Length? —— ——
 Weight? —— ——
 Density? —— ——
 Sweep? —— ——
- Did working in another hand help relieve you of some of the responsibility for the result? —— ——

Project 2 - C — Free Hand Drawing YES NO

- Are your gesture sketches loose and scribbly? —— ——
- Do they generally capture the action of the pose? —— ——
- Did you keep your pencil on the paper at all times for the connected-line drawing? —— ——
- During the five-minute burn, did you draw rapidly and without stopping for the entire time? —— ——
- Did you use the distant grip throughout? —— ——

Project 2 - D — Make a Tonal Bar YES NO

- Look at your tonal bar from a distance of about three feet. Is there an even transition from light to dark? —— ——
- Is the middle-grey tone in the center of the bar? —— ——
- Did you eliminate most of the light and dark "spots"? —— ——
- Did you build up the tones slowly and patiently, using both the side and the point of your pencil? —— ——

Project 2 - E — Match the Tones YES NO

- Place your drawing and the photo side by side and squint. Are they similar in tone? —— ——
- Does your drawing have both hard and soft edges? —— ——
- Did you keep your pencil sharp for the hard edges? —— ——
- Were you able to create smooth transitions in the graded tones, avoiding spottiness? —— ——
- Did you build the tones gradually? —— ——

Project 2 - F — Alternate Free and Control Hands YES NO

- Did you shift from the distant grip to the close grip and back again at least four times? —— ——
- Is there evidence of each grip in your drawing? —— ——
- Were you able to feel the difference between the free and the control hand modes? —— ——
- Does your drawing contain some focused areas? —— ——

3

PROPORTIONS: TAKING THE MEASURE OF THINGS

SIGHTING • FINDING THE MIDPOINT • USING PLUMB AND LEVEL • LOOKING FOR COMPARATIVE MEASUREMENTS • FORESHORTENING • INTENSIFYING PROPORTIONS

All gifted draughtsmen seem to have in common an almost infallible eye. I once watched a demonstration by an illustrator who was known for his uncanny drawing skill. He was drawing from a model. He first made a mark near the very top of his paper, then another at the bottom. He began the top of the head at the upper mark and rapidly worked his way down, finally hitting the big toe of the foot exactly on the bottom mark. Of course, everything in between was accurate. This feat is simple enough to describe but exasperatingly difficult to execute. I have often watched a friend of mine of even more prodigious abilities draw sweeping, complicated passages without lifting his charcoal from the paper. In a single, beautiful line, he would draw the model's out-thrust hip, then follow down the leg, catching each curve of muscle and jut of bone, turn sharply at the foot, articulate the toes, cross over the overlapping second foot and up the other leg, all with flawless precision.

As inspiring as these virtuoso performances are, it should be reassuring to all that the eye and hand can be trained to perform such feats — not necessarily with the same style, grace or intensity as the most gifted artists, but with considerable accuracy. In fact, drawing accurate proportions is probably the aspect of draughtsmanship that improves most with training and practice. Proportions are relationships — one part to another and all the parts to the whole. Although all good drawing requires it, when the human form is the subject, accuracy is most important because the average human viewer knows the human form intuitively. Proportions are the one area of art that everyone feels competent to criticize. "That's a nice drawing, but isn't the (fill in the blank) a little too (fill in the blank)?" When proportions are badly drawn, it interferes with the viewer's appreciation of other qualities in the picture. When proportions are drawn correctly, it's hardly even noticed — which is just what we want.

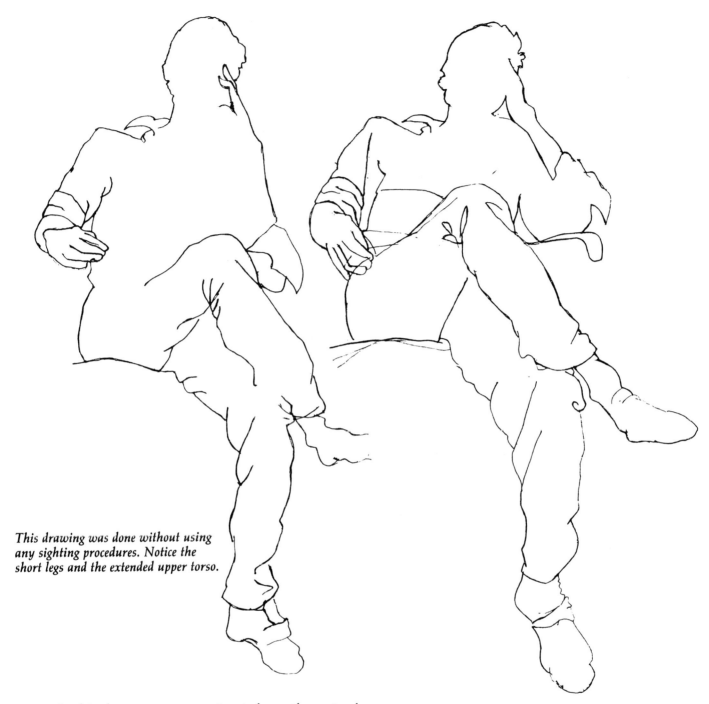

This drawing was done without using any sighting procedures. Notice the short legs and the extended upper torso.

In this chapter, you are going to learn three simple strategies for taking accurate measurements. All of them employ the drawing tool as a measuring instrument in a method called *sighting*.

To demonstrate the immediate benefits of sighting, I asked a student to make an outline drawing of me. The left-hand drawing above was the result. I then explained just one of the sighting techniques — finding the midpoint — and asked her to try again. The difference is remarkable. In the first case, the torso is unnaturally elongated and the legs shrunken. These defects are corrected in the second drawing, producing not only the proper size relationships but also a natural and graceful pose. I hope you will agree that it is an altogether more life-like drawing than the first.

This drawing was done by the same student after finding the midpoint. Here the leg-to-torso relationship is more credible and the pose seems more natural.

For vertical measurements

For horizontal measurements

Drawing by eye

All methods we've discussed in the first two chapters amount to drawing by eye. Most of us have a pretty good eye, more accurate than we realize. When we judge which of two pieces of cake is larger, or whether a floor is level, or — impossible for me — whether a couch will fit through a doorway, we are relying on the same estimating skills used in drawing. These are the skills we've been developing up to this point. Now we're ready to add to these some objective measuring strategies.

Sighting — a tool for measuring

By holding your drawing tool in front of you and sighting along it, you have a valuable aid to accurate proportions. The procedure is this: grasp your pencil between your thumb and first two fingers so that most of it extends vertically as shown. Hold it at arm's length, elbow locked. Now, holding your head still, one eye closed, sight along the pencil at your subject. This will be the basic position for the measuring techniques we call sighting.

 I'm using the term *pencil* for simplicity's sake, but all of the following applies as well to pen, crayon, or charcoal.

Three sighting strategies:
1. Finding the midpoint
2. Using plumb and level
3. Taking comparative measurements

These immensely useful and versatile procedures yield immediate and effective results. You'll learn to measure proportions as you *see* them rather than as they actually are. Of course, we know that objects appear the way they do because of their underlying form, but we are going to draw what we see *rather than what we know*. It is a fact that the average human figure is about seven heads high, but when your model is slouched in a chair, legs pointed toward you, that information is of little help. Using the sighting methods of midpoint, plumb and level, and unit of measure will prove to be a more direct means of obtaining accuracy in your drawing.

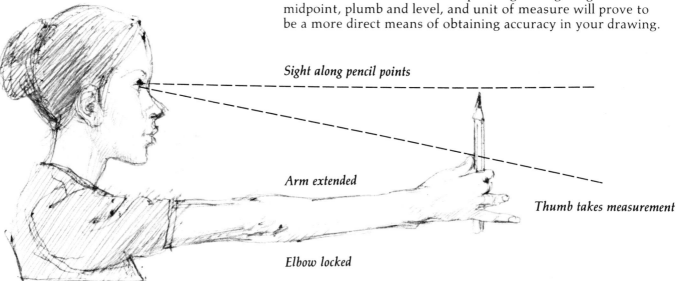

Sight along pencil points

Arm extended

Thumb takes measurement

Elbow locked

Finding the midpoint

Think of your subject as a shape which you divide at the midpoint. That half above the midpoint must fit into the top 50% of your drawing area and the half below must fit into the lower 50%. Studiously finding and using the midpoint in this way ensures that each half of whatever you divide will be in proportion to the other.

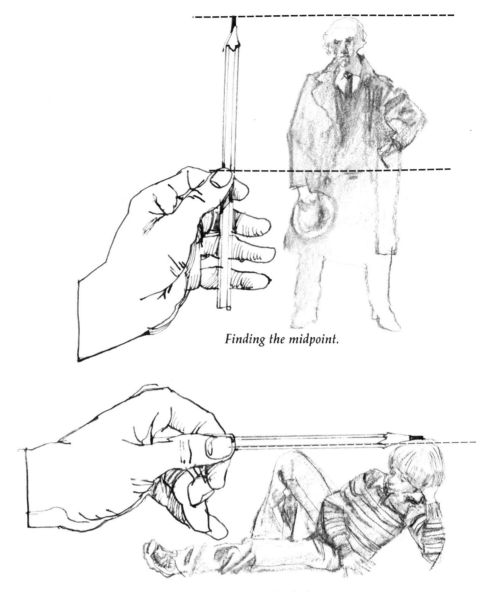

Finding the midpoint.

Using plumb and level

Using your pencil like a carpenter's tool, you can establish the vertical and horizontal alignments of your subject and transfer them one at a time to your paper. This strategy is especially useful in establishing the action of your pose.

Using a level alignment.

Using comparative measurement

Measuring the head to compare with another part.

In this strategy you measure with your pencil the length of one part of your subject and compare it to the length of another part. The head is a commonly-used unit of measure, for instance, and might be compared to upper arm length or to shoulder width. This procedure is basic to finding proper proportions.

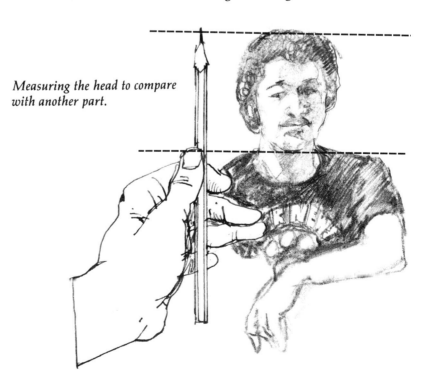

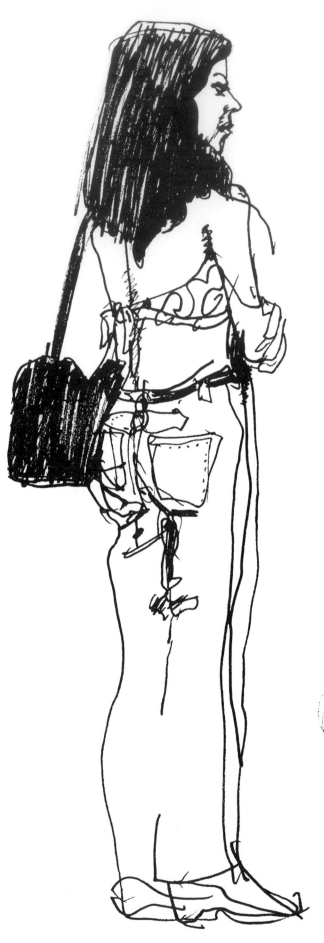

Finding the midpoint

Finding the midpoint starts you off on your drawing with a major proportional problem solved. Your subject will have been divided into two manageable halves, and, more important, they'll be placed correctly on your page. This measurement is used in the early stages of the drawing, probably only once, and it will save you a world of trouble later on.

To find the midpoint, first regard your subject — in this case a standing figure — as a shape. Lightly and loosely sketch that shape the size you desire on your page. This sketch need be little more than an amorphous indication, but make sure you clearly indicate the top and bottom of the shape. Now study your subject again and estimate the halfway point between the top of the head and the bottom of the feet. Make a mental note of that spot.

To see if it really is the midpoint, do a sighting with your pencil. Align the point with the top of the model's head and place your thumbnail against the pencil at the point that aligns with your midpoint guess. Now, keeping your thumb in place, lower your pencil tip to the midpoint and see if you thumb aligns with the bottom of the model's feet. If it does, you succeeded in dividing the model in half; and your eye is very good. If it doesn't, take another guess and try again; your eye will improve with practice.

Remember to keep your head straight and your elbow locked in the same way every time you measure. When you've found the midpoint, return to your paper and find the midpoint of the shape you've drawn. Mark that spot lightly, corresponding to the midpoint of the figure. Sketch it in. Now you've divided both your subject and your drawing into two manageable halves, your boundaries are set, and you're ready to proceed.

First indicate on your paper the general size and placement of your subject.

Find the midpoint of your subject and transfer it to the center of your placement shape.

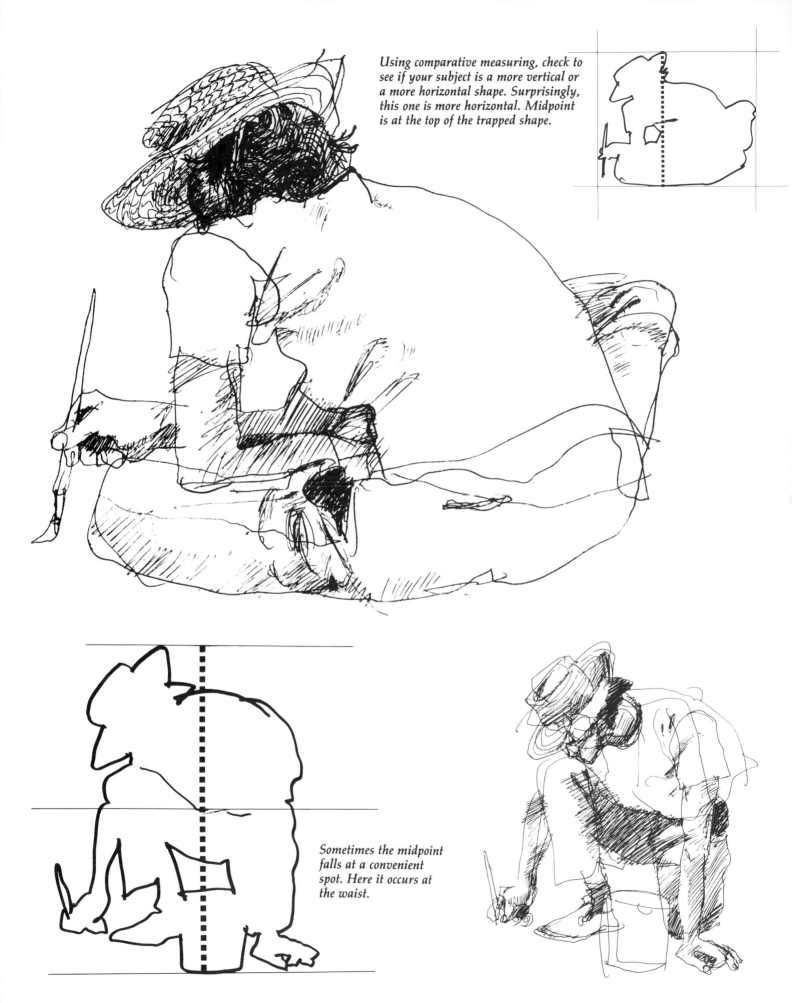

Using comparative measuring, check to
see if your subject is a more vertical or
a more horizontal shape. Surprisingly,
this one is more horizontal. Midpoint
is at the top of the trapped shape.

Sometimes the midpoint
falls at a convenient
spot. Here it occurs at
the waist.

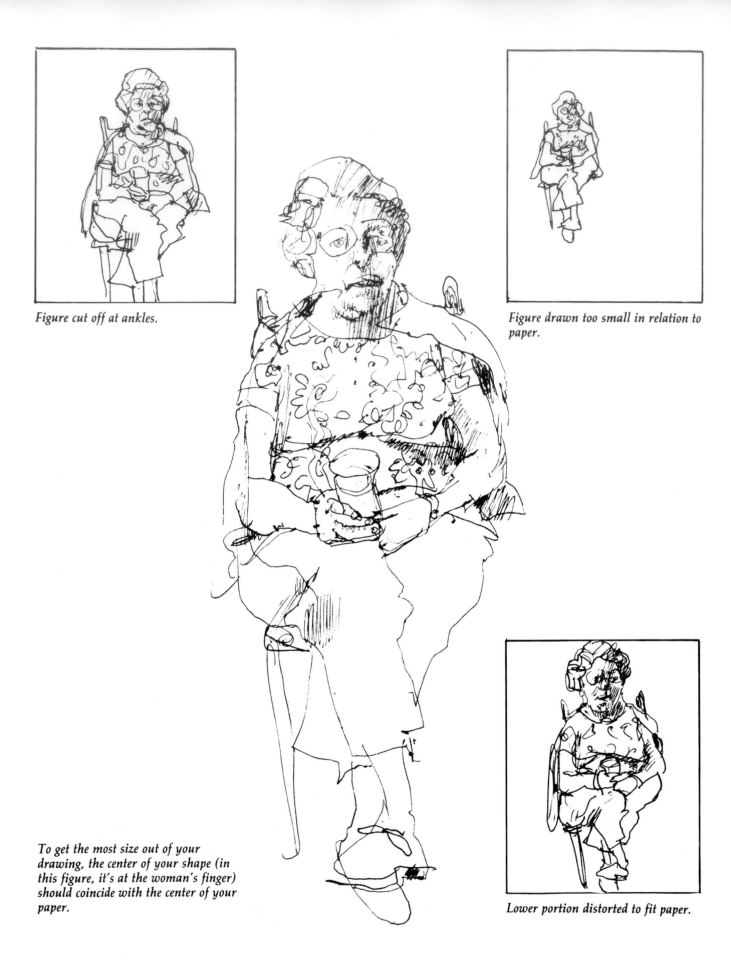

Figure cut off at ankles.

Figure drawn too small in relation to paper.

To get the most size out of your drawing, the center of your shape (in this figure, it's at the woman's finger) should coincide with the center of your paper.

Lower portion distorted to fit paper.

Why find the midpoint?

One of my strongest grade school memories is that of my art teacher pacing between our desks with a frequent injunction, "Don't make little drawings in the center of the paper. Fill the entire page." It was good advice, but we soon realized what a trick it was to fill the page *and* get everything in at the same time. Invariably I'd end up having to choose between cutting something off (usually the feet) or compressing the proportions (usually the legs) when I began to run out of paper. For a long time, every horse I drew was either hoofless or pygmy-legged.

One of the great values in finding the midpoint is that it helps you "place" your drawing on the page. Without those top, bottom, and midpoint marks on your paper, it is difficult to draw a figure head to foot so that it just fills the area. Finding the midpoint solves the problem of running out of paper or leaving too much blank. If, with a few indications of head and upper torso, you find you have extended your drawing below the center mark of your paper, you will know you are drawing too large. If you end up above the center mark, you are drawing too small. In either case, you can quickly make the proper adjustments by restating.

Naturally, there will be times when you will want to fill the paper with only a part of the figure or to draw the figure quite small in a large empty space. Here again, finding the midpoint will help you place your subject exactly where you want it. If you wish, you can use finding the midpoint to further divide each half for more careful consideration.

Project 3 - A — Standing Figure

Draw a proportionately accurate figure, filling the page from top to bottom. Coax or cajole someone to take a standing position for you about ten feet away. Make two small marks on your paper, one near the top and one near the bottom to represent the extreme of the figure. Next include a center mark between those two points. Then spend less than a minute lightly and loosely sketching in some general placement of lines to indicate head, shoulders, hips, legs, and feet. Now, using the sighting method, find the midpoint of your model. This point will correspond to the center mark on your paper. Finish drawing the figure in detail, working with a top half and a bottom half. Use pencil or charcoal and restate as necessary. Allow 30-40 minutes.

The midpoint works as well as a horizontal or as a vertical. Here, midpoint is at the hip bone.

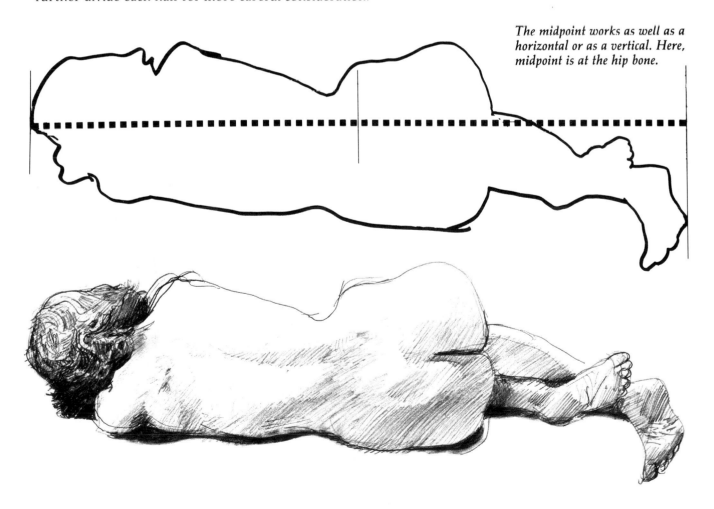

Alignments — using plumb and level

Proper use of alignments will capture the action of a pose. A plumb line is a vertical line, a level line is a horizontal one. All of us, with our sensory and balancing equipment, can judge verticals and horizontals quite accurately. Again, using our pencil as a measuring tool, we simply extend it in front of us over the subject and turn it this way and that at key points on the model to see what lines up vertically and horizontally.

There is a specific action to the pose of the figure drawn below. We can gather a sense of that action by lightly sketching in a simple shape or gesture and then employing our plumb and level alignments. Any protrusion such as a knee, shoulder, hip, elbow, toe or chin is a potentially good place to use alignment measurements. On the facing page, I've diagrammed the plumb and level measurements used in the drawing below.

After making a preliminary sketch to place the figure, I sighted a level line from the point of the knee, determining that it was on a line with the model's nose. This was an important measurement because, beyond placing the nose, it gave me the location for the entire head. This information was transferred to my drawing where horizontals and verticals were easily made parallel by using the edges of the paper as guides.

With this one alignment, I felt confident to sketch in the head, right shoulder, and chair. The chair itself offered some alignment information. By following down its back and legs, I could see the various points at which it intersected the figure. I

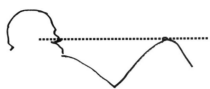

Nose and knee align.

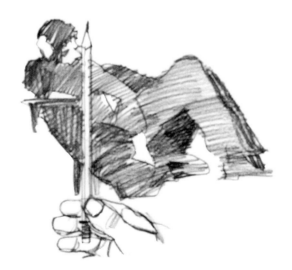

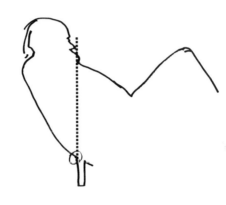

Nose and chair-leg align.

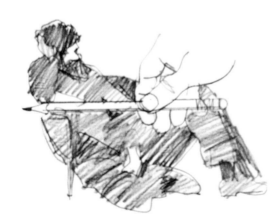

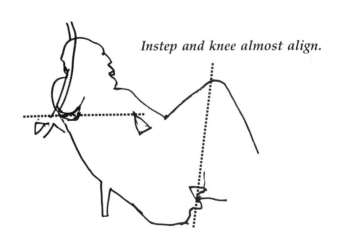

Instep and knee almost align.

Elbow and arm/leg intersection align.

Project 3 - B — Lounging Figure

Make a drawing from a casually reclining model. Pose the figure propped on one elbow with one knee raised. With pencil or charcoal, lightly and loosely place the figure on your paper by drawing by eye and then adjust the proportions with sighting strategies. Find the horizontal midpoint. Use plumb and level and comparative measuring at least twice each. Restate as necessary. Allow 30-40 minutes.

then decided to check the plumb lines extending downward from the nose, and I saw the point at which the model's back intersected the chair leg. An additional alignment established the right elbow to be level with the point of intersection of the left arm and leg. A plumb line extending downward from the knee helped me locate the right foot.

You can see how a few plumb and level lines establish the action of a figure in addition to helping you get better proportions. However, I don't want to convey by these explanations and diagrams that drawing can or should be reduced to any step-by-step system. In actual practice, use of alignments is mixed in a busy potpourri of gesture strokes, restatements, blind drawing, smudging, and erasing. How often you make use of this particular procedure will depend on your purpose at the time. The more accuracy you desire, the more plumb and level you will use.

For simple sketchbook studies, like the ones on these pages, you might use only one or two. In such cases, look for unusual alignments like a shoulder that is even with the knee, a jutting hat even with the bulge of a stomach, or a protruding lip even with the tip of a nose. Your eye will gradually develop the capacity for making these judgments automatically.

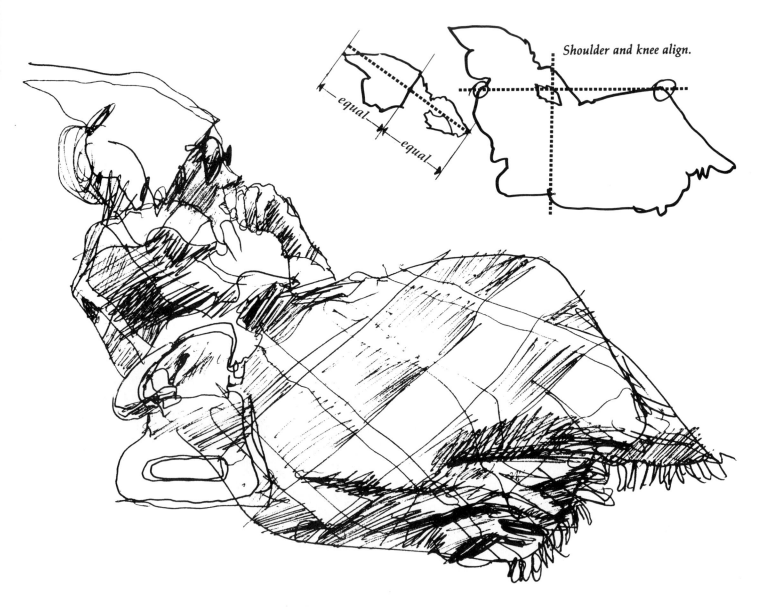

equal

equal

Shoulder and knee align.

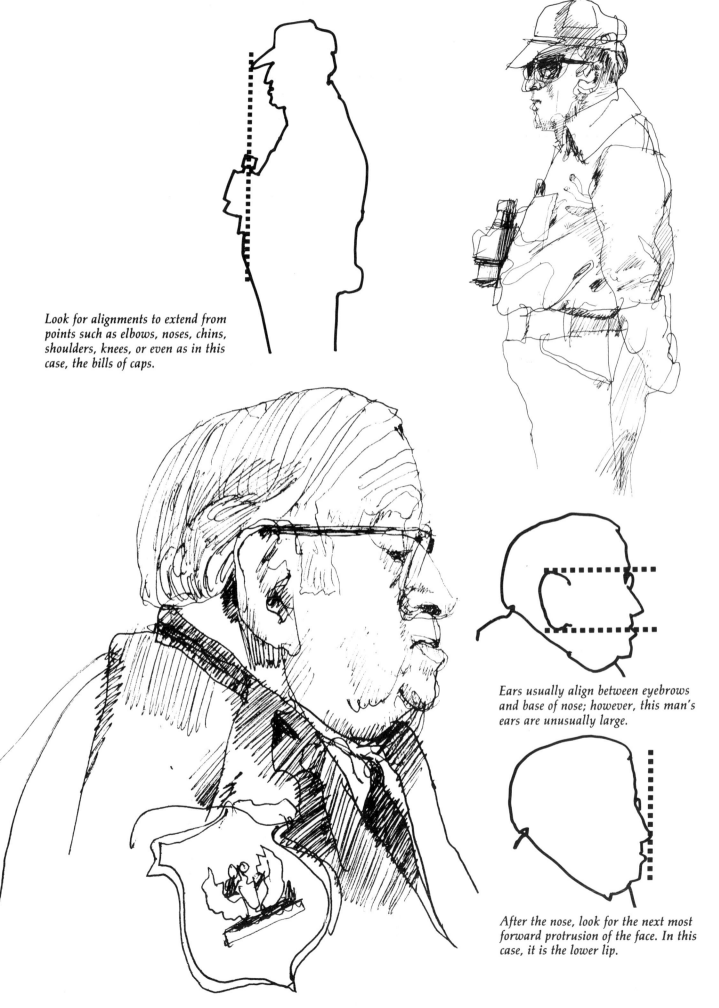

Look for alignments to extend from points such as elbows, noses, chins, shoulders, knees, or even as in this case, the bills of caps.

Ears usually align between eyebrows and base of nose; however, this man's ears are unusually large.

After the nose, look for the next most forward protrusion of the face. In this case, it is the lower lip.

Taking comparative measurements

Taking frequent comparative measurements is a good way to check on proportions during the course of your drawing. Use your pencil as a measuring tool to compare the length of one part of your subject to the length of another part so you have an idea of their relative sizes.

Although you can use any part of your subject for this purpose, the head is a common unit of measure so use that as an example. Using our sighting method of pencil held upright, arm extended, one eye closed, put the tip of the pencil at the top of the head and mark the chin with your thumb. Now you have a means of comparing that distance to other parts of the model — perhaps to the length of the upper arm or width of the shoulder.

That measured distance on your pencil is for use *against the model*. It doesn't translate directly to your paper unless you are drawing what is called sight-size. More than likely your drawing is proportionately larger or smaller than you've sighted on your pencil. Your pencil measurement keeps relationships within the model straight in your mind.

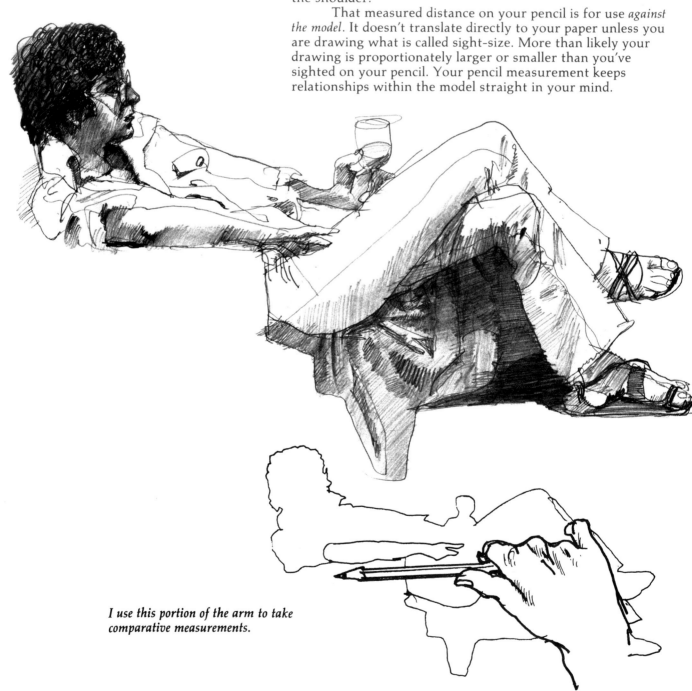

I use this portion of the arm to take comparative measurements.

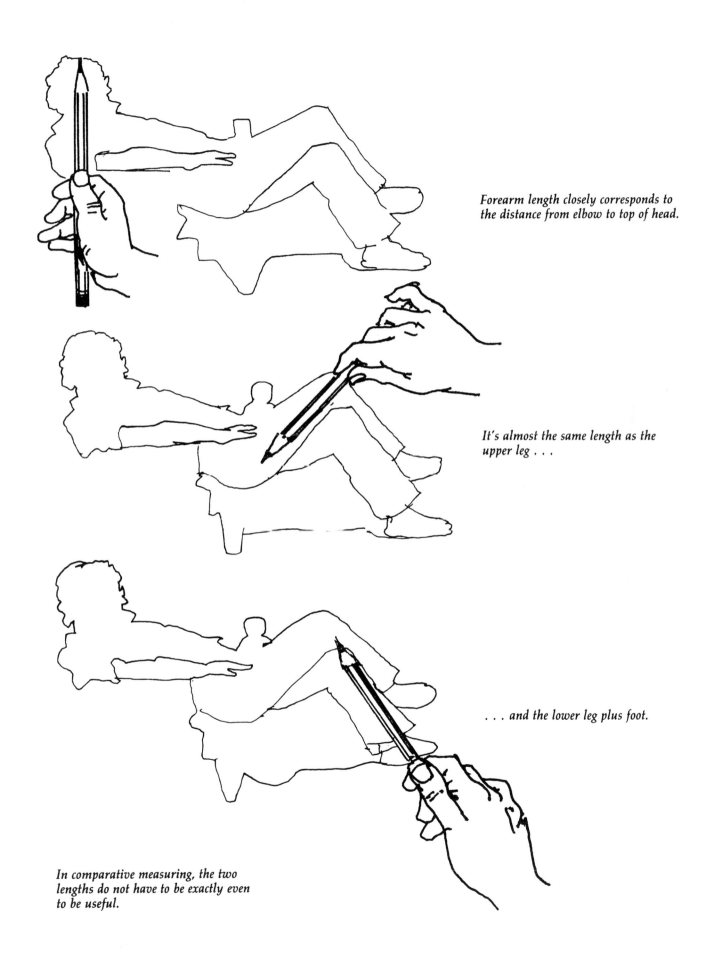

Forearm length closely corresponds to the distance from elbow to top of head.

It's almost the same length as the upper leg . . .

. . . and the lower leg plus foot.

In comparative measuring, the two lengths do not have to be exactly even to be useful.

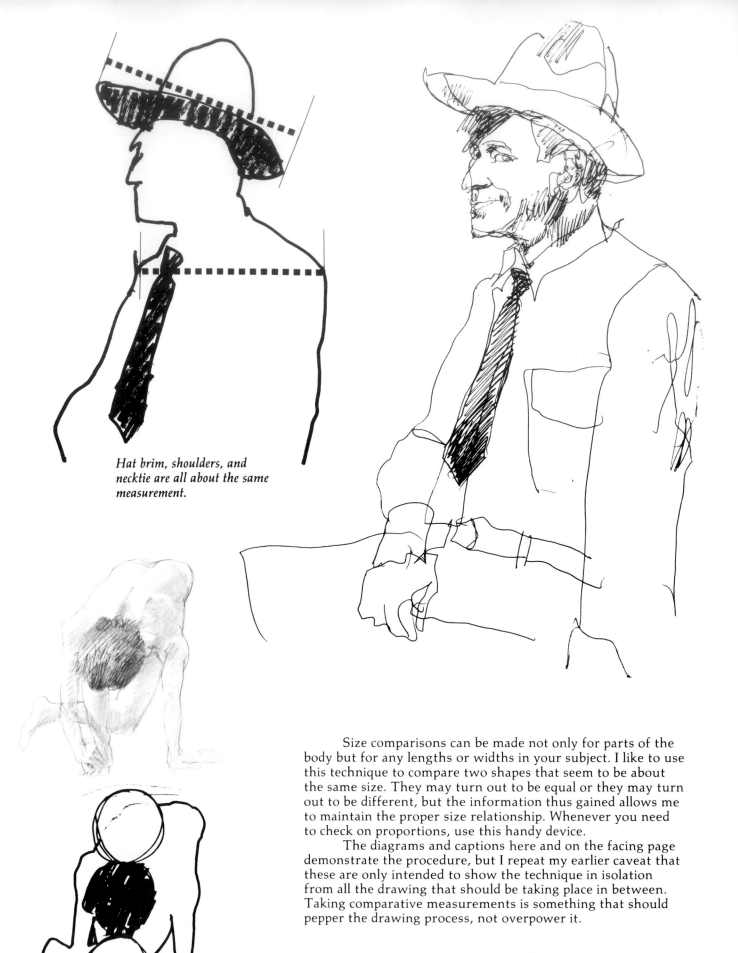

Hat brim, shoulders, and necktie are all about the same measurement.

Size comparisons can be made not only for parts of the body but for any lengths or widths in your subject. I like to use this technique to compare two shapes that seem to be about the same size. They may turn out to be equal or they may turn out to be different, but the information thus gained allows me to maintain the proper size relationship. Whenever you need to check on proportions, use this handy device.

The diagrams and captions here and on the facing page demonstrate the procedure, but I repeat my earlier caveat that these are only intended to show the technique in isolation from all the drawing that should be taking place in between. Taking comparative measurements is something that should pepper the drawing process, not overpower it.

Head is used as a measure. From this view, the figure is three heads high.

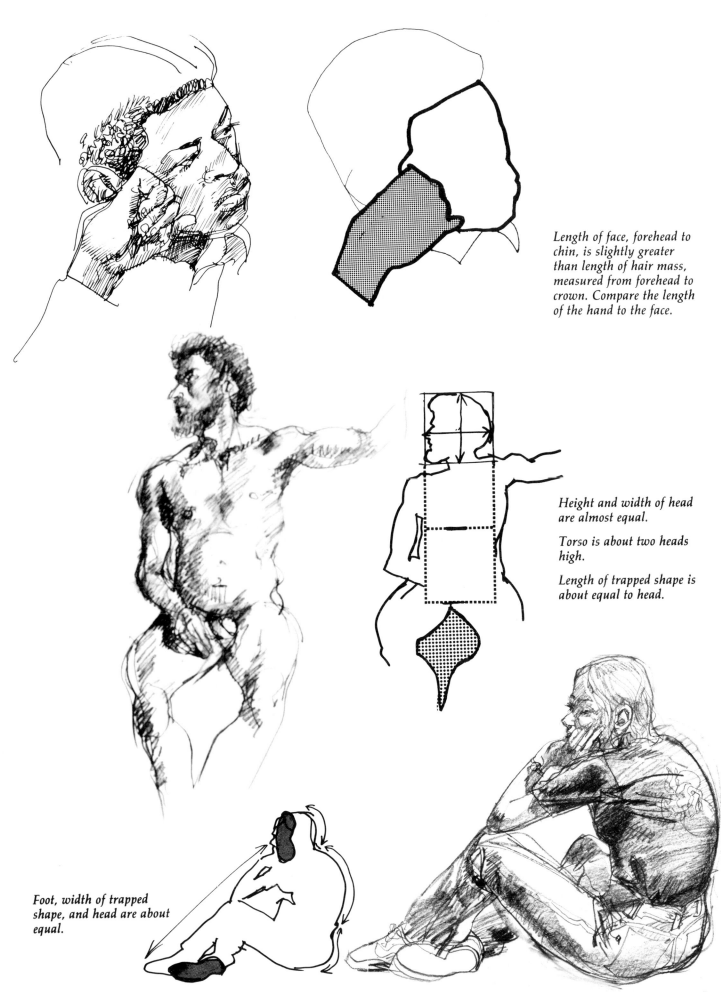

Length of face, forehead to chin, is slightly greater than length of hair mass, measured from forehead to crown. Compare the length of the hand to the face.

Height and width of head are almost equal.

Torso is about two heads high.

Length of trapped shape is about equal to head.

Foot, width of trapped shape, and head are about equal.

Foreshortening

Foreshortening is drawing a person or object in perspective. In essence, it involves a simple principle: the more we see of the end of something, the less we see of its sides. Foreshortening means violating certain things we know in favor of drawing what we see, but you should be getting comfortable with that now. It may require you to draw a person you know to be tall and thin as compressed and squat. Of course, when you are finished, the drawing will look right, but while you're working it may not feel right.

Foreshortened shapes often seem nonsensical. That strange little shape isolated on the facing page doesn't look like a head. If you had just drawn it yourself, wouldn't you be tempted to alter it to make it more recognizable? Foreshortening, however, requires that you have faith in the authority of your eye, and trust that by the time you've added features you'll wind up with a convincing head.

All three sighting strategies are of inestimable value in drawing an end view. I especially recommend finding the midpoint. In a foreshortened figure, the midpoint is almost never where you would guess it to be. On the figure on the facing page, the midpoint is located just above the knee — much lower than you might expect. If you were to draw the same figure from a top-end view, the midpoint would fall somewhere on the upper torso.

As the glass tips toward us, we see less of its sides. The same is true of the human figure.

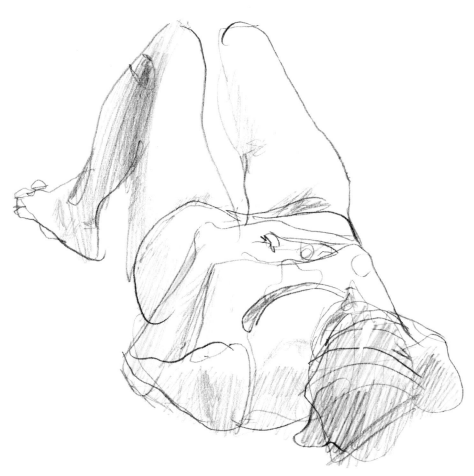

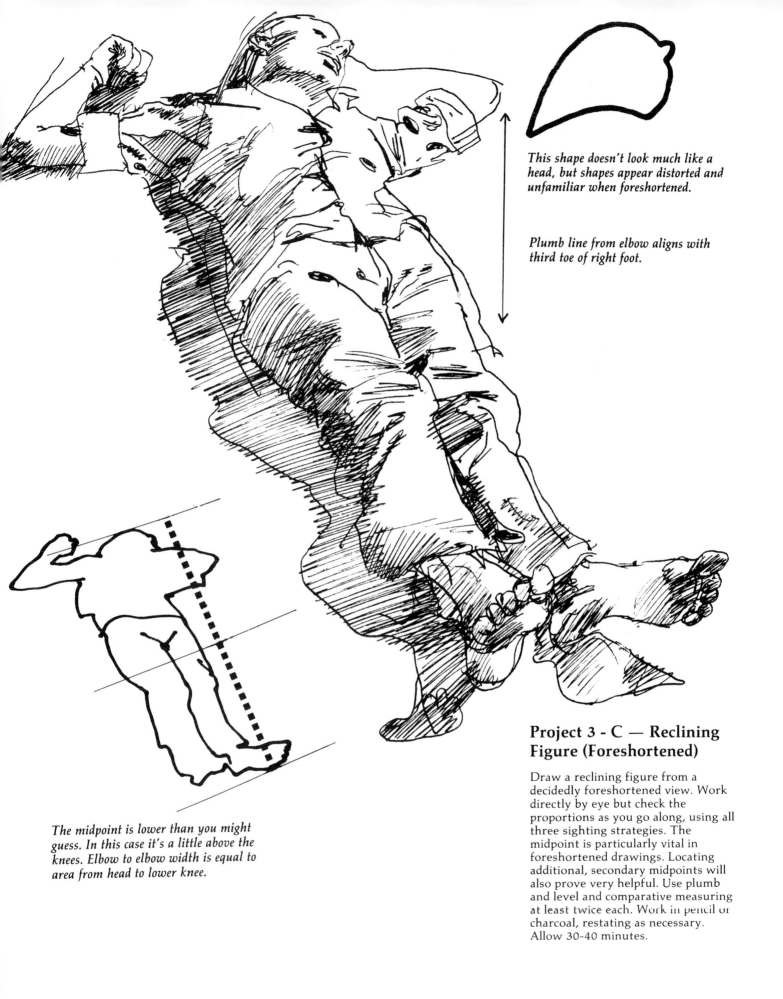

This shape doesn't look much like a head, but shapes appear distorted and unfamiliar when foreshortened.

Plumb line from elbow aligns with third toe of right foot.

The midpoint is lower than you might guess. In this case it's a little above the knees. Elbow to elbow width is equal to area from head to lower knee.

Project 3 - C — Reclining Figure (Foreshortened)

Draw a reclining figure from a decidedly foreshortened view. Work directly by eye but check the proportions as you go along, using all three sighting strategies. The midpoint is particularly vital in foreshortened drawings. Locating additional, secondary midpoints will also prove very helpful. Use plumb and level and comparative measuring at least twice each. Work in pencil or charcoal, restating as necessary. Allow 30-40 minutes.

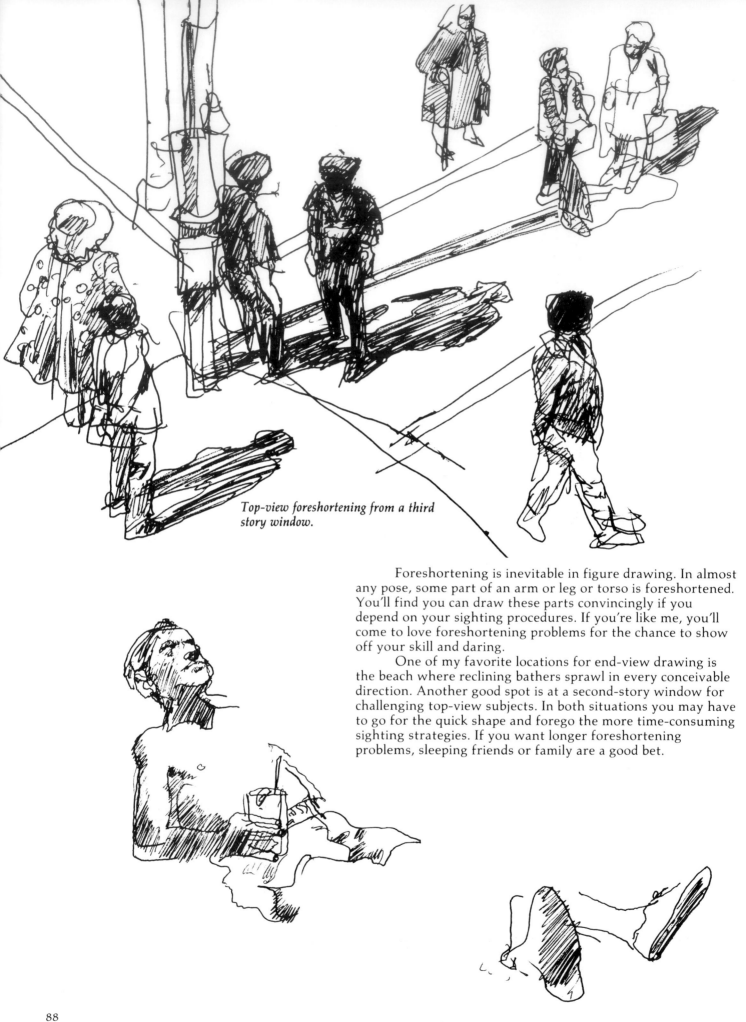

Top-view foreshortening from a third story window.

Foreshortening is inevitable in figure drawing. In almost any pose, some part of an arm or leg or torso is foreshortened. You'll find you can draw these parts convincingly if you depend on your sighting procedures. If you're like me, you'll come to love foreshortening problems for the chance to show off your skill and daring.

One of my favorite locations for end-view drawing is the beach where reclining bathers sprawl in every conceivable direction. Another good spot is at a second-story window for challenging top-view subjects. In both situations you may have to go for the quick shape and forego the more time-consuming sighting strategies. If you want longer foreshortening problems, sleeping friends or family are a good bet.

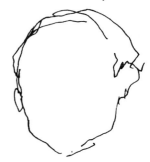

Three initial steps.

Sketch overall shape.

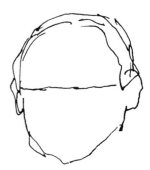

Lightly establish midpoint line

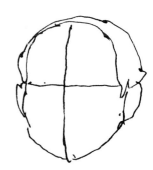

. . . and center line.

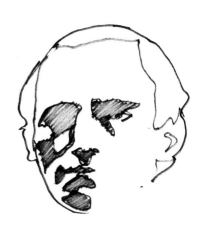

Shadows on the face create small shapes which make drawing easier.

Critical measuring — portraits

Much art instruction teaches the student to first draw the underlying form, then to proceed to the specific case. ("Learn to draw the head as a basic shape with simplified parts, then you'll be able to draw a portrait.") It is a sound approach, and I've borrowed a few ideas from it. For the most part, however, the focus of this book is on drawing the specific and individual from the start. A thorough knowledge of what lies below the suface of an object tends to get lost in my method. However, I believe the adventure of diving into a drawing more than compensates for the loss. By risking ourselves with a live, individual subject, we are likely to draw better than we think we can; and we'll learn much about underlying structure in the process.

We are now ready to apply our three sighting strategies to heads and portraits. I've called this critical measuring because an individual face is a collection of subtle relationships, and a good deal of accuracy is required to capture a likeness. The smallness of the shapes involved and the distances between them require a lot of precision. If the features are incorrectly sized or placed, the drawing loses its likeness. John Singer Sargent summed up the difficulty: "A portrait is a picture of a person in which the mouth isn't quite right."

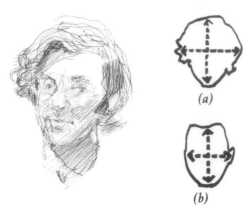

Compare height to width of (a) entire head and (b) face shape only.

Front view

You're going to need a model who is willing to sit for perhaps an hour. Place him or her about four feet away. See to it that the subject is relaxed and comfortable, and take breaks about every ten minutes. If you can't find a willing model, you'll have to draw yourself. In that case, seat yourself comfortably at arm's length from a mirror. You'll be moving your head as you shift your eyes from the mirror to your drawing so you'll need to re-set your pose each time you look up. Measure by closing one eye and placing your pencil up against the mirror.

We'll be drawing the head from front view, but before you do any drawing or measuring, pause to look at your model — or reflection — for a few moments. Let your eyes sweep over the entire head, seeing it as a whole. What are the first two or three things that strike you? Dark features? Small chin? Strong cheekbones? These will make good triggering words. Repeat to yourself even impressions that aren't physical characteristics: tired eyes, inner strength. Squint until the head becomes a vague shape. Scan the outlines of that shape and note the main light and dark areas within it.

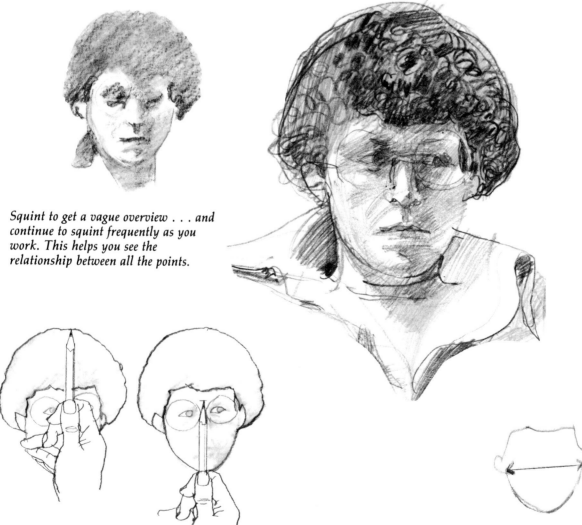

Squint to get a vague overview . . . and continue to squint frequently as you work. This helps you see the relationship between all the points.

Place eyes near midpoint line. Measure to be certain.

Where is the widest part of the face? You'll usually find it at the cheekbones.

Now you're ready to begin drawing. Start by lightly sketching the overall head shape. Once you've done this, find the top-to-bottom midpoint, using the methods already described. The midpoint will be somewhere near the eyes but you'll want to be as precise as possible. Rather than making a simple point there, draw a line horizontally across the face. Now draw a light vertical center line through the face from top to bottom. This line is a rough guide for the placement of features.

At this point, you should have something that looks like the examples on page 89. Drawing the overall shape, midpoint line, and center line has probably only taken a couple of minutes, but you've established three valuable references.

From now on, you'll be mixing use of your sighting strategies with drawing by eye in a back-and-forth process. There is no set procedure for doing this. I prefer to draw by eye first and then correct by measuring. Typically, I might draw in the eyes, nose, and mouth shapes lighty and then begin to measure and correct. You'll find the location of the eyes by their relationship to the midpoint line.

Measure the width of one eye and see if it is equal to the space between the eyes, as it is likely to be. Find the midpoint from the bridge of the nose to the chin. Is the base of the nose above or below it? Correct your drawing as needed. Is the mouth nearer the nose or nearer the chin? Extend plumb lines down from the pupils to locate the corners of the mouth. Compare widths of upper and lower lip. Use a level line to see how the mouth aligns with the corners of the jaw.

It's still too early to expect much resemblance to your model but patient measuring procedures combined with stepping back now and then will bring you increasingly closer to the likeness. The subtle refinements necessary here will require more erasing and adjusting than I've been encouraging until now, but don't be timid about leaving some restatements in your finished drawing.

Project 3 - D — Front View Portrait

Draw a front view head, mixing drawing by eye with all three sighting strategies. You will need to take many plumb and level measurements as well as comparative measurements — at least three of each. Use a model or draw your self-portrait in the mirror. Follow the procedures indicated in the text. Draw slowly and painstakingly, correcting and making subtle adjustments as you work. Use restatements as well as erasures to gradually refine your drawing. Work in pencil or charcoal and allow at least one hour, permitting the model to break every 15 or 20 minutes.

Measure distance between eyes. They are generally one eye-width apart.

Measure length of nose and see how it compares to distance from base of nose to chin. Also compare this with nose to ear distance.

Notice, from your viewing angle, the exact points where neck and jaw meet. Avoid tendency to make neck too thin.

Center of mouth and base of nose are usually on center line. Here, because of the viewing angle, and a slightly protruding dental arch, the mouth is slightly off the center line.

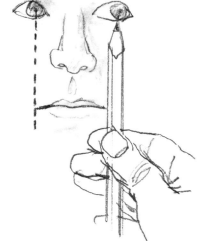

Measure width of nose and compare it with width of eye.

Look for special distinguishing features. Here the lips are thin and the corners of the mouth turn slightly down.

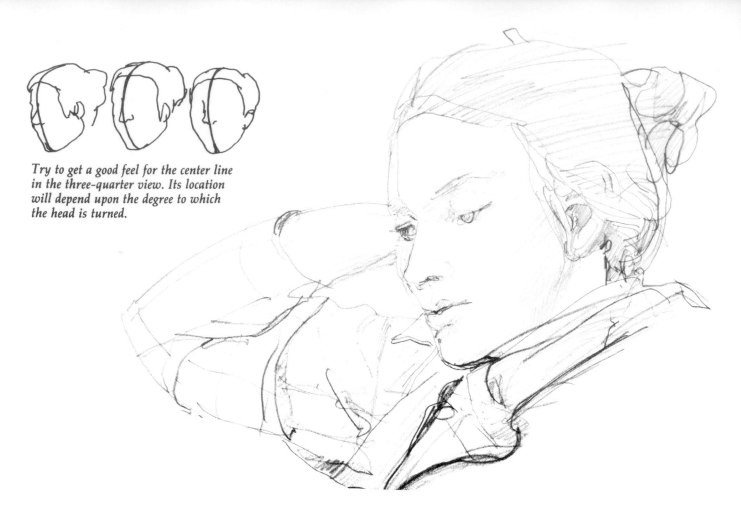

Try to get a good feel for the center line in the three-quarter view. Its location will depend upon the degree to which the head is turned.

The three-quarter view

Drawing the head in the three-quarter view involves taking many of the same measurements we took with the full face. There are, however, a few noteworthy variations.

When viewed from the front, the head is basically egg shaped, that is, longer than it is wide. As it is turned to the side, though, more of the back of the head is revealed until, at full profile, the distance from the forehead to the back of the skull is about the same as from the top of the head to the chin. Students commonly shave off the back of the head unless they are careful to make their comparative measurements. Be sure also to measure the distance from the near eye to the chin and compare it to the distance from that eye to the back of the ear.

See how pupils of eyes align with corners of mouth.

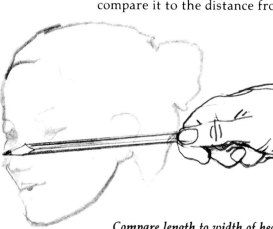

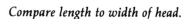

Compare length to width of head.

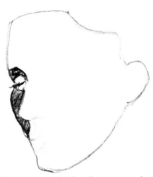

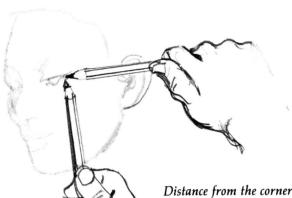

Draw carefully the trapped shapes created by the coincidence of nose and cheek (the darkened areas of the diagram).

Distance from the corner of the eye to back of ear is about equal to corner of eye to chin.

Eye shapes are different from each other, especially when seen in three-quarter view.

Because the face is three-quarter turned, the center line — on either side of which the features are aligned — will be off to one side or the other as shown in the diagram at left. This means that all the features are uniformly shifted in that direction. It follows then that the tip of the nose and the far cheek are going to be in some proximity to each other. They may even form a tangent, but, whatever the relationship, it will provide an important indication as to how far the head is turned. This juncture of nose and cheek also creates a trapped shape on the far side. Remember, "If you see a trapped shape, draw it." In the example shown, several trapped shapes have been created. The piece from the tip of the nose to the eyebrow has some smaller shapes within it, and there is another piece of cheek between nose and lower lip. Take the time to draw these shapes carefully.

In the three-quarter view, the eyes will not be one eye-width apart, and they will be noticeably different from each other in size and shape. Recalling our discussion of eyes in Chapter 1, you'll remember that the far eye appears as a smaller and more open shape.

As you can see from the examples, an off-center mouth is a common and serious student problem. If the center of the mouth does not align with the base of the nose, everything else in the lower face is likely to be wrong, too. The center line will help you align these two points so that you can then draw in the mouth line. The darker, more important, mouth line is drawn first, and serves as a reference for placement of the lips.

Notice exact point where neck disappears behind ear.

Watch the nose/mouth alignment carefully.

Mouth too far to the right

Mouth too far to the left

Nose and mouth properly aligned

Project 3 - E — Three-Quarter View Portrait

Follow the procedure in Project 3 - D for a front view portrait but pay particular attention to the location of the center line, so you can properly align the features. Also note the size and character of the trapped shapes on the far side of the face.

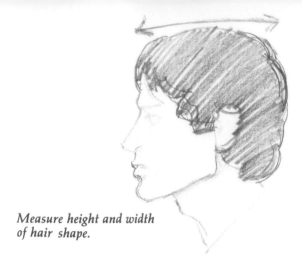

Measure height and width of hair shape.

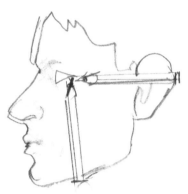

Compare eye to back of ear with eye to chin. They should be approximately equal.

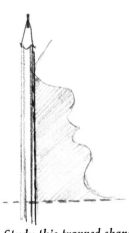

Study this trapped shape between pencil and lower face. Does chin align with base of nose?

Check alignment from front of eye to corner of mouth.

Front-view head is much longer than wide.

Three-quarter-view head is only a little longer than wide.

In the profile, length and width are nearly equal.

Profile

In the profile view we concentrate critical measuring on the front portion of the face. Here is where we'll do most of the subtle individualizing of our model. As usual, study your subject for a few moments. You'll definitely need a model for this project. Your own reflection won't work, even with two mirrors.

You might want to get your impression of the head down on your paper with a few light strokes. You'll have no center line in a profile head of course, and, for the moment, we'll eliminate consideration of the midpoint line as well. You'll want to focus all your energy on the contour line which encompasses forehead, nose, mouth, and chin. I recommend drawing this by eye. Be prepared to make a number of revisions after measuring and aligning.

At this stage, a useful procedure is to take a vertical sighting of your model off the tip of the nose to see if you can get a feeling for the trapped shapes both above and below the tip of the nose. Is there a pronounced bridge to the nose? How much curve is in the forehead? Study the action of the forehead and chin and note whether they are more or less parallel to your pencil or, if they fall away, at what angles.

Establish the chin and crown. Find the midpoint, which should be at or near the eye. In placing the eye, make sure it is far enough back from the bridge of the nose by comparing that distance with the width of the eye shape.

The mouth line generally occurs about one-third of the way down between the base of the nose and the chin. Ascertain this by measuring. A plumb line from the front of the eye should help you locate the corner of the mouth. Drop a plumb line from the base of the nose. Do the lips protrude beyond this line? If not, by how much are they recessed? Check the chin in the same manner. There are other fine measurements you can make, for instance, the relative thickness of the upper and lower lips, the distance from eye to eyebrow, the width of the nose flange. Although I don't want you to forget about spontaneity, every additional measurement you take will contribute to overall accuracy.

It's important not to undermine your good efforts in the critical area of the face by lazy observation of the simple parts. Let's consider the rest of the head. We mentioned before the common mistake of drawing the back of the head too small. Measure the length of the head and compare it with the width — including hair mass — so you aren't tempted to shave off any of the skull. Make sure you get the hair shape sufficiently large and accurately drawn; it's frequently about the same size as the face.

To get the proper ear placement, compare the distance from the corner of the eye to the back of the ear and, perpendicular to it, the distance from the corner of the eye down to the jawline. Pay attention to the neck, notice how it pitches slightly forward and joins the head at a higher point in the back than in the front. To get the width, a good comparison to make is with the distance from the corner of the eye to the jaw.

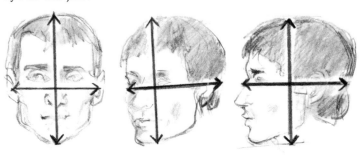

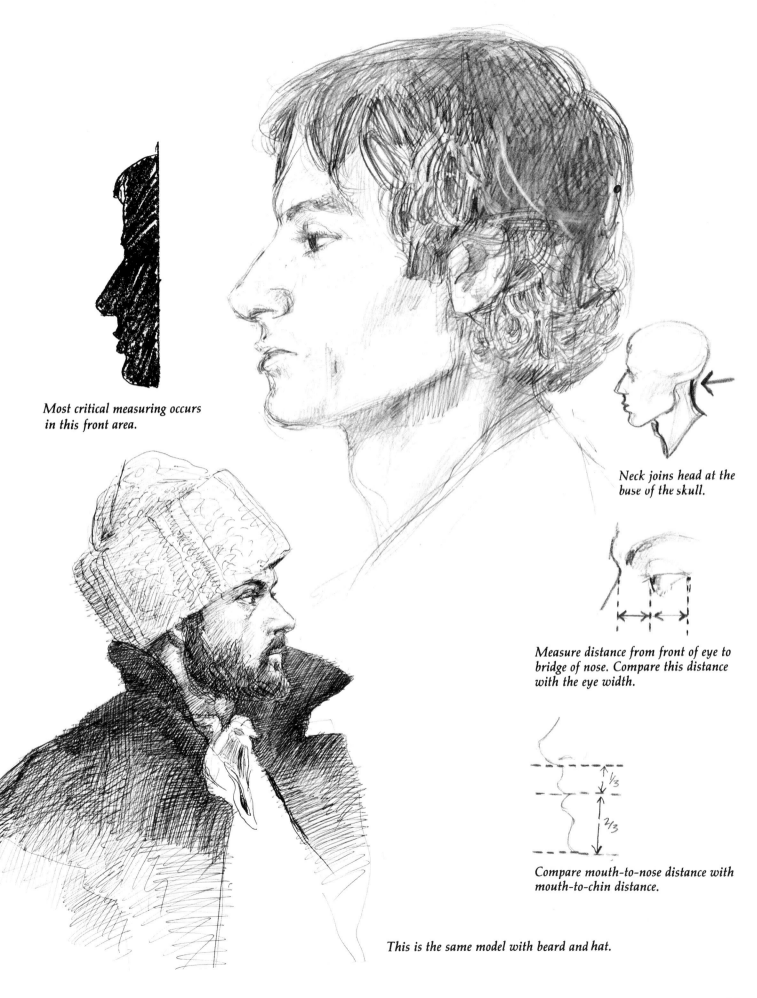

Most critical measuring occurs in this front area.

Neck joins head at the base of the skull.

Measure distance from front of eye to bridge of nose. Compare this distance with the eye width.

$\frac{1}{3}$

$\frac{2}{3}$

Compare mouth-to-nose distance with mouth-to-chin distance.

This is the same model with beard and hat.

95

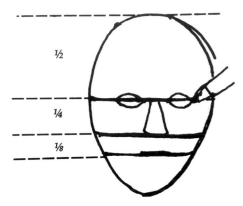

Using an egg as a conceptual model, draw a line around the midpoint.

½

¼

⅛

Draw nose line at the half-way point below the eye line, and draw the mouth line one-third the distance below that. Add simple features.

Compare egg with a real person.

Foreshortening heads

We've seen the kind of shape and proportional distortions that occur when the head is looked at from an end view. Drawing can be difficult in such cases, because the distortions may seem too great to accept. Instead, beginners will frequently alter their drawings to make them more "sensible," but will be perplexed when the result is less than convincing.

Some of you will trust me when I say, "Draw what you see," and you will get good results. For those of you who are resistant, I offer something that was of enormous help to me when I first tackled this problem: the egg head.

You'll need to draw three horizontal lines around an egg upon which will be drawn the eyes, nose, and mouth. The eye line is drawn around the middle of the egg, the nose line halfway below that, and the mouth line one-third the distance below that. Darken two little almond-shapes for the eyes on the mid-line and draw in a long wedge-shaped nose from between them and down to the nose line. On the line below that, draw in a mouth. Putting in some eyebrows, too, will help you place the ears. Turn your egg to either side and draw them in between the nose and eyebrow lines.

You'll get more out of this if you can get someone to sit about five feet from you and tip their head forward and back as you move the egg in the same way. Close one eye and hold the egg up beside your model's face. Adjust forward and back until the egg is the same size as the human head.

When you look straight at the egg, the features appear proportionally spaced, and the lines you've drawn appear as straight horizontals. When you tip it, you create an example of foreshortening. As one end is tipped toward you, the features compress and gather at the other end. Notice that the same thing happens on your friend's face. Tip the forehead-end of the egg toward you and ask the model to do the same. Notice how the features seem to gather down near the chin. Tilt it back the other way, and you'll see how they gather at the forehead. Notice how the facial features become more curved the further you tip the head, revealing the wrap-around nature of their underlying form.

Project 3 - F — Foreshortened Head

Draw from a model a foreshortened head, tipped either up or down. Mix drawing by eye with all three sighting strategies, but take special care to accurately find the midpoint. Force yourself to draw exactly and only what you see. Use level lines to make sure features appear to curve around the head. Use eye, nose, and hair mass for comparative measuring. Use pencil or charcoal and restate and erase as necessary. Allow at least one hour.

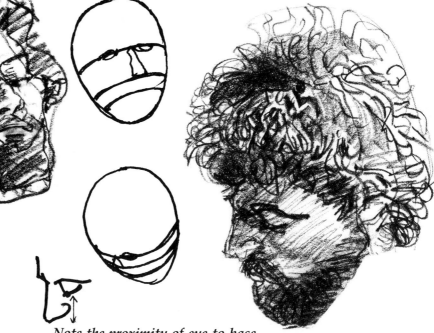

Note the proximity of eye to base of nose in this foreshortened view.

Though their shape alters when the head is tipped, the ears act as pivot points and remain in the same place. They will appear, however, much higher than the eyes when the head tips down and much lower than the eyes when the head tips back.

The egg model is an excellent way to understand what you see when you look at a foreshortened head, but it does not account for the protrusion of the nose and inset of the eyes. For an understanding of these complications, we must look to our human model. When the head is cast far downward, the nose tip may extend to or even overlap the mouth. It sounds strange, but it makes sense when you see it. When the head is tilted severely back, the nose may extend above the eyes and eyebrows.

The inset of the eyes in their sockets makes for another unusual situation. Viewed from above, the eyebrows are very close to the eyes and perhaps may obscure them. From below, the eye-to-eyebrow measurement may actually increase over the same distance when viewed from the front.

Students commonly find it difficult to force themselves to draw these things when they occur unless they have a little understanding of the underlying principles. In the egg, we have a conceptual model that clarifies what happens when the head is viewed either from above or from below. If measuring is generally critical when drawing the human face, it is particularly so when drawing the foreshortened face. Because the features are more compressed, the tolerances are that much closer. You should, however, find yourself able now to use your sighting procedures unimpeded by old mind-sets about the face.

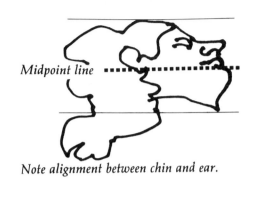

Midpoint line

Note alignment between chin and ear.

When tipped back, features gather near the top.

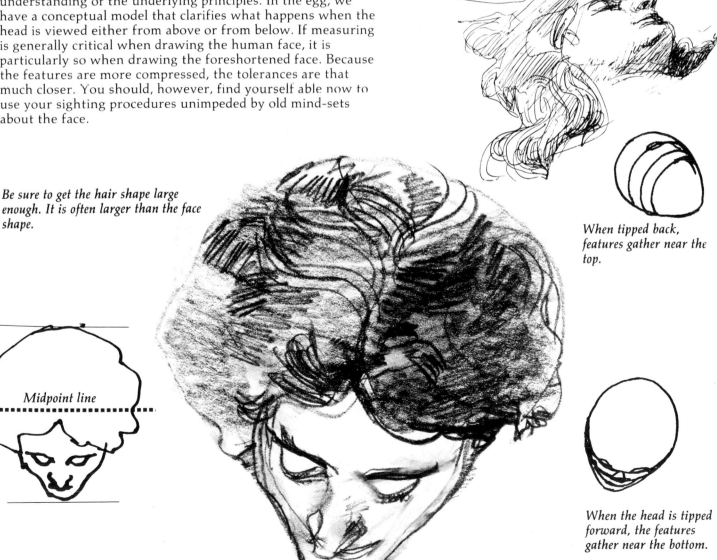

Be sure to get the hair shape large enough. It is often larger than the face shape.

Midpoint line

When the head is tipped forward, the features gather near the bottom.

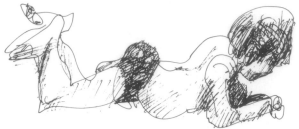

Intensify "kid" proportions like pot belly, sway back, rounded rump.

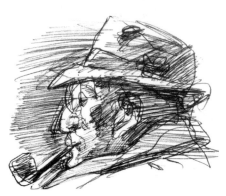

This profile had a Dick Tracy quality. I made it even more so.

Intensifying proportions

In case you're feeling slightly constrained by all this talk of "accuracy and precision" and "drawing only what you see," I recommend that you break out from time to time and intensify important characteristics in your subject. Draw what you see — only more so. If something is round, make it rounder. When you see bony angles, make them bonier.

I believe that most of us, students and artists alike, ought to concern ourselves less with what we think is the right way to draw and more with letting our feelings flow through our hand. In this way, we stretch our dynamic nature. Our larger goal should be to draw in a way that expresses our vision. We'll discuss other ramifications of intensifying in later chapters, but for now I suggest that in your casual drawings you occasionally get into a playful spirit and add a dimension of excess.

I emphasized the heavy rounded shapes.

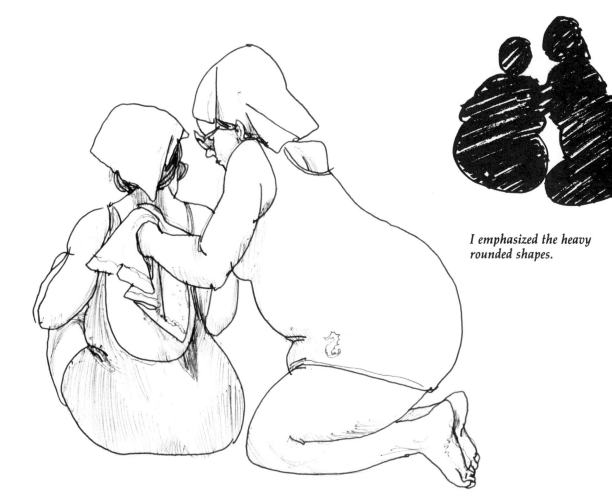

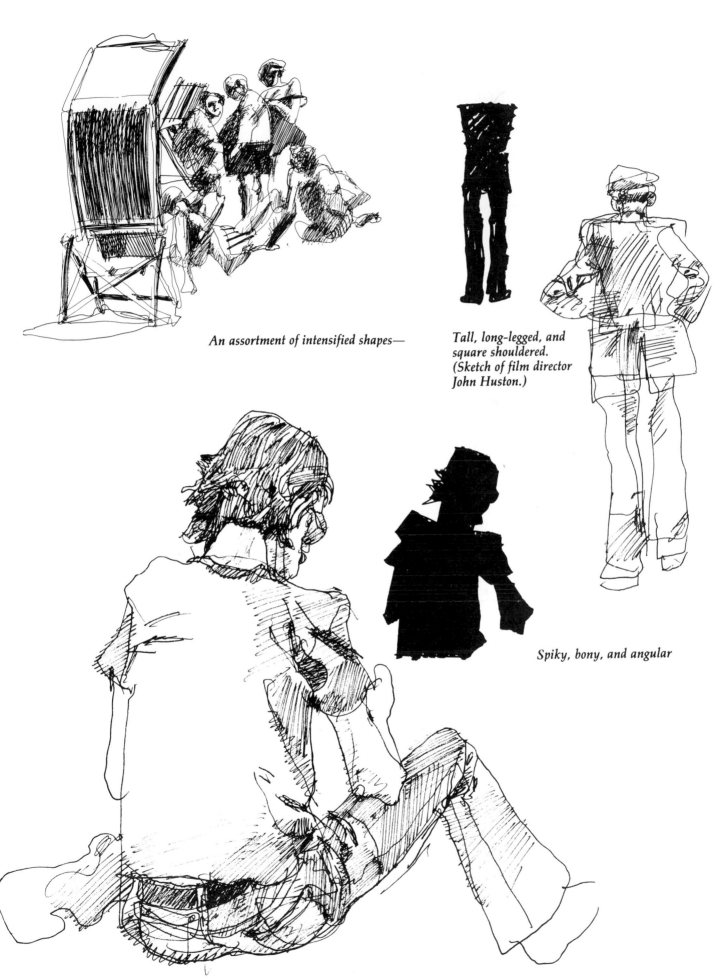

An assortment of intensified shapes—

Tall, long-legged, and
square shouldered.
(Sketch of film director
John Huston.)

Spiky, bony, and angular

KEYS TO CHAPTER 3
Proportions: taking the measure of things

- **Sighting.** Use your pencil as a measuring tool by holding it in front of you, arm extended, one eye closed. Take measurements between the point of the pencil and your thumb.

- **Find the midpoint.** Use this method to get a quick overall sense of proportions. It will also help you place your subject on the paper.

- **Use plumb and level.** By holding your pencil either vertically or horizontally, you'll be able to establish alignments which not only enhance proportions but also provide you clues to the action of the pose.

- **Compare measurements.** Various parts of your subject should be measured in relation to others. In particular, look for parts which seem to be of more or less equal length.

- **Foreshorten.** The more you see of the end view of something, the less you see of its sides. An object so situated should be drawn in just this way even though, as you draw, it may seem distorted.

- **Measure critically.** Where accuracy is essential, as in portraiture, take special care with your measurements and take more of them.

- **Intensify proportions.** Look for distinguishing characteristics and emphasize them. This occasional expression of the interaction between your feelings toward your subject and the subject itself stimulates your faculties.

SELF-CRITIQUE OF YOUR PROJECTS

Project 3 - A — Standing Figure YES NO

- Did you alternate between drawing by eye and measuring?
- Did your drawing fill the page from top to bottom?
- Did you use the sighting procedure to find the midpoint?
- Is the midpoint of your figure near the middle of your page?
- Did you locate a secondary midpoint?

Project 3 - B — Lounging Figure YES NO

- Did you begin with a gesture sketch?
- Did you modify and correct with comparative measurements?
- Did you alternate between direct drawing by eye and by measuring?
- Did you use at least two plumb alignments?
- Did you use at least two level alignments?
- Did you locate the midpoint and does your drawing fill the page?

Project 3 - C — Reclining Figure (Foreshortened) YES NO

- Did you position yourself to establish a definite foreshortened view?
- Did you draw the shapes just as you saw them?
- Did you find the midpoint with the sighting method?
- Did you use at least two plumb and two level alignments?
- Did you correct and restate with at least two comparative measurements?
- Were you careful in accurately drawing the head shape?

Project 3 - D — Front View Portrait YES NO

- Did you first gather an overall impression, using triggering words to remind yourself of the subject's prominent features?
- Did you lightly sketch in the overall head shape with a few suggested lines for features?
- Did you establish a center line to properly align the features?
- Did you locate the midpoint line and note its relationship to the eyes?
- Did you use at least three comparative measurements?
- Did you make subtle adjustments by erasing and restating?

Project 3 - E — Three-Quarter View Portrait YES NO

- Did you first gather an overall impression, using triggering words to remind yourself of the subject's prominent features?
- Did you lightly sketch in the overall head shape with a few suggested lines for features?
- Did you establish a center line to properly align the features?
- Did you locate the midpoint line and note its relationship to the eyes?
- Did you use at least three plumb and three level alignments?
- Did you use at least three comparative measurements?
- Did you observe and carefully draw the trapped shapes on the far side of the face?

Project 3 - F — Foreshortened Head YES NO

- Did you mix drawing by eye with measuring strategies?
- Did you establish the midpoint carefully and accurately?
- Did you force yourself to draw only what you saw?
- Did you use level lines to ensure that features curved around the head?
- Did you use eye, nose, and hair mass in your comparative measuring?
- Did you take pains to draw the face shape accurately?
- Did you pay particular attention to the location of the tip of the nose?
- Did you make subtle adjustments by erasing and restating?

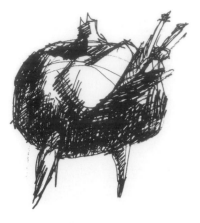

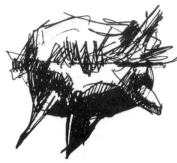

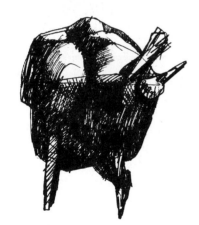

4

THE ILLUSION OF LIGHT

MAPPING • MODELING • MANAGING EDGES • ANALYZING THE LIGHT • INTENSIFYING MOOD • MERGING SHAPES • DESIGNING WITH LIGHT

As artists, we want the audience to share our experience when they look at our work. We do this in part by playing with the viewers' senses, recreating the sense of light, depth, and surfaces we found in our original subject. The viewer *knows* he is looking at a drawing but feels the presence of the actual subject. Scientists and philosophers may strive to dispel illusions, but artists strive to create and sustain them. That is our job.

Of the various illusions, the re-creation of light is certainly the most dramatic. This is because light is such a pervasive part of our sensory and emotional experience. Most of our information is taken in visually. Light is also a metaphor of the mind — we "see the light," we "shed light on a subject," we are "enlightened," we "take a dim view of," we have "dark" moods, and so on.

A wonderful feature about the illusion of light is that it's not difficult to create if we look carefully and draw sensitively. It helps a great deal to know that light and shadow behave in a logical and consistent pattern. Once we understand that light and shadow pattern (called the l/s pattern), we have the measure of the illusion.

In addition to learning how to model forms realistically through use of the l/s pattern, this chapter will also show you the ways in which lighting and light quality can be used to create and intensify mood. Finally, we will, again, discuss shape and the role of light and shadow shapes in strengthening and enriching the design quality of your drawing.

Light and shadow will make any form look solid and three-dimensional, even abstract forms like these studies for sculpture by Ed Reinhardt.

Creating the illusion of light is largely a matter of sensitively observing shapes, tones and edges. Notice the "pieces" of light in this drawing by Robert Baxter

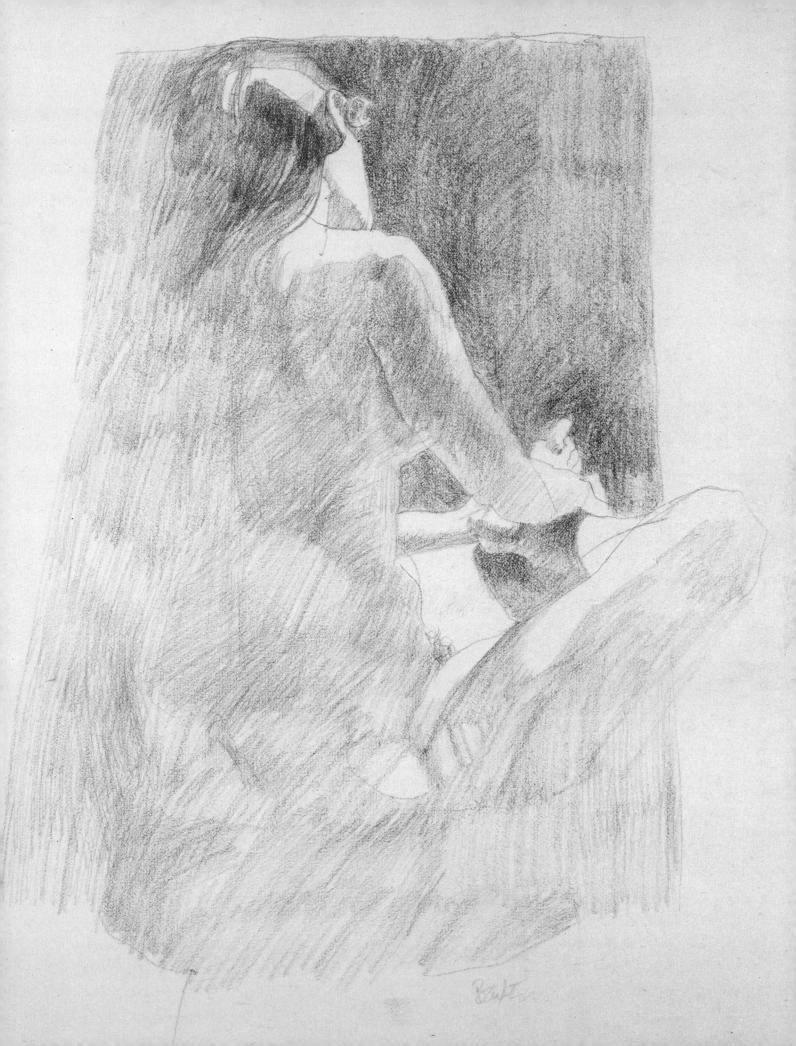

Mapping

Light is an illusive subject. It is sometimes harsh and brilliant, creating stark contrasts with the sharp shadows it casts. At other times, it behaves in a subdued, almost modest way, filling a room with a diffuse presence. To learn to draw light in its various moods is to first get a sense of its patterns and then understand how those patterns work. The former is accomplished by a procedure I call *mapping*.

In this strategy you break down all lights and all shadows into well-defined shapes, as if they were territories on a map. You must assign a definite boundary to every shape. When shadows seem indistinct, you impose boundaries anyway, arbitrarily if necessary. In doing this you create an organized map which serves as a starting point for later refinements.

The beauty of mapping is its speed. As you can see from the examples, mapping patterns are deliberately simple. There's no attempt at subtlety. Sometimes you'll end up with only a two-shaped map, one light shape and one dark shape. At other times, depending upon how the light and shadow play on your subject, you'll have as many as eight or ten shapes in your map.

Mapping is something you can employ right away, without theory or practice. Initially though, you should use it only in those situations where the light is strong, such as in direct sunlight. As you get comfortable with it, you'll discover its broader applications. Mapping can be used in quick sketches as an end in itself, or as the basis for more comprehensive drawing. In the latter case, your mapping lines will need to be more lightly drawn, but in either case, decisiveness is the key feature.

For quick sketches, there is a little trick I use to distinguish between hard and soft edges. For hard edges, I try to stop my fill-in strokes right at the boundary lines. For soft edges, I run the strokes over the boundary line in a jagged manner. When you're using pencil, map with a couple of middle tones as well as with black.

Mapping divides the shape into light and shadow areas with definite boundaries.

As the figure moves, the number and character of mapped shapes change.

This drawing (from a photograph) is simply a group of mapped shapes.

The logic of light

We're encouraging a mixed strategy for learning to draw light. Mapping is a sense-oriented activity. The l/s (light and shadow) pattern is a conceptual model for understanding what we see.

The way light falls on objects, though often subtle and complex, is invariably logical and consistent. The logic can be stated simply: when light strikes a three-dimensional object, it creates a light side, a shadow side, and a cast shadow. If you are observant, you can see that the shadow side is not evenly dark. Reflected light bounces off other objects and into the shadow area. To observe these four elements — the light side, the shadow side, the cast shadow, and reflected light — place a grapefruit or light-colored ball on a white sheet of paper and about ten to twelve inches from a table lamp. Turn on the lamp and study the pattern — the light side, the shadow side, the cast shadow, and the reflected light. These make up the l/s pattern. If you were to map this pattern, you would assign boundaries to each of the four elements. Move the light and look at it again. Notice that even though their shapes change, all the elements are still present. You can expect them all to be present wherever there is strong light.

Squint your eyes as you continue to move the light. Notice the soft edge where light side meets shadow side. The transition from light to dark is gradual compared to the slightly sharper edge of the cast shadow. This is the way light behaves on rounded forms. Reflected light causes portions of the shadow side to lighten slightly, most noticeably near the outer edge of the form. It is invaluable in creating a three-dimensional illusion, so be alert to it.

The advantage of learning the l/s pattern is that it gives you a basis for understanding. It's not a formula for drawing; it's a formula for observing. Coupled with mapping, it enables you to make sense out of complex problems.

A simple set-up for examining the l/s pattern.

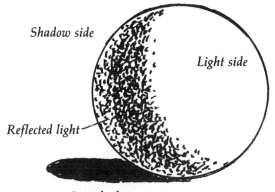

Shadow side

Light side

Reflected light

Cast shadow

Project 4 - A — Three Mapping Drawings

This project requires three drawings of a model out of doors in strong, direct sunlight. In each drawing, after quickly sketching the general shape of the figure, map out the pattern of light and shadow shapes. Squinting will help you see the pattern most simply. Outline these shapes decisively as if they were territories on a map. Fill them in using only a light, dark, or middle tone. For the strongest light areas, use the white of your paper. Draw three different poses from three different angles. Each pose should take five minutes. Use any drawing medium you choose.

Modeling light

To draw light on form requires not only careful observation but good use of your control hand as well. I'll want you to follow along with me while drawing, so I suggest you first read through this section once.

With the light directed from above and to one side of the grapefruit, try mapping the grapefruit first. Simply divide the dark and light areas as you see them and fill in the darks.

Next try drawing it more methodically. Begin with a very light mapping as before, but this time build up the tones slowly. Instead of a sharp division between the light and shadow sides, make a very soft transition between the two as shown. Put in the reflected light by darkening the shadow above it. Getting the right tone for the reflected light requires careful judgment. It's never as light as the light side, never as dark as the rest of the shadow area. Save your darkest dark for the cast shadow especially where it meets the bottom edge of the grapefruit. The edge of your cast shadow should probably be a little sharper than the shadow edge of your grapefruit. Finally, fill in the appropriate background tone above the tabletop. This tone should meet the grapefruit in a hard and precise edge.

Step back and look at your study. Look for all four elements of the l/s pattern. Look for the soft transition between light side and shadow side, the subtle reflected light and the darker tone of the cast shadow, as well as the crisp edge where the background meets the grapefruit. To the extent you handled all these elements well, you've created a successful three-dimensional illusion.

Light on other basic forms

The l/s pattern occurs on every form. As far as light is concerned, the only difference between a grapefruit and a block is the difference in edges. The soft edges of the shadow on a grapefruit are in marked contrast with the sharply defined planes of the block. This much is obvious. What is not

The effect of changing light on simple forms.

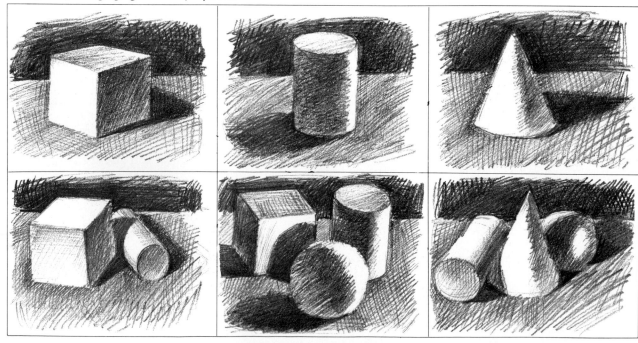

so obvious is the reflected light. We saw in the sphere how the reflected light gathered at the bottom edge near the cast shadow. This is also true in the case of the cube. The shadow-side plane is darkest right along the edge where it meets the light side. The way I remember it is: the contrast is always greatest where the form turns.

The sphere, the cube, the cylinder, and the cone are what Cézanne called the four basic forms — the fundamental configurations from which all of nature is comprised. If drawing light is new to you, assemble these forms and draw them under a strong light. A few examples are shown below. For a cylinder you might use a can of cleanser covered with paper to eliminate the confusing label, a cone can be made of white paper taped together. The cube could be a simple block painted white.

These forms appear in various guises in everything we draw. A building is basically a cube, a tree trunk and branches are actually cylinders, a mountain is a variation on the cone. Even the human figure can be seen as a series of cylinders. A little practice in drawing light on the basic forms will help clarify the l/s pattern in your mind and be of considerable benefit when drawing complicated subjects.

I've already mentioned that the best way to draw light is through a two-fold strategy: first, thinking of the l/s pattern and then mapping. In drawing a head for example, I first think of it as an egg. I realize that the intricate pattern of the face before me is nothing like the surface of an egg, but I use the egg concept for the sake of simplicity. I want to understand the division of light side and shadow side. Period. With this simple image fixed firmly in my mind, I map the head as I see it, catching the pieces of light and shadow created by the eye sockets, nose, cheek bones, and lips. I squint frequently to keep things simple. The entire process takes only a minute or two, but it lays the foundation for all that follows.

Project 4 - B — Light and Form

Locate three simple forms: a grapefruit, a cardboard carton of any size, and a coffee or similar type can. Place all three in an interesting arrangment on the floor or on a table. Direct a strong light from a portable lamp placed on your left side of the setup. Be sure the light is strong enough to create a definite light and shadow pattern on the three forms.

With any black and white drawing medium you wish, and at any size you want, make a careful rendering of the objects. Pay particular attention to the way the shadows fall. Use the light and dark patterns to help define the forms of each object. Be sure to indicate all the elements of the l/s pattern: light side, shadow side, cast shadow, and reflected light. Try to accurately render both the hard and the soft edges. Do not include any surface lettering, marks, or ornamentation that might be on the forms. Allow 40 minutes to one hour.

Supplementary Project 4 - B
Make a second drawing of the same forms in the same position, but shift the light source to another angle.

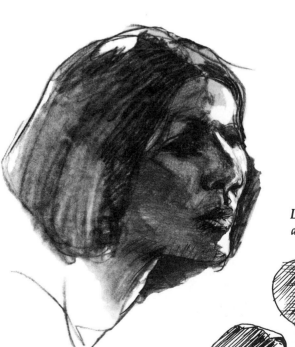

Light from right and behind.

Light coming from the upper left.

Cast shadows generally have rather hard edges. These softer shadows describe the undulation of the form. An effective way to soften the edges of pencil or charcoal work is to rub with finger or paper stump.

107

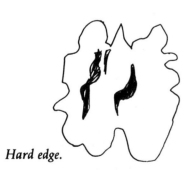

Contrast demands attention. Surrounding Yul Brynner's shaven head with a dark shape focuses our attention there. The hardest edge is along the light-struck side of his head and shoulder. (Drawn at the Hollywood Wax Museum.)

Managing hard and soft edges

The word "edge" normally conveys something sharp and well defined, such as the edge of a tabletop. In drawing, however, an edge is any boundary where two shapes meet. Edges can be clearly delineated like those of the table, or they may be only vaguely implied like a figure in the fog. The skillful manipulation of these two kinds of edges accounts for much of the quality we admire in a handsome tonal drawing.

As a youngster, I used to love to draw WWII aircraft on my notebook paper at school. By copying friends, I had learned a shading trick that imparted a semblance of realism to my planes. On every form, I darkened all the outer edges and gradually lightened the tone as I worked inward. I considered no drawing complete without an exhaustive working of this device! I liked the effect so much, I began to use it on everything I drew including faces, figures, and animals. I didn't realize at the time that I was not really shading, although I was developing my control hand. After awhile I learned how to draw hard and soft edges without thinking about them. Having acquired the hand skill, I was able to put it to better purpose later on. With practice, you will too.

A hard edge requires a sharp tool. It can be expressed in an incisive line or a tone that simply stops abruptly at the shape boundary. Hard edges are used to describe sharp borders, abrupt turns, and areas of high contrast. Soft edges describe indistinct borders, gentle curving forms, and areas of low contrast, and they require all manner of softening techniques from crosshatching to side strokes to rubbing and erasing. A soft edge is actually a graded tone and as such should take a little time and patience to build up.

Generally, the harsher and more direct the light, the harder the edge. This phenomenon can be put to good use, as in the drawing below where the light sharply illuminates the upper portion of the walnut and softens the lower portion where it drops off. You may recognize this as a form of

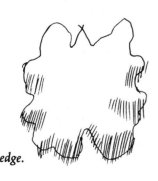

Hard edge.

Soft edge.

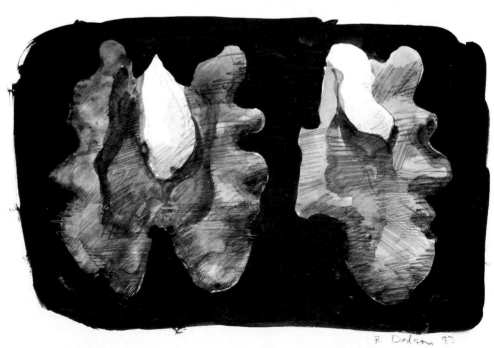

With ink media you need to use crosshatching or ink washes.

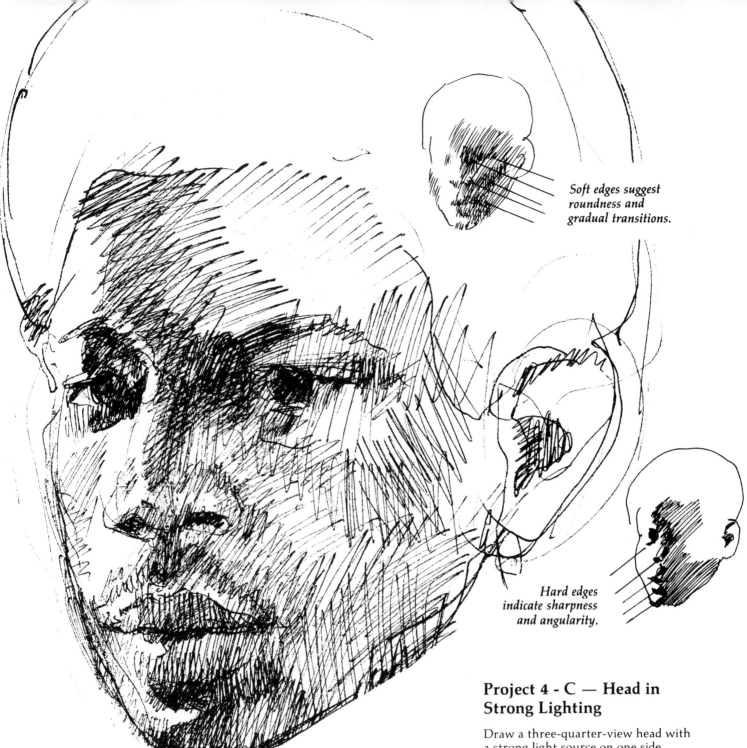

Soft edges suggest roundness and gradual transitions.

Hard edges indicate sharpness and angularity.

Project 4 - C — Head in Strong Lighting

Draw a three-quarter-view head with a strong light source on one side throwing the other side into strong shadow. Use the sighting techniques discussed in Chapter 3 to establish good proportions. Lightly map out the l/s pattern and then patiently match the tones of the subject. Be especially sensitive to the edges, making a clear distinction between those that are sharp and crisp and those that are subtle and elusive. Keep the features soft on the shadow side and more defined on the light side. Look for soft transitions within the shadow areas, but continue to squint now and then to maintain a strong overall pattern. Work in pencil or charcoal and allow at least one hour.

focusing. You can use it deliberately, making the sharpest contrasts in the areas you consider most important and softening contrasts in areas you wish to subdue.

A human face, such as in the example above, is a veritable catalogue of hard and soft edges. Hard edges occur mostly in the light-struck side, along bony protrusions and sharp creases. The cartilage of the nose, the edge of the mouth and upper lip, and the outer edge of the face are examples of hard edges. The soft edges occur mostly on the shadow side in the reflected light on the cheek and in the curve of the forehead. The eyes are each handled differently. Notice the hard edges on the light-side eye and soft edges on the shadow-side eye. Orchestrating these contrasts imbues a drawing with much of its richness and beauty.

The light source

Something exciting happens when you start looking at light. The phrase "seeing the light" can be taken quite literally here because that is exactly what you do when you shift your attention from objects to the light falling on them. It actually lies in little pieces across the forms you draw.

The quality of light depends on its source. A room evenly lit by fluorescent lights will dictate drawing flat shapes with soft modeling, while natural light from a window produces stronger modeling and sharper contrasts. Begin every tonal drawing with the question: where is the light source? Once you determine this, you can apply the logic of light, and the l/s pattern will be clear.

To make sense of light, imagine that it is all coming from a single source. By means of the grapefruit and one strong light, you were able to discern the four elements of the l/s pattern. Even though it is rare that your light should come from one direction only, try to impose some of that simplicity on your subject. With practice, you will be able to sense the direction of your main light source and even predict the pattern. This knowledge can give you confidence to draw what you see.

Ask a friend to sit facing you as you move a lamp to various station points around the head. First, hold it directly above and observe the l/s pattern, then move it off to the right slightly, noting how the pattern changes. As you continue moving the light clockwise around the face, try to predict which areas will be made light and which will be thrown into shadow. Shine the light from the side and from below and observe the differences. Next shine the light from almost directly behind the head. If your predictions are faulty the first time around, they probably won't be the second.

Here's a little test. See if you can match the drawings below to their light sources in the following list:

a. Frontal lighting (light nearly directly in front)
b. Back lighting (light source behind object)
c. Light from above and to the right
d. Light from low and to the right
e. Indirect light (light coming equally from numerous directions)

(Answers are below.) If you missed more than two of these, you should practice some mapping drawings, using the basic forms under a strong lamp as described on page 105.

1d, 2b, 3c, 4a.

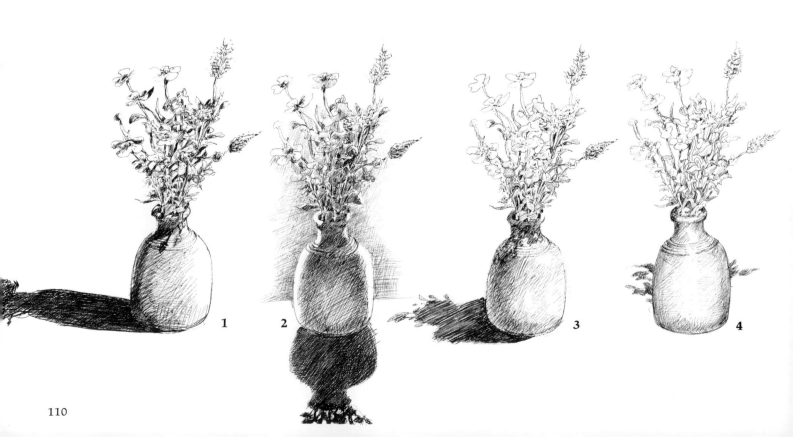

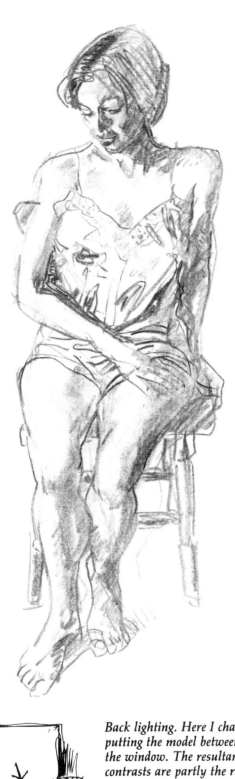

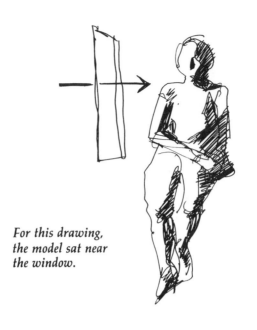

For this drawing,
the model sat near
the window.

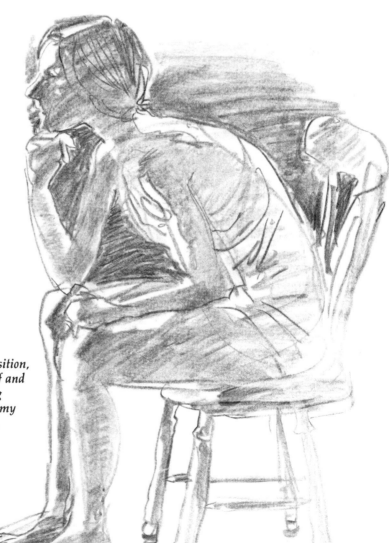

Back lighting. Here I changed position,
putting the model between myself and
the window. The resultant strong
contrasts are partly the result of my
looking directly into the window.

Project 4 - D — Light and Mood

Following Monet's example, draw a simple scene in your yard or neighborhood park such as a tree silhouetted against a large expanse of sky. In any drawing medium you wish, create three pictures of the subject, each in distinctly different lighting. By catching the same subject at different times, try to suggest any three of these four conditions:

a. A bright, sunny morning
b. A dull, overcast day
c. A threatening thunderstorm
d. Dusk

This will be a long-term project because you will have to wait for substantially different lighting conditions. You may draw inspiration from the painter J. M. W. Turner, who allegedly lashed himself to a boat's mast in order to paint a storm. Your drawings should take about 45 minutes to an hour each. Use any medium, but use the same medium for all three drawings.

The effect of light quality on mood

In 1890 Claude Monet painted a series of pictures of haystacks in the French countryside. The compositions are similar but what makes them all strikingly different is the lighting. Some were done in the early morning, others at midday, and still others in the late afternoon or at sunset. Some of the scenes were painted in a wintry haze while others were rendered in hot glaring sun light. For Monet, the subject was not haystacks but light. In a letter to a friend he wrote, ". . . the further I go, the more I realize . . . what I'm after: the 'instantaneousness,' the envelope of things, with the same light pouring in everywhere."

Light quality is evocative. Certain lighting conditions can trigger memories too subtle to express in words. When I step out into a bright summer day, I sometimes get a nostalgic flash of my childhood in Phoenix, Arizona. Sunlight so glaring as to reflect brightly into the shadows reminds me of the washed-out photographs in the family album.

A good way to experience light and mood is to emulate Monet, using a simple subject as a vehicle for studying and drawing light. The wash drawings on these pages were done with this in mind. A simple composition of sky, trees, and fields was drawn at three different times of day. A hazy afternoon, shown in the first drawing, nearly eliminates the l/s pattern. This is typical of the effect of indirect lighting. The trees are a flat dark shape, almost a silhouette.

An assertive l/s pattern emerges in late, sunny afternoon. The trees are strongly mottled by the sun coming from the upper left. In spite of their merging into a forest shape, each tree has a definite light side and shadow side. The cast shadows, although gathered together, are decisively painted.

A darkened sky in the distance with direct sunlight slicing through the clouds and spotlighting the trees and foreground is a dramatic reversal of the usual pattern of dark earth against light sky. Small flickering lights on the leaves (dug out of the paper with a razor blade) suggest the wind before a storm.

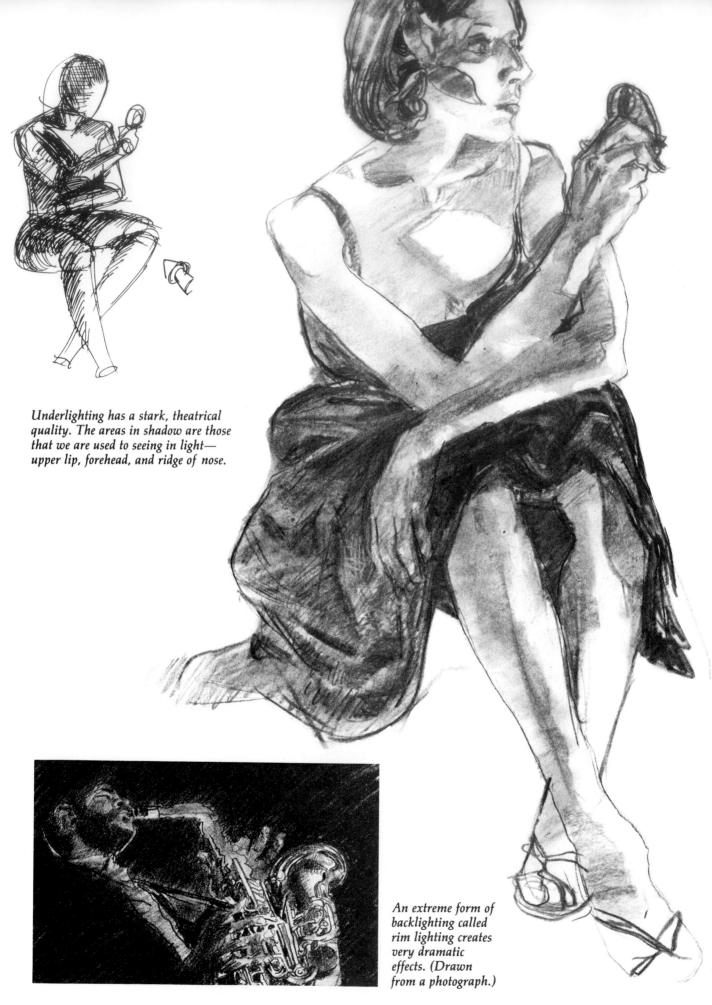

Underlighting has a stark, theatrical quality. The areas in shadow are those that we are used to seeing in light—upper lip, forehead, and ridge of nose.

An extreme form of backlighting called rim lighting creates very dramatic effects. (Drawn from a photograph.)

Backlighting from both sides gathers the shadows in the front of the face where the features are almost mysteriously lost.

Intensifying mood with striking or unusual lighting

There is something about the uncommon that is especially conducive to learning. Strangeness forces us to see things intensely and with fresh eyes. That's why I encourage you to draw subjects under striking or unusual lighting. This may mean spotlighting your subject from a low angle or perhaps from directly overhead. It may mean drawing by candlelight or using two strong lights from opposite directions. It may mean allowing strong shadows to fall right across your subject.

By deliberately setting up unusual lighting conditions, you can train yourself to recognize those you happen upon by chance. It's a good idea to devote some of your sketchbook pages solely to drawing light in its more dramatic forms. Copying strangely lit photographs is a good practice. You'll find that striking or unusual lighting is not more difficult to draw than conventional lighting if you keep in mind the principles we have already discussed.

- Ask yourself, "Where is the light source?"
- Look for the l/s pattern: light side, shadow side, reflected light, cast shadow.
- Map these areas early in your drawing.
- Model with hard and soft edges.
- Save the greatest contrast for the most important areas and soften the contrasts elsewhere.

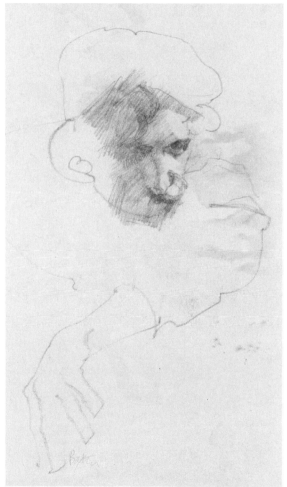

Robert Baxter

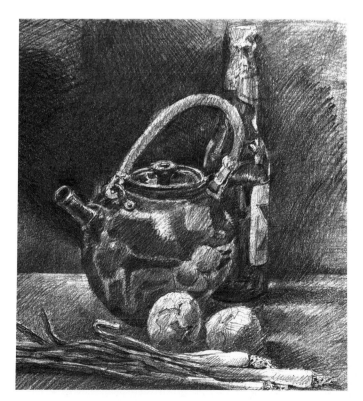

Ginny's Teapot. This is a low key and low contrast drawing created by a patient and time-consuming buildup of tones. Because of the near absence of pure whites the mood is soft and subtle.

Intensifying mood with cast shadows

One of my indelible film memories is that of Fred Astaire dancing with his own shadow. At first the shadow matched Astaire step for step but then, at a certain magical point, it broke loose, gliding, turning, and dipping in syncopated counterpoint to Astaire's routine. In another old film, *The Adventures of Robin Hood*, there is a memorable duel between Errol Flynn and Basil Rathbone. The conflict was intensified during one special sequence by showing only the two dueling shadows thrown up against the castle wall in a gigantic and distorted fight to the death.

These scenes point up the dramatic possibilities in the almost independent nature of cast shadows which suggest without merely repeating the shapes and sizes of their owners. This potential is of real value to us as artists, for we can subtly move, darken, lengthen, enlarge, and reshape the cast shadows for dramatic and emotional effect.

Study a cast shadow and note the particular way it relates to the object that produces it. When a light is directly over our grapefruit, the cast shadow is squat and bunched right up under the sphere. When the light strikes from the side, the cast shadow extends into an elongated ellipse. Although these are both reflective of the grapefruit, the longer shadow has more potential as a tool. Stretched out as it is, there is more to work with. This is one reason many landscape artists prefer to paint in the early morning or late afternoon rather than at midday.

Cast shadows help describe the spirit of the forms they fall across. The example at upper right was drawn from a still of the film *¡Viva Mexico!* by the Russian director Sergei Eisenstein. The shadows of the palm fronds travel up and over the contours of each figure in a flowing, almost liquid description of the lovers. In addition to enhancing the three dimensional effect, the striped shadows create a tropical mood as well. Daylight, warmth, intimacy, rhythm, and relaxation are all communicated by these cast shadows.

We've concentrated so far on the supporting and enriching role of shadows. However, with a slight shift of emphasis and a bit of nerve, you can make them your center of interest. Imagine you're a film director and you've just made a cast shadow your leading actor. Its role is to be the dominant force in your picture. The object casting the shadow should be off-stage and out of the picture. You may want to convey by the shape of this shadow what that object is or you may want to leave it ambiguous.

To make your shadow a more complex character, you will want to give it something to do. When it travels up and over other forms, it gathers interest as it goes. Striking across the floor and up a wall or undulating over the covers of an unmade bed, the shadow reveals not only itself but the objects beneath it as well. For an intricate challenge, you might try something like the shadow of a houseplant falling across a typewriter or the shadow of a Venetian blind across a face.

The above suggestions are verbal ideas. To really make this project work, do some experimenting by moving a light around and looking for yourself. When you hit on something interesting, you'll know it. Be alert to the shadow patterns in your house. Something you've seen a thousand times may suddenly strike you as a compelling subject. Remember to play with the shadow's elastic and fluid qualities.

Cast shadows have a life of their own.

116

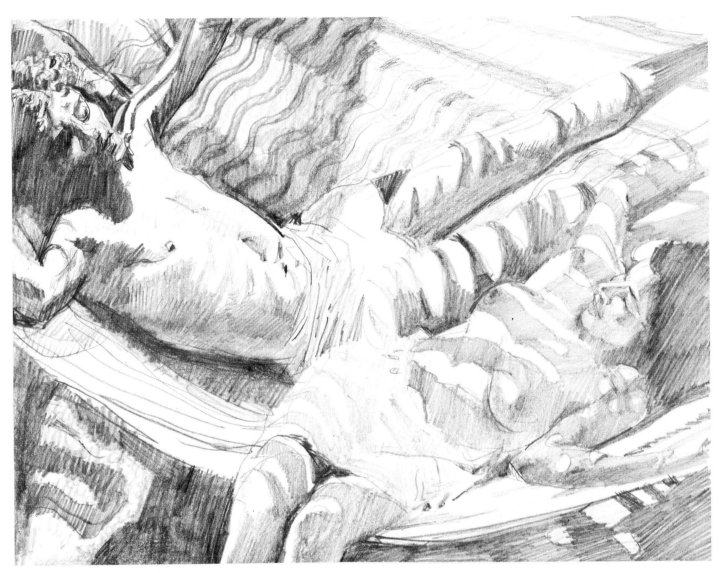

Undulating shadows from Eisenstein's film ¡Viva Mexico! (Drawn from a still.)

An overpowering shadow can actually become the subject of your drawing.

Project 4 - E — The Cast Shadow

Make a drawing of one or more cast shadows as the most important element in your picture — you might want to wait until you encounter a shadow effect that just hits you with potential to be a center of interest. If not, you'll need to be inventive and set something up either in bright sunlight or with a strong spotlight. Use the suggestions on the left-hand page for ideas. Remember that the cast shadow itself has a definite shape. Also remember that it reveals the character of any object it passes over. This project could take from 30 minutes to two hours. Use any medium.

Tonal relationship: strategies for a full tonal drawing

Making a full tonal drawing is rewarding but tricky business. Tones are based on relationships; that is, tones look light or dark in relation to other tones. When you have only the white of your paper to work against and nothing else to compare to, tonal relationships are difficult to establish.

A beginning student, confronted with a landscape like the one pictured below, will frequently get into problems early. Unlike this photograph, the real outdoors comes with a moving light source, confusing colors, and no borders. You can appreciate the difficulties. Furthermore, it's cold.

Having lightly sketched in the main shapes, our student confronts the problem of rendering the tones. Meanwhile, the shadows are changing as the day advances. Daringly, the first tone is set down and immediately seems too dark because there is only the white of the paper to compare it to. Uncertainty sets in. Actually, that first tone will usually prove to have been too light, but without a dark on the paper to establish the outer range, it's hard to know how to grade the early tones.

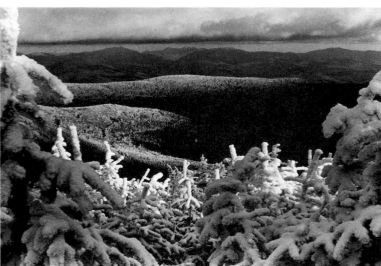

Photo by William Arrand

Squinting reduces the subject to two or three tones as suggested by this out-of-focus photo. Working with only a few tones makes it easier to establish a simple value sketch.

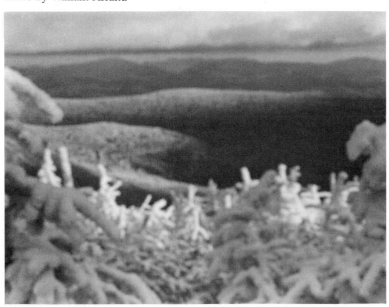

Another problem is mind-set. Knowing that snow is white, the beginning student is reluctant to apply any tone to it for modeling. Close examination of the photograph, however, reveals that there is in fact little pure white in a snow scene. Clinging to mind-sets and failing to get the tonal range dark enough can make capturing a challenging scene nearly impossible. Too early expectations are an added difficulty. A full tonal drawing requires a patient build-up of values. The student who looks for finished results without laying the groundwork will become discouraged. With all these problems slowly compounding, it's not long before the novice packs up and goes home.

Becoming overwhelmed by a complex landscape need not be your experience because there are five strategies that simplify the problem:

1. Keep your paper out of the direct glare of the sun
2. Use squinting techniques
3. Use a viewfinder
4. Make a value sketch
5. Build tones patiently

By positioning yourself to keep your paper out of direct sunlight, you lessen the problem of the stark white paper creating an overpowering contrast. You will also minimize eye fatigue. Squinting simplifies observation, allowing us to take in a single overview when our habit is to scan from part to part. By squinting through a viewfinder (a small rectangular hole cut out of a piece of white cardboard), you get the large overall pattern of tone, and you can compare the lights that you see to the white of your framing device. You may be surprised at the darkness of the tones.

By squinting you reduce those tones to three main values: light, medium, dark. Let the white of your paper make the fourth value: there won't be much of it in your drawing. Then freeze that pattern by making a *value sketch*. A value sketch is a little notation of the general distribution of these three tones. If you're going to invest an hour or two in a full tonal drawing, you will want to increase your chances of success by making a value sketch at the start.

As you begin your full-sized drawing, keep the value sketch handy for reference. Use of a viewfinder will remind you of the big picture and the arrangement of the three main values. Use your squint to establish your three main tones and then shift to a half-squint so you can discern more of the middle-range tones. Can you see how the process works from the general to the specific?

Finally, develop the more subtle tonalities and details, using your control hand to work the l/s pattern and the hard and soft edges. Though stated here in a single sentence, this last stage will take most of the drawing period. If you have done the early work well, this part is pure pleasure because your mind can drift and the time will fly. Reinforce your darks with the triggering word "dark" or "black." At any point of confusion, consult your viewfinder to reestablish comparisons with the white of your paper. Don't get too far ahead in any one area because the rest of your drawing may not fit into the range you set. Keep stepping back to get the big picture. Use objects within your drawing to make these comparisons and keep asking yourself, "Which is darker?" and, "Which is lighter?"

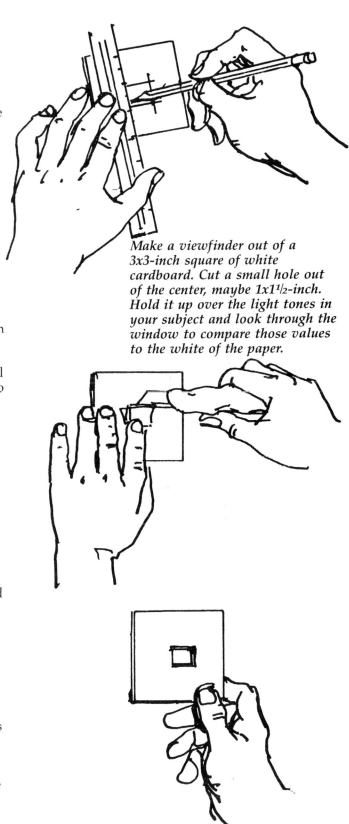

Make a viewfinder out of a 3x3-inch square of white cardboard. Cut a small hole out of the center, maybe 1x1½-inch. Hold it up over the light tones in your subject and look through the window to compare those values to the white of the paper.

Local values.

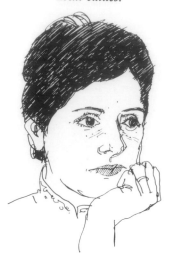

l/s pattern.

The value pattern.

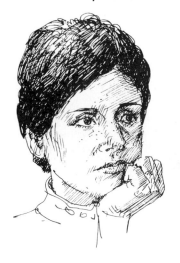

From a photograph.

The value pattern

The l/s pattern does not account for *all* of the tones you see in your subject. The additional complication is that some colors absorb more light than others. As a result, a red apple is darker than a yellow grapefruit, a navy blue sweater is darker than a pair of tan slacks. We call this tonal characteristic of an object its *local value* or its *poster* (I use *value* and *tone* interchangeably). The full tonal range of anything you look at — *the value pattern* — is actually a combination of two things: the light/shadow pattern and local values.

We use this combination in this way: let's say you're drawing a person's head under a strong direct light. As we have seen in Chapter 1, it is useful for drawing purposes to see your subject as an arrangement of shapes, each shape having its own value: light, dark, and in-between. The model in the example is fair skinned with dark brown hair. This means that the *local value* of the face is light, and the *local value* of the hair is dark as illustrated in figure 1.

Due to strong lighting, however, the subject's face and hair also has a definite l/s pattern as diagrammed in figure 2.

The local values and the l/s pattern together make up the value pattern. In figure 3, we see how these two elements combine.

Notice that although the light is striking both the skin and hair, the hair highlights are not as light as the skin highlights due to the influence of local values. Accordingly, the shadow side of the hair is darker than the shadow side of the face. When the lighting is exceptionally strong and direct, these two areas will appear to be the same value, and they will merge together. When the lighting is flat and diffuse, the l/s pattern disappears.

The value pattern is simply the breakdown of your subject into its component tonal shapes: lights, darks, and in-between tones whether the result of shadow or poster. We put together our picture based on the value pattern. It incorporates, but is not the same as, the l/s pattern. Under some lighting conditions (for example, flat indirect light such as you would find on a hazy day or under fluorescent lights), there is no discernible l/s pattern. In that case, the local values alone comprise the value pattern. But the brighter and more direct the light, the more the l/s pattern influences the value pattern.

The l/s pattern.

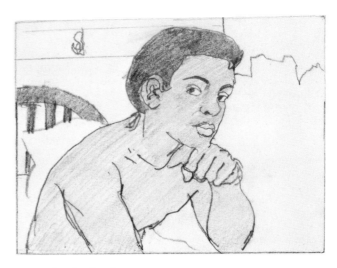

. . . plus local values . . .

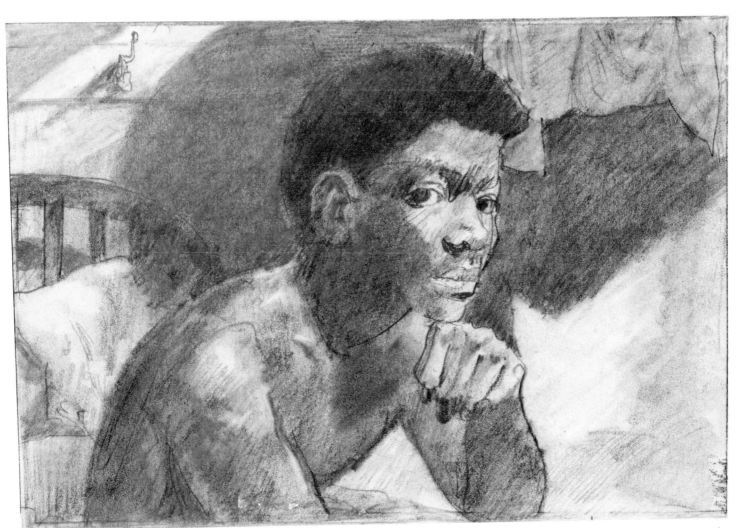

. . . combine to make the **value pattern.**

From a photograph.

Project 4 - F — Merging Shadows

Following the examples shown on these pages, make a drawing in any medium you like of human or non-human animals in strong, direct lighting. Look for opportunities to merge a dark local value such as black hair or dark clothing with a cast shadow. Look also for light local values to merge with light-struck areas in the background. When merging, eliminate the boundaries between the two shapes, tying them together into a single larger shape. Arrange at least two such mergers in your drawing. Work in the medium of your choice and allow 45 minutes to an hour.

The large shadow in this backlit view runs freely from the chair to the figure and back again, in places eliminating the distinction between the two.

Merging lights and shadows

Light and especially shadow shapes can be used as powerful connecting elements. In the drawing of the old Spanish woman at right, the black of her dress and the black of the shadow behind her run together as a continuous shape. On one level you might say that there has been a connection established between shadow and shroud, portent and death. But I had no conscious intention of such connections when I made the drawing. I merely joined those two shapes because they were both dark, and I like to tie shapes together for unity.

Merging shapes brings about cohesion. In the cardplayer's face, the shadow shapes tie the features together. They act as little puddles that have run together here and

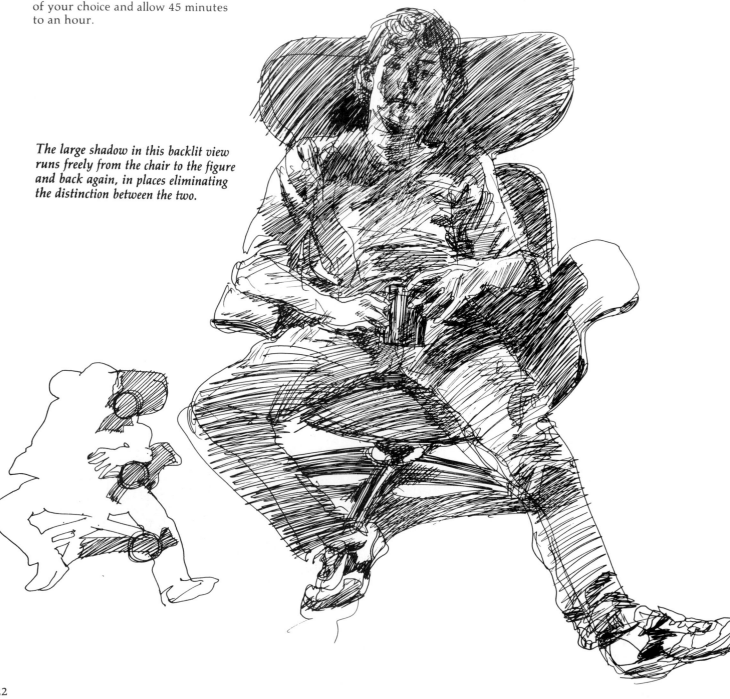

there, gathering in and unifying the isolated parts. Paradoxically, little shadow shape-mergers like these can make a face more expressive than a detailed rendering of the facial expression.

When you merge shapes, you break down the separateness of things. On the left-hand page, the backlighting blurs the distinction between the boy and the chair. The boundaries between them are broken and run together in several places with a uniform tone. Boy and chair come together as a unified presence. Little connections like this help us experience, however slightly, the seamless web of reality in which all things are connected.

Remember the rule for merging: when values are the same, or nearly the same, connect them. You needn't connect them everywhere along their borders, sometimes here and there is enough. It's like working in watercolor when two pools of very wet color are laid side by side on the paper. If they are kept apart, even the slightest bit, they retain their independence, but if they ever touch they explode and fuse together violently. As every watercolorist knows, some of the most beautiful passages occur this way.

Black dress merges with background shadow.

Features are tied together by the larger shadow shapes.

Light, shadow, and design

One of your functions as an artist is to put things into patterns or to intensify the patterns that are already there. This isn't difficult once you translate the visual world into the language of shapes. Let's continue the discussion of shape consciousness begun in Chapter 1. Imagine that every object in front of you is a shape. Further, imagine that every space in between those objects is also a shape. This means that everything around you can be seen as a series of interlocking shapes. The objects and spaces all fit together like pieces of a jigsaw puzzle. With the addition of light and shadow shapes, you have that many more puzzle pieces to play with — pieces that are arresting and evocative, even surprising.

Catherine Murphy's use of light in *Still Life with Pillows and Sunlight* makes us aware of the presence of an object not in the picture — a window. If the artist had chosen to eliminate the sunlight, she would have been left with something like the diagram at left, and the picture would have suffered severe impoverishment. The special beauty and significance of this drawing owes much to the rectangular light shapes on the wall coupled with the subtle shadow shapes on the couch and pillows. In Chapter 1 we called these *enrichment shapes*, and indeed we can see how the drawing is enriched by their presence.

The three drawings on the opposite page are of a memorial sculpture of the World War I marshal, Ferdinand

Shaft of light spilling across wall and couch creates a dynamic diagonal shape in what would otherwise be a static composition.

Catherine Murphy, *Still Life with Pillow and Sunlight.*
Xavier Fourcade, Inc., New York.

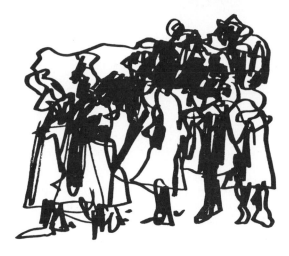

Foch. You probably wouldn't know it to look at my drawing, but the sculpture is a realistic depiction of a fallen leader being carried by his soldiers. In doing these sketchbook studies, however, I emphasized the stark pattern created by an overhead light. Rather than render a faithful copy of the sculpture, I intensified the blackness of the shadow shapes and left white paper for the lightstruck shapes, shattering the forms into little enrichment pieces.

Light and shadow contribute to design in the form of enrichment shapes and shape mergers. Used in combination, the two recast our ordinary way of looking at things into something new and special. Initially you may be a bit timid about giving the same authority to the shape of a light as you do to the shape of an object, but if you like the effect of these pieces of light on the wall in Catherine Murphy's drawing, you'll be impelled to get over that timidity.

Stark mapping of this sculpture of Marshal Foch creates a shattering of little black and white shapes and makes for an abstract quality.

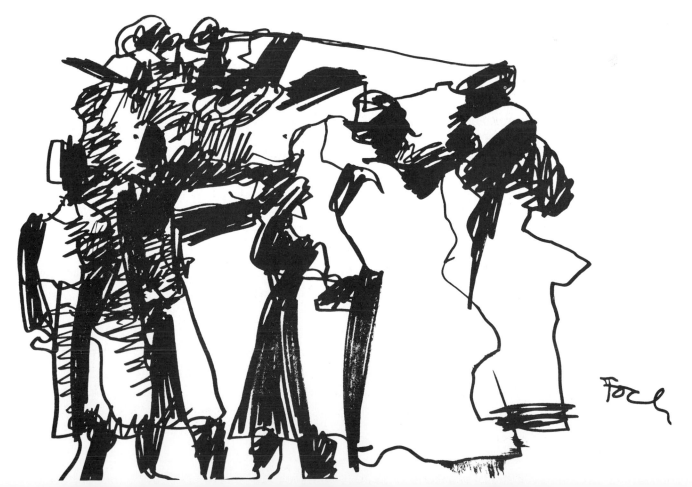

KEYS TO CHAPTER 4
The illusion of light

- **Map areas of light and dark** as if they were territories on a map. Initially assign definite borders to your shadows. Later you may want to soften and modify some of these borders.

- **Model with the l/s pattern.** Look for the four elements of the light and shadow pattern: light side, shadow side, cast shadow, and reflected light. Rendered sensitively, all four act to create a strong three-dimensional illusion.

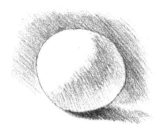

- **Manage hard and soft edges.** Hard edges are decisive; soft edges are subtle. A sensitive interplay between the two ensures a high degree of realism.

- **Analyze the light** by identifying its source and quality.

- **Intensify mood.** You can imbue your drawings with a deeper, more emotional quality by use of striking lighting, unusual cast shadows, or the play of light against dark in important areas.

- **Contrast and compare tones** to establish tonal relationships. Tones appear light or dark in relation to each other.

- **Merge shadow shapes.** Shadows are great unifiers, pulling together various parts of your drawing. A single shadow shape can gather a group of smaller shapes together "under one roof," subordinating detail but adding structure to the overall drawing.

- **Design with light.** As you begin to see lights and shadows as shapes in their own right, they become tools for design, creating patterns.

SELF-CRITIQUE OF YOUR PROJECTS

Project 4 - A — Three Mapping Drawings YES NO

- Did you draw the light and shadow shapes decisively as if they were territories on a map? ———— ————
- Did you squint to see your subject more simply? ———— ————
- Did you use only three tones in your drawings? ———— ————
- Were you able to create three distinctly different mapping patterns? ———— ————
- Were you able to catch, however coarsely, a strong sense of light and shadow? ———— ————

Project 4 - B — Light and Form YES NO

- Did you light your still life to show the forms clearly? ———— ————
- Did you lightly map your still life to establish the overall pattern? ———— ————
- Did you include all four elements of the l/s pattern: light side, shadow side, cast shadow, and reflected light? ———— ————
- Do the forms in your drawing look solid and three-dimensional? ———— ————
- Did you build the tones patiently? ———— ————
- Did you establish both hard and soft edges? ———— ————

Project 4 - C — Head in Strong Lighting YES NO

- Did you establish a clear l/s pattern in your drawing? ———— ————
- Did you first map the pattern lightly? ———— ————
- Did you build the tones patiently? ———— ————
- Were you careful to distinguish between hard and soft edges? ———— ————
- Did you keep the features relatively soft within the shadow areas? ———— ————
- Were features sharp and defined in the light areas? ———— ————

Project 4 - D — Light and Mood YES NO

- Did you draw your subject under three distinct lighting conditions? ———— ————
- Did you make use in your drawings of both hard and soft edges? ———— ————
- Did you squint frequently to capture the overall quality of the light? ———— ————
- Did you use triggering words to help you capture the mood? ———— ————
- Do your three drawings convey three different moods? ———— ————

Project 4 - E — The Cast Shadow YES NO

- Were you lucky enough to find a shadow subject or at least an inspiration for your set up? ———— ————
- Is your cast shadow the most important element in your drawing? ———— ————
- Does the shadow reveal any forms as it travels over them? ———— ————
- Did you carefully develop tones other than shadows in your drawing? ———— ————
- Is there an element of mystery or even abstraction in your drawing? ———— ————

Project 4 - F — Merging Shadows YES NO

- Were you able to unify elements in your picture by merging figure with light or shadow shapes? ———— ————
- Do you have at least two shape mergers or tie-ins? ———— ————
- Were you able to make use of:
 - Mapping? ———— ————
 - The l/s pattern? ———— ————
 - Hard and soft edges? ———— ————
- Did you need to alter, even slightly, the values you saw in order to accomplish these mergers? ———— ————

5

THE ILLUSION OF DEPTH

OVERLAPPING FORMS • DIMINISHING SIZES • CONVERGING LINES • SOFTENING EDGES AND CONTRASTS • DRAWING THROUGH • SIGHTING ANGLES • USING EYE LEVEL AND VANISHING POINTS • DRAWING ELLIPSES

Recently I asked a friend, a novice at drawing, to sketch the corner of his living room for me. He began confidently, first drawing the vertical line where the walls joined. Next he drew the joint where one of the ceiling beams met the wall. Then he was stuck. He had observed that the beam appeared to be on a slant, but every time he started to draw it, he was stopped by the knowledge that the beam was actually level. He couldn't decide which way to make it.

I've seen this paralyzing conflict between seeing and knowing many times in beginning students. Often they will want to turn their paper over and start again, hoping the problem will resolve itself with a fresh start. I insisted, however, that he stay with his original drawing, and I encouraged him to overrule his knowledge that the beam was level in favor of his seeing that the beam was slanted. To reinforce this choice, I had him hold his pencil level in front of him and compare it to the angle of the beam. The beam did indeed appear slanted, and that gave him the confidence needed to draw it that way. By trusting his eye and occasionally using his pencil/level to clarify, he was able to convey a credible three-dimensional room.

Creating depth in a picture is largely a matter of drawing what you see. For those times, however, when you simply don't understand what you're seeing, or desire more exactitude, or wish to push the depth illusion, you will need a few concepts to reinforce your observations. In this chapter, we will cover devices that create and enhance the illusion of depth. You will learn the principles of perspective and some quick methods to check your observations.

Richard Haas, *18th Street and Broadway*. From a photograph.
Brooke Alexander, Inc., New York.

Four ways of creating depth

The illusion of depth is created by devices which mimic the way the eye sees three-dimensional space. For the most part, these devices are simple and readily understood. Four are shown here:

Overlapping shapes—When two shapes overlap, the eye perceives one as being behind the other, thus creating a third dimension.

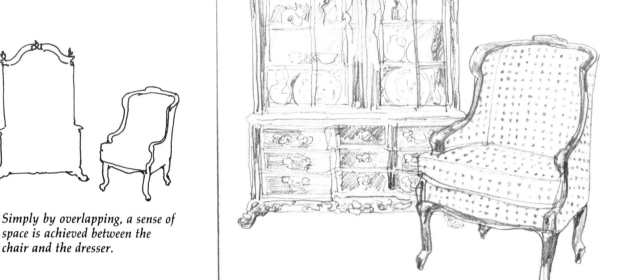

Simply by overlapping, a sense of space is achieved between the chair and the dresser.

Diminishing sizes—Same-size objects which recede into the distance appear to get smaller. Even objects of irregular size, such as clouds, are better able to suggest depth if those nearer the horizon are drawn smaller.

By drawing these boats different sizes, you "place" them in space.

Converging lines—Sets of parallel lines like highways, railroad tracks, and telephone lines will appear to converge as they meet the horizon. This phenomenon is the basis for linear perspective.

We know that the slats of this bench are parallel, but, viewed from one end, they appear to converge at the far end.

Softening edges and contrast—As objects become more distant, the intervening atmosphere will soften edges and lessen contrasts. This is sometimes called aerial perspective.

Because of intervening atmosphere, these hills become increasingly softened and blurred as they recede into the distance.

Intensifying depth

The four characteristics of depth on the preceding page are not only principles of seeing distance, they are keys to drawing it as well. Easy to remember and requiring no special knowledge, they are especially handy in enhacing the depth illusion. Subtly emphasizing each characteristic deepens the picture space and intensifies the viewer's experience. To that end, we should feel free to exaggerate or even invent when necessary.

Overlapping objects creates an instant three-dimensional effect. If you're doing a still life, overlap the objects when setting them up or simply move one shape behind another on the paper. If you're drawing a distant landscape, you can increase the sense of space by putting something in the foreground to serve as an overlap. If a near tree, for instance, doesn't exist in your scene, you might borrow one from another view.

Diminishing size is a well known aspect of depth perception. You can emphasize the phenomenon by deliberately shrinking background objects further in order to enhance the feeling of depth.

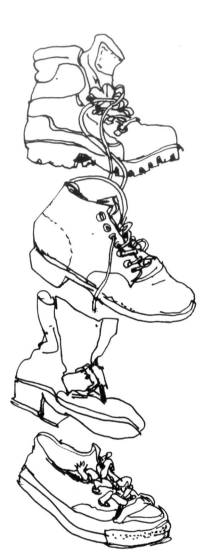

A random selection of shoes . . .

. . . placed in overlapping positions conveys a sense of depth.

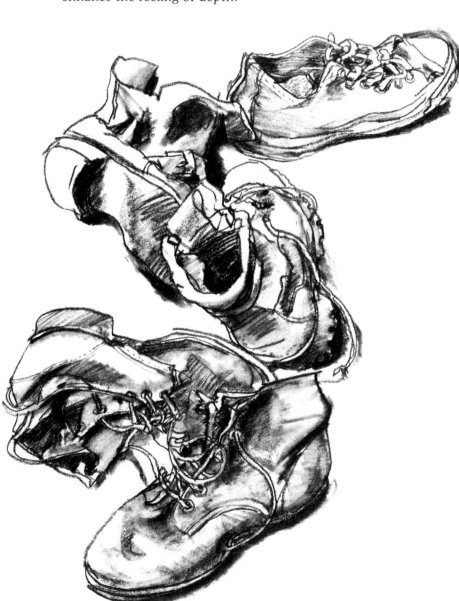

Converging lines also do a great deal to convey receding space. Even a few fanning lines such as those of floorboards or table tops can make a difference. Also known as perspective, the art of converging lines will be discussed in more detail later in the chapter.

Softening edges and contrasts is usually reserved for distant backgrounds where detail and color are lost, but you may impose the same principle within the confines of a room or on a shallow still life. You can suggest depth in these cases by slightly blurring the edges or the more distant areas and sharpening the details of those nearer, even if the difference is just a matter of a few inches.

It doesn't take much of this sort of thing to intensify the illusion of depth. A little emphasis here, a softening there, a slight enlarging, a subtle rearranging — when used in combination, they exert a powerful cumulative effect. This kind of invention invites the viewer to look into the drawing as well as at it.

Project 5 - A — Intensifying With Depth Principles

Set up six or eight cartons and old rummage items such as stacks of magazines and children's toys. Arrange them haphazardly but ensure that they go back in space. Make a drawing of them, intensifying with the four depth principles. Unless you can place these items on a tile floor or wooden floor boards, you may need to omit the converging lines principle. Draw the shapes by eye but feel free to exaggerate, adjust, and change what you see to deepen the sense of space. Use rubbing and erasing techniques to soften the most distant objects. Do not include a background. Work in pencil or charcoal and allow one hour.

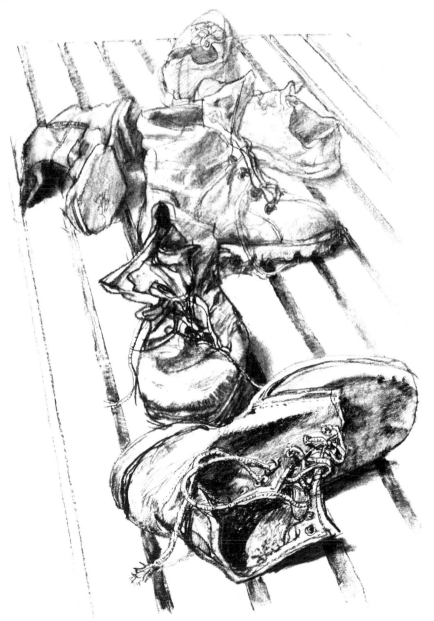

The illusion of depth is increased with the addition of diminishing sizes, converging lines, and softening edges and contrasts.

Shape drawing of coffee cup . . .

. . . coffee cup "drawn through."

Project 5 - B — Drawing Through

From direct observation at any angle you wish, make a pencil drawing of a chair. First construct by drawing through a three-dimensional cube that corresponds to the legs and seat of the chair. The four points upon which the legs rest will comprise the corners of the cube's base. The seat of the chair will comprise the cube's top. Superimpose the chair over the cube, mixing shape drawing with drawing through. Draw what you see and, in this case, what you don't see, such as the points where the chair legs attach to the underside of the seat. Draw the trapped shapes created by the chair's struts. Use the sighting strategies to measure angles and to compare heights with widths. Work in line; do not be concerned with light or shade. Restate as necessary. Allow 20-30 minutes.

Drawing through — a method for experiencing depth

One of the best ways to create a convincing three-dimensional effect is to actually experience the third dimension as you draw by means of a method called *drawing through*. In drawing through, we act as though our subject were transparent. We draw both what is seen and what is unseen, and we go beyond just drawing the outer shape to capturing the underlying structure. In this way we get a felt sense of volume and depth in space.

You will recall from Chapter 4 that all objects can be reduced to just four basic forms: the sphere, the cube, the cylinder, and the cone. In drawing through, you go one step further and treat your reduced forms as if they were made out of glass. If you were drawing a layer cake, you would draw not only the top ellipse but the bottom and center ones as well. If you were drawing a chair, you would imagine that the seat, four legs and floor comprised a cube, and you would draw, albeit lightly, right through the seat and get all six sides. As a result, you would avoid lopsidedness and the illusion that any part of the object was floating. When I want to be sure that an object like a box, a jar, or the wheels of a car look planted squarely on the surface, I make use of drawing through. It's a simple way to help prevent a lopsided box, a flattened jar, or a floating tire.

Another good drawing-through subject is the human figure. With its neck, torso, and limbs, the figure can be looked on as a set of modified cylinders. I especially like to draw through belts, necklaces, watches, collars, cuffs, and anything else that encourages my pencil to go around rather than across the cylindrical form. If you take the pains to lightly draw through in this way, you will be surprised at what a sense of solidity and dimension you achieve. Of course, if you try to draw through every form in your picture, you'll end up with a hopeless tangle of lines. Drawing through is a method that is best used sparingly and when symmetry and structure are important. With practice, you'll be able to accomplish drawing through without making a line.

Years ago I worked as an instructor at the Famous Artists School in Connecticut. One of the assignments I regularly corrected required that the student draw a barn and silo which are a modified cube and cylinder. In the years I worked there, I corrected thousands of barns and silos of all types and from all angles. My repeated redrawing of student errors deeply ingrained in me the advantage of drawing through. My eye became trained to see the basic forms underlying all structures, and now, even when I don't use the method, I clearly see things in solid three-dimensional terms, making drawing considerably easier for me.

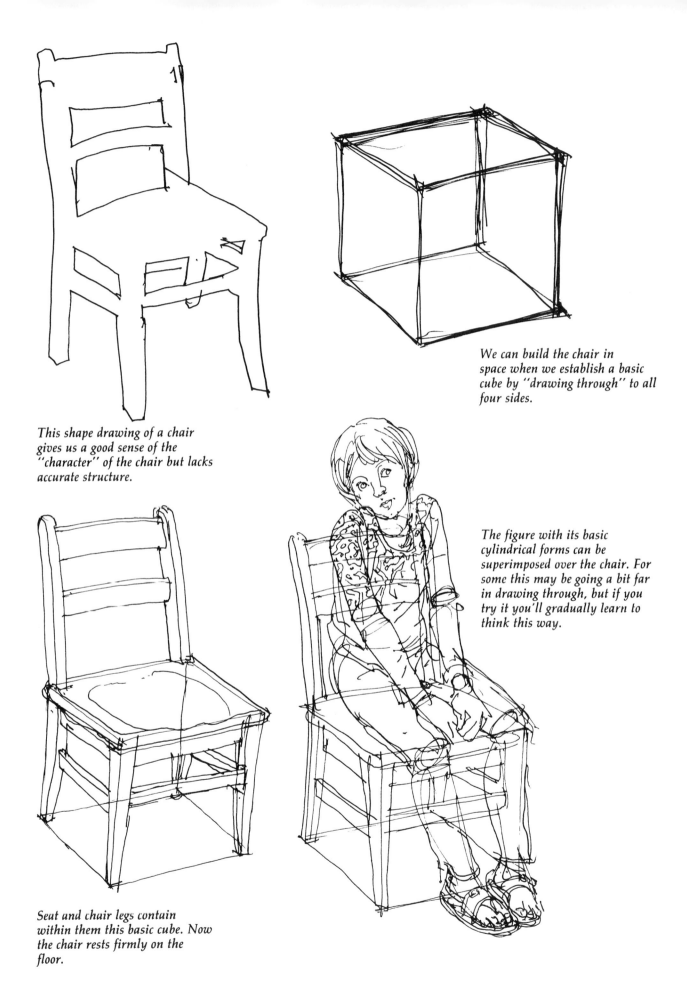

This shape drawing of a chair
gives us a good sense of the
"character" of the chair but lacks
accurate structure.

We can build the chair in
space when we establish a basic
cube by "drawing through" to all
four sides.

Seat and chair legs contain
within them this basic cube. Now
the chair rests firmly on the
floor.

The figure with its basic
cylindrical forms can be
superimposed over the chair. For
some this may be going a bit far
in drawing through, but if you
try it you'll gradually learn to
think this way.

Thinking of structure

In many sketching situations, particularly with architectural subjects, you're simply trying to get as much information down as quickly as possible. You haven't time for lengthy analysis or precise perspective. You know that much of architecture is a series of basic cubes, and you also realize that a lot of drawing through will tend to be confusing and perhaps spoil the charm of the sketch. In such cases, I like to substitute *thinking through* for drawing through.

In my mind, I imagine the building as a group of boxes stacked and clustered in various arrangements. Often I move my pencil in the air as if drawing through. If I'm not too rushed, I might even do a preliminary "study of boxes" to

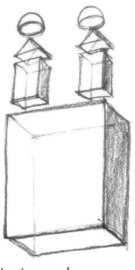

Every geometric structure can be reduced to its basic form. It's good to think in these terms even when you don't actually draw through.

The Spanish Steps, Rome.

Trafalgar Square, London.

really understand what I'm looking at. Most of the time, however, I'll just plunge right in, keeping the cube principle in mind while I work.

You'll notice there is an obvious freehand quality to the sketches on these pages. Although you won't always want to work this loosely, it's a good idea to learn to draw buildings by eye and without the need of a straightedge. In spite of the helter-skelter look you'll sometimes create, this approach helps prepare you for more precise studies.

In structural terms, a group of buildings is no more than a jumble of building blocks. More distant blocks appear flatter than near ones.

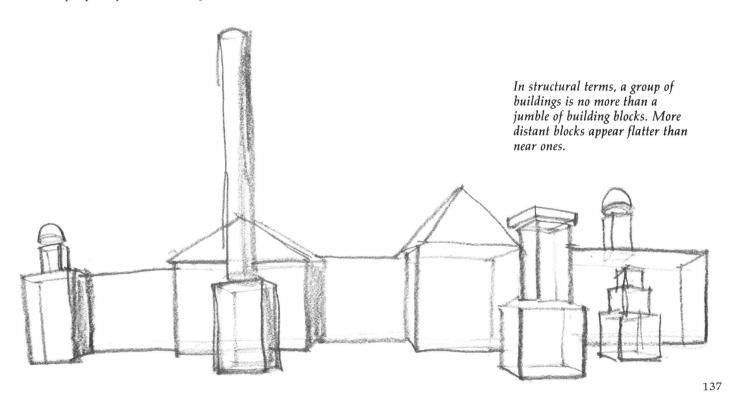

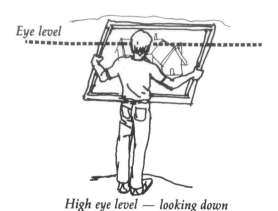

Everything in your picture will be related to your eye level.

Eye level

High eye level — looking down at objects.

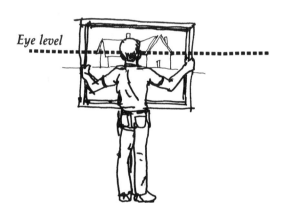

Eye level

Middle eye level — looking across at objects.

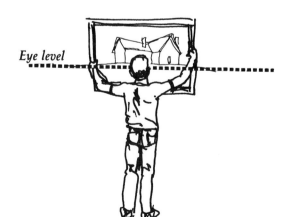

Eye level

Low eye level — when looking up at objects, your eye level is low.

Perspective — a visual approach

Linear perspective is a formalized system for drawing three-dimensional space, particularly where straight, parallel lines are concerned. It's an elaborate system open to a wide spectrum of study. At one end is a strict set of rules involving precise calculations and mechanical drawing instruments. At the other end of the spectrum are a few simple principles which aid observation.

This book takes the latter, more casual, approach to perspective. I want you to be able to go out sketching and successfully tackle a Victorian house or a city street if you choose. Those of you who become intrigued with complex architectural scenes and the science of perspective can obtain books which explain the formulas in detail. For the rest of us, a rudimentary knowledge of the principles of perspective is all we need to use it effectively. A general grasp, coupled with good obervation, is enough for most working artists.

Eye level and vanishing points

Take a moment and look at one of the corners of your room. Look straight out as if you were gazing past the walls and all the way to the horizon. Imagine that, in front of you floating is a horizontal line that cuts right across your corner. This is your eye level or horizon line — the two terms are used interchangeably.

Notice that all the horizontal lines above your eye level, like the window lintels, the top of the door frame, and the ceiling molding, appear to slant downward as they go away from you. All the horizontal lines below the eye level, such as table edges, window sills, and base boards, appear to slant upward. If there happens to be a horizontal line exactly at eye level, it will have no slant. The vertical lines of doorways, window, and walls remain vertical because they maintain, more or less, the same distance from you throughout their length. This is the essence of perspective.

If you're drawing loosely, you might simply measure the angles of the converging lines by eye, reinforcing what you see by occasionally sighting level lines as discussed in Chapter 3. For greater precision, and to fit the whole into a cohesive scheme, you'll sometimes want to rely on the perspective system of vanishing points.

A vanishing point is a spot where parallel lines appear to meet. All parallel horizontal lines going back into space will appear to converge at a point somewhere on the eye level. These points give you an exact method for determining the angle of each and every receding horizontal line.

Sometimes eye level and vanishing points are located on your paper and sometimes they are not. Sometimes you have one and not the other. When the horizon line and both vanishing points are on the paper, you have an easy time of it. If you have an extreme over or under view, however, the horizon line will be above or below your paper, and, more times than not, one or both vanishing points will be off to either side.

If you are drawing at a large table, you can treat its surface as an extension of your paper, establish the horizon line out there and use push pins or dots to mark your vanishing points. Sitting outdoors with a sketchbook in your lap, however, requires that you imagine their locations and estimate the slant of the converging lines. It takes practice to work beyond your paper in this way, but it can be done.

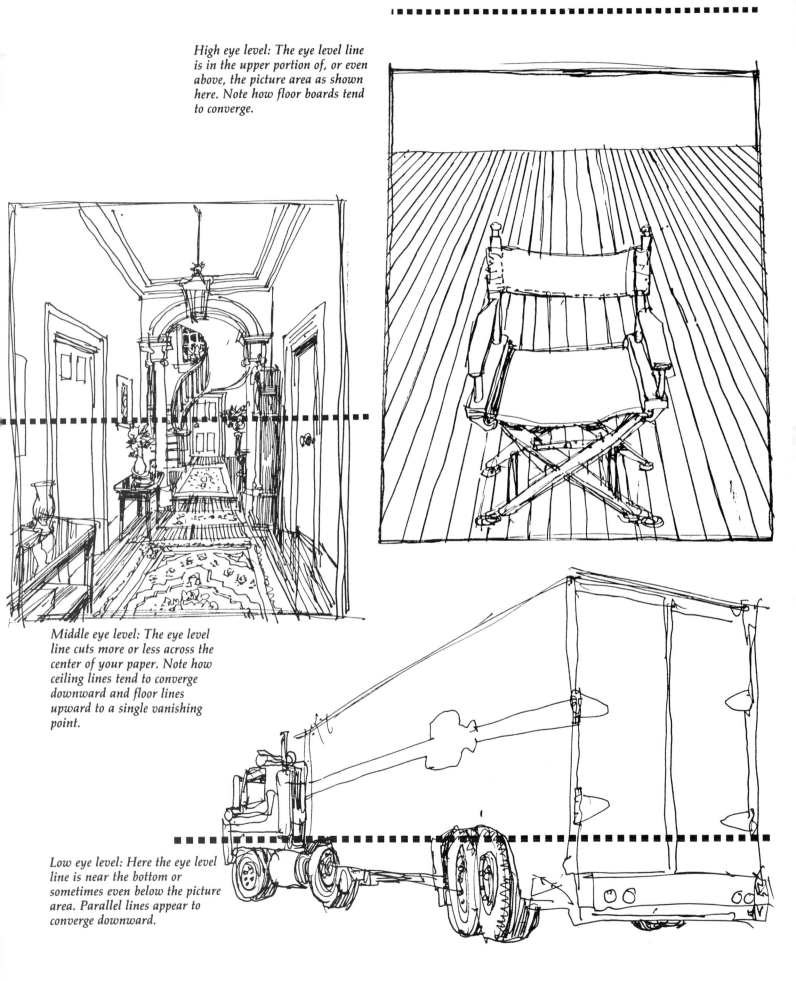

High eye level: The eye level line is in the upper portion of, or even above, the picture area as shown here. Note how floor boards tend to converge.

Middle eye level: The eye level line cuts more or less across the center of your paper. Note how ceiling lines tend to converge downward and floor lines upward to a single vanishing point.

Low eye level: Here the eye level line is near the bottom or sometimes even below the picture area. Parallel lines appear to converge downward.

Project 5 - C — A One-Point Perspective Drawing

Make a drawing looking toward the far end of a long room, church, or hall. Include the sides of the room and all windows, doorways, and furnishings in your scene. Establish your eye level line lightly on your paper. Estimate the vanishing point and indicate it as well. All lines parallel to the side walls will appear to converge at this vanishing point. Draw free by hand, by eye, and restate as necessary. Use pencil or pen. Allow one hour.

Perspective with one vanishing point

We need only one vanishing point when we orient ourselves squarely down a street, hallway, or room or look at the end or side view of a chair, building, or vehicle.

We don't need mathematical formulas for finding the eye level and the vanishing point. We establish these by simply observing. Looking directly down the railroad tracks in the example on this page, we can see clearly how the parallel rails converge at the horizon. When both eye level and vanishing point are contained within the picture area, as they are in this case, drawing is made a lot easier. The lines parallel to the tracks such as the front of the station, the platform, the station roof line, windows, and doorways also run to the same vanishing point. We could lay a straight edge from each of these to the vanishing point and draw them with considerable precision, or we could simply estimate the angles using the vanishing point as a guide. In most sketching situations we would choose the latter.

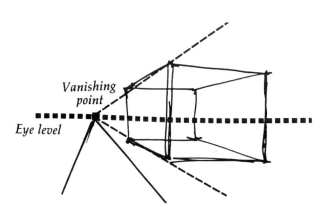

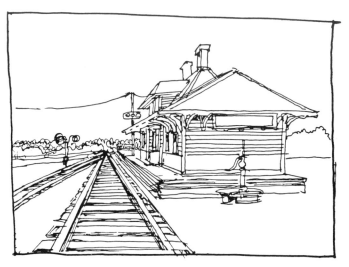

Parallel lines appear to converge at the eye level whether high, low, or middle.

In the one-point perspective view, the railroad ties and this side of the building are so nearly parallel to our eye level that they can be treated as straight horizontal lines. Be aware of the diminishing sizes of the railroad ties. Not only do they get narrower and shorter as they recede, they also get closer together as do the spaces between the doors and windows of the depot.

The vertical lines are all straight and parallel because they maintain their distance from us throughout their length.

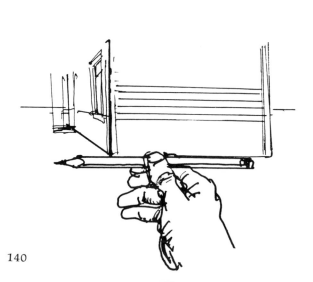

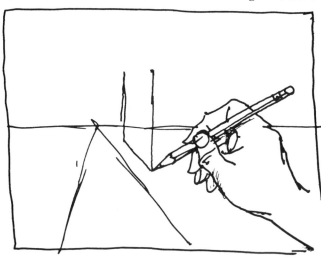

Perspective with two vanishing points

When two vanishing points are involved, as when we face into a corner of a building, room, or other geometric object, we can be pretty sure that at least one vanishing point and sometimes both will be outside the picture area. This adds more guesswork because we have to imagine the vanishing point in space beyond our page. For this reason, we'll want to employ the sighting strategy from Chapter 3.

 To sight angles, simply hold your pencil level in front of you, closing one eye and comparing any angle in your subject with the horizontal of your pencil. When you draw that angle, use the horizontal edges of the paper as a guide. From time to time, you'll want to check the accuracy of your angles by asking yourself, "Do all the parallel lines of each plane seem to be converging toward the same point?" You can judge this with reasonable accuracy even when the point is off your paper.

 In all this discussion of measuring and checking, let's not lose sight of the fact that for the most part we are drawing by eye, using the look-hold-draw process discussed in Chapter 1. Do your measuring after you've already sketched in some of the lines. Loosely capturing the big picture and then modifying it is easier than preplanning each line before you put it down. It's also less mechanical. Measuring by sighting and checking with perspective should be used as a basis for restating and refining.

Project 5 - D — A Two-Point Perspective Drawing

Make a drawing looking toward one corner of a house. Show the entire house, and as you draw imagine it as a large simple cube. Establish your eye level line lightly on the paper. Notice how the roof line and the foundation line of each of the two sides you see appear to be converging toward separate vanishing points on the eye level. Imagine the location of those two points in space on either side of your paper. Sight level lines to estimate the angles. Use pencil or pen and restate as necessary. Allow one hour.

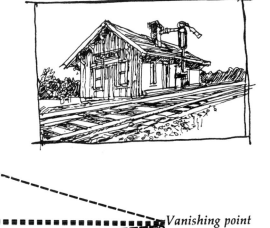

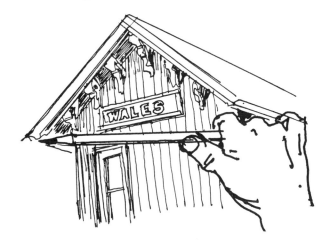

Vanishing point ← *Eye level* → *Vanishing point*

When you view a building from the corner, each side appears to converge at a vanishing point on the eye level.

Simplified perspective diagram.

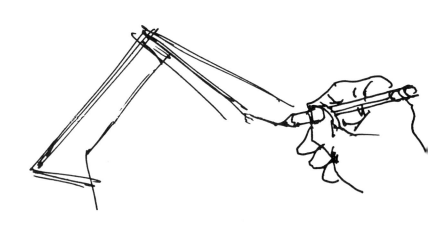

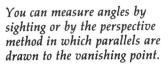

You can measure angles by sighting or by the perspective method in which parallels are drawn to the vanishing point.

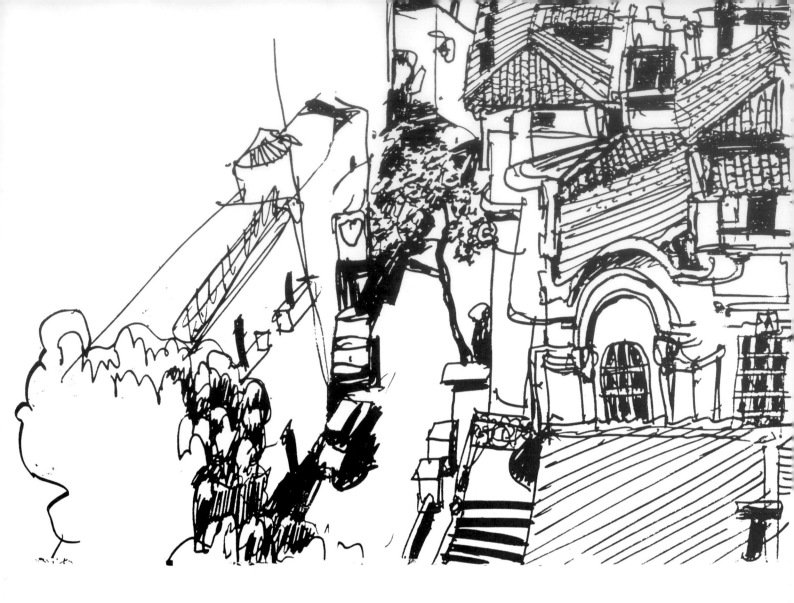

Vanishing points not on the eye level

So far in our discussion we've considered a perspective view of things that are looked at straight on. In such cases only the horizontal lines appear to converge while all the vertical lines remain parallel and vertical. But what happens in the case of tall buildings, for instance, when we must look up or down at objects near us?

Here we confront a new problem. As we look up at a building, the parallel sides recede from us so they too will appear to converge at a point *above* the building. This requires an extra vanishing point since we will still have one or two vanishing points on the horizon. The same situation occurs when we look down at objects and the extra vanishing point is located *below* it.

In a third case, where the planes are pitched at various angles not parallel to the ground, as in the case of a many-faceted roof top, you may have multiple vanishing points not on the eye level. It's rarely important, for our purposes, to determine the exact location of these points. We only need to develop the ability to observe the convergences. Simply by being aware of the vanishing point in space, you can feel its pull as you draw. The vertical lines of the cabinet doors and stove in the sketch at lower right generally tend toward convergence even though they are sketched in.

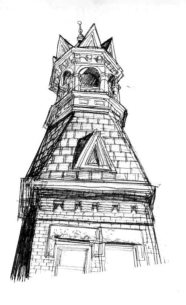

It's hard to draw while looking up at something in this way . . .

. . . but it helps to realize that the tower is a basic rectangle, the sides of which are converging toward a vanishing point somewhere above it.

Project 5 - E — Looking Down on Objects

Make a drawing looking down on objects from a high vantage pont, such as lower buildings seen from a high window or a view from a balcony into a room below. By holding your pencil out vertically, observe how all vertical lines appear to be converging at a point somewhere below. Imagine the location of that point and, even though you're drawing by eye, try to slant your vertical lines so as to converge at that point. Use pencil or pen and restate as necessary. Allow one hour.

Eye level and vanishing points are basic to an understanding of linear perspective. My advice is to reread, study the illustrations, continue your drawing through, and see architectural subjects as boxes. You will soon find yourself making use of these two important tools to confirm what you already see.

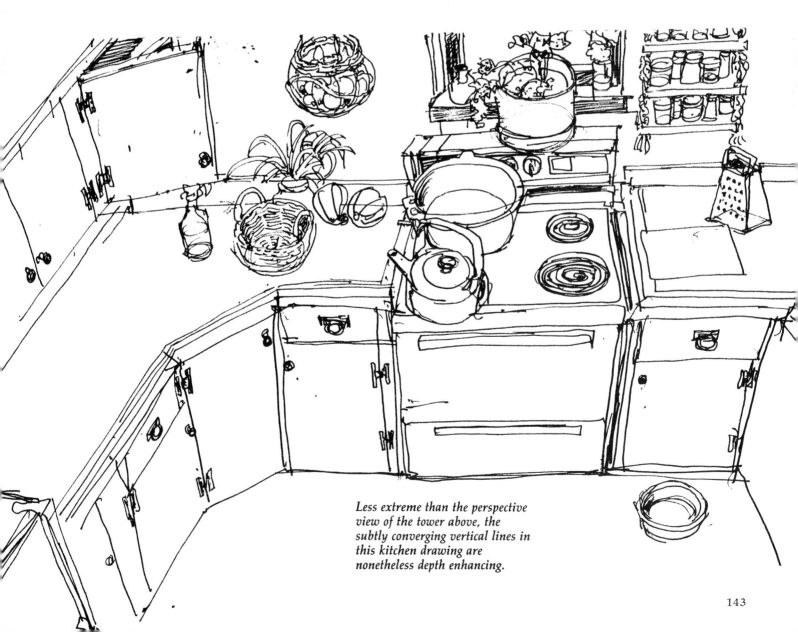

Less extreme than the perspective view of the tower above, the subtly converging vertical lines in this kitchen drawing are nonetheless depth enhancing.

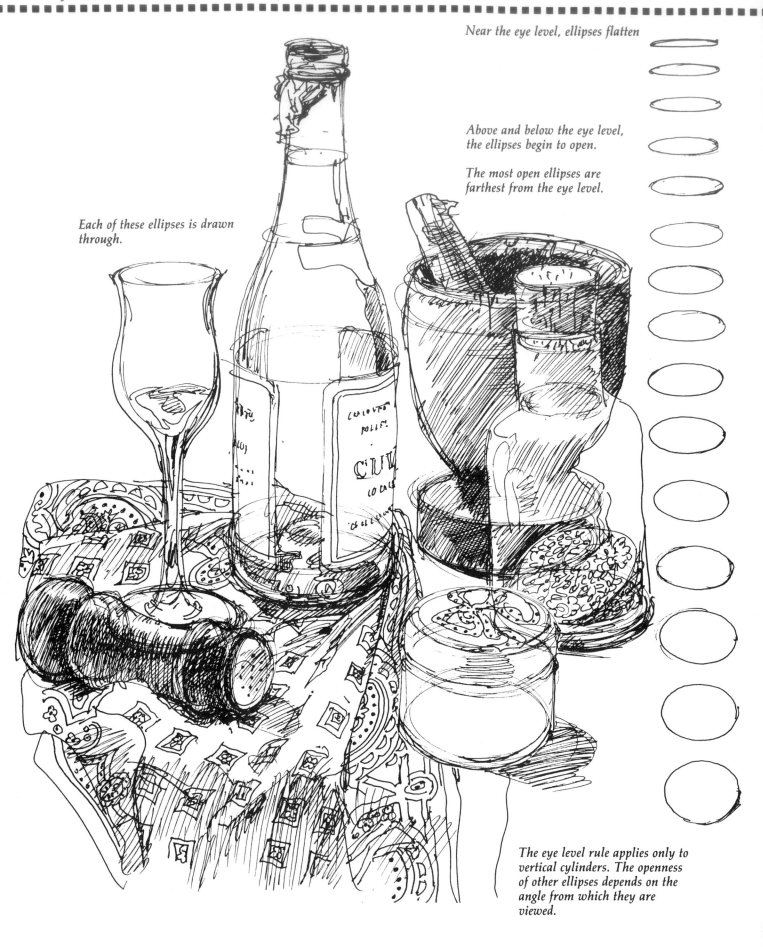

Near the eye level, ellipses flatten

Above and below the eye level, the ellipses begin to open.

The most open ellipses are farthest from the eye level.

Each of these ellipses is drawn through.

The eye level rule applies only to vertical cylinders. The openness of other ellipses depends on the angle from which they are viewed.

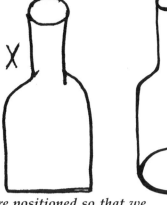

If we are positioned so that we can see down into the top of the bottle, the bottom of the bottle will appear as an ellipse as well.

Ellipses

An ellipse is a circle seen in perspective. Anytime you draw a bottle, glass, dome, pole, coin, wheel, bowl, or other cylindrical, spherical, or half-spherical object, you will be involved with ellipses. The rules for ellipses are relatively simple but frequently violated by beginners.

You may have seen drawings like the one of the bottle at immediate right. The top of the bottle is drawn as if we were looking down on it, while the bottom of the bottle is flat. This is two different eye levels for the same object. It's not so much that this is wrong — the Cubists did this sort of thing regularly — it's just impossible from a single perspective. If we choose the view that shows the top ellipse, it means that our eye level is above the top of the bottle. If we choose the view represented by the bottom of the bottle, it means our eye level is low — in line with the base.

This brings us to Rule #1 for drawing ellipses: establish your eye level. We must know whether to make our ellipse open (more nearly round) or closed (more flat). We determine this by how near to or far from the eye level the ellipse is. This gives us Rule #2: the ellipse closes, or flattens out, as it nears your eye level.

We can see how this works in the drawing on the facing page. The bottle has several sets of ellipses, all parallel—at the top of the bottle, at the top and bottom of the label, and the bottom thickness of the bottle. We place the bottle on the table and, observing Rule #1, establish our eye level as a line just above the top of the label. Rule #2 tells us that the label top will be nearly flat, being so near the eye level. It also tells us that as we get farther from the eye level, the ellipses will gradually open up, the roundest areas being at the two extreme ends of the bottle. (Good observation would tell us exactly the same, but these two little rules are good to keep in mind when your eye is uncertain).

Accurate ellipses

Drawing a good ellipse takes practice. You'll have a lot more success if you keep in mind that it is absolutely symmetrical, and the ends are always rounded, never pointed, as illustrated in the drinking glass examples at right. If you want precision, you can place your ellipse within a rectangle, keeping in mind that an ellipse is always divisible into four equal quadrants. In the end, however, you should learn to draw an ellipse with a loose, free-swinging stroke. Drawing through is helpful in this regard, but basically these are no shortcuts. To make a good ellipse, you will have to draw a lot of them.

Project 5 - F — Ellipses

Make a drawing of a group of bottles, glasses, and cans arranged on a table. Choose at least five items of varying heights and widths, much like the still life on page 144. Draw from an eye level that is slightly above the top of the tallest bottle. Establish your eye level line lightly on your paper. Take special care to draw the ellipses symmetrically and rounded at the ends. Each ellipse will vary in openness according to its distance from your eye level. Draw through all ellipses, even those you don't see on the bottoms of the cans and bottles. Use any medium and allow 45 minutes to an hour.

Ellipse ends are always rounded, never pointed.

KEYS TO CHAPTER 5 —
The Illusion of Depth

- **Use the four depth principles.** Overlap forms, diminish sizes, converge parallel lines and soften edges and contrasts to increase the illusion of three-dimensional space.

- **Draw through** solid objects as if they were transparent in order to gain an understanding of their basic construction.

- **Sight angles.** Use plumb and level alignments as a quick way to measure the angles of objects seen in perspective.

- **Establish eye level and vanishing points.** When drawing architectural or mechanical subjects, first determine the eye level and vanishing points. It helps to estimate them even when they aren't on your paper.

- **Draw ellipses.** When drawing circles in perspective, make them symmetrical, with rounded ends, and related to the eye level.

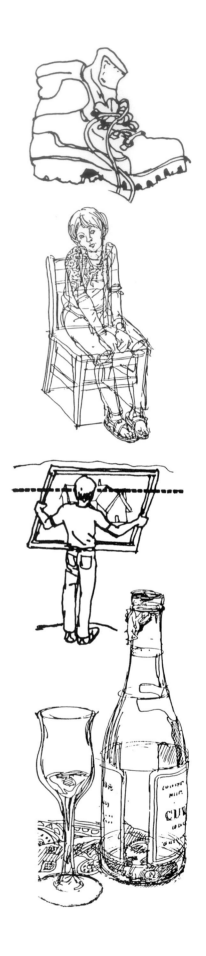

146

SELF-CRITIQUE OF YOUR PROJECTS

Project 5 - A — Intensifying With Depth Principles YES NO

- Do the elements in your drawing appear to move back in space? ___ ___
- Did you overlap at least some of your objects? ___ ___
- Did you soften the most distant objects by rubbing or erasing? ___ ___
- Did you exaggerate the size difference between the nearest and furthest objects? ___ ___

Project 5 - B — Drawing Through YES NO

- When drawing through, did you visualize the forms as if they were made of a transparent material? ___ ___
- Do the chair legs look as if they are resting firmly on the floor plane? ___ ___
- Does the seat plane appear parallel to the floor plane? ___ ___
- Did you draw some of the trapped shapes? ___ ___
- Did you use sighting? ___ ___
- Did you restate? ___ ___

Project 5 - C — A One-Point Perspective Drawing YES NO

- Were you looking squarely at the far end wall? ___ ___
- Did you include the side walls? ___ ___
- Did you establish your eye level line on your paper? ___ ___
- Did you establish your vanishing point and was it on your eye level line? ___ ___
- Do all lines parallel to the side walls appear to be converging at the vanishing point? Use a straight edge to check. ___ ___

Project 5 - D — A Two-Point Perspective Drawing YES NO

- Did you draw through the basic cube form of the house, including the sides you didn't see? ___ ___
- Did you establish your eye level on the paper? ___ ___
- Did you imagine a vanishing point for each set of parallel lines represented by the two visible walls? ___ ___
- Do the parallel lines for each wall, including windows, doorways and roof line, appear to be converging toward one vanishing point? ___ ___
- Did you use level alignments to help estimate the proper angles? ___ ___

Project 5 - E — Looking Down on Objects YES NO

- Did you imagine a vanishing point below, toward which all vertical lines appear to converge? ___ ___
- Do the vertical lines near the outer edges of your paper lean inward more than those near the center? ___ ___
- Did you make use of one or two other vanishing points on your eye level for the converging horizontal lines? ___ ___
- Did you use plumb lines to help estimate the proper angles? ___ ___

Project 5 - F — Ellipses YES NO

- Did you establish your eye level lines on your paper? ___ ___
- Are the ellipses nearest eye level the most flattened? ___ ___
- Are the ellipses farthest from eye level the most open? ___ ___
- Did you draw through all ellipses? ___ ___
- Are your ellipses symmetrical and rounded at the corners? ___ ___

6

THE ILLUSION OF TEXTURE

ARTICULATING AND SUGGESTING • SENSING THE STROKE • REPEATING AND VARYING • CONTRASTING TEXTURES • UNIFYING TEXTURES • SHIFTING STROKES FOR DISTANCE

This chapter is about touch and its role in drawing. As Kimon Nicolaides stated in his book *The Natural Way to Draw*, "Merely to see . . . is not enough. It is necessary to have a fresh, vivid, physical contact with the object you draw through as many of the senses as possible — and especially through the sense of touch."

I love the phrase "fresh and vivid contact." It suggests using the eyes as a tactile organ. This may sound like a technique you must learn or something you have to force yourself to do. Actually, though, it is an act of relaxing. Touch is an intuitive sense, closely allied with feeling. To some degree it is a sense you've been relying on all along, but now you're going to give it a more active role.

You've probably noticed that most of the keys in this book are of the "way into" type rather than of the "how to" type. The keys in this chapter are especially so. Texture will not be presented as a set of rendering formulas but as a sense-oriented subject with broad inspirational possibilities. We offer several key strategies for bringing your own tactile senses into play, and we give you a close look at some specific textural effects. Accompanying most of the examples are actual-size details and notations of the materials used.

Texture is frequently thought of as something filled in or added onto an otherwise completed drawing. Actually it plays a much larger role. As discussed here, texture will reconnect us with such familiar concepts as illusion, pattern, handwriting, and the inventive use of tools and procedures.

Articulation and suggestion

To articulate something is to draw it carefully; to suggest something is to summarize it. Articulation is slow, deliberate, and specific while suggestion is quick, spontaneous, and general. Successful rendering of texture usually requires a combination of articulation and suggestion. The two work together to deliver a stimulating tactile experience to the viewer. Just when they are nearly persuaded by skillful articulation that they are seeing the real thing, scribbles and smudges intrude to remind them that it's all an illusion. Somewhere in every good drawing is a reminder that "this is a drawing."

Susan Dowley, *A Closer Look*. Penc

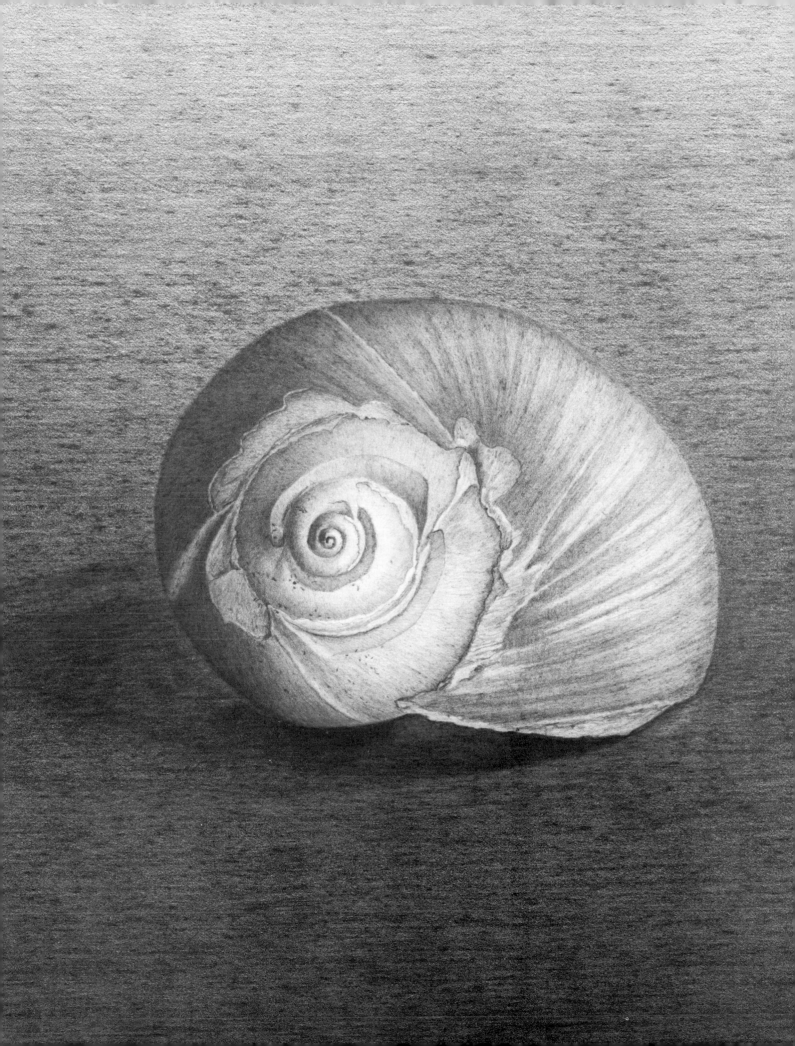

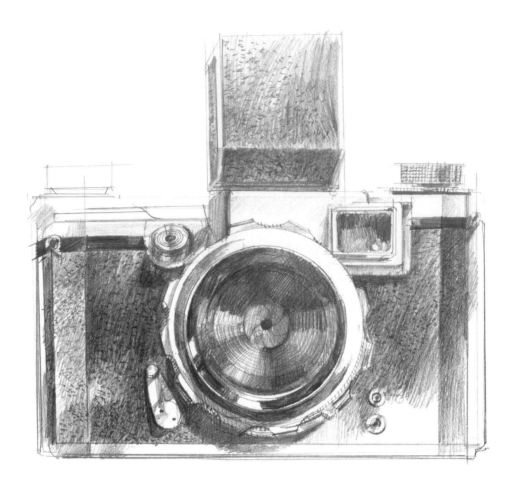

Tight scribbles built-up in layers, dashes added. (Pencil)

From the beginning we've encouraged careful articulation in your drawing, but when it comes to texture, that could mean trying to draw a chicken by delineating each and every feather. Even if an artist had the patience required, such meticulously detailed drawings sacrifice spontaneity. Bringing in a little suggestion helps cut the richness of too much detail and provides relief from exhaustion on the part of artist and viewer alike.

Suggestion manages to convey texture beyond the area of careful articulation with simple, repetitive strokes. These strokes are intuitive and stylized as compared to articulated ones, and yet are a product of careful observation. We might say that they are a little more experimental.

Sensing the stroke

Suggesting a texture is largely a matter of responding to feelings. I find a good strategy is to work my way into it. By articulating a bit first, you might find some visual clues that will lead you into an effective suggested stroke. If that doesn't work, just begin moving your hand in a kind of scribble and see where that takes you. After a few strokes, you'll undoubtedly start modifying your scribble to better reflect the surface you are drawing. Keep your eyes moving from subject to paper and back again. Your scribble might evolve into short, choppy strokes or nervous, wavy lines or small, stipple dots. Depending on the tool you are using, you might begin spattering, rubbing, erasing, or scratching out. Because you are generally working within a shape, I call this method *shape and scribble.*

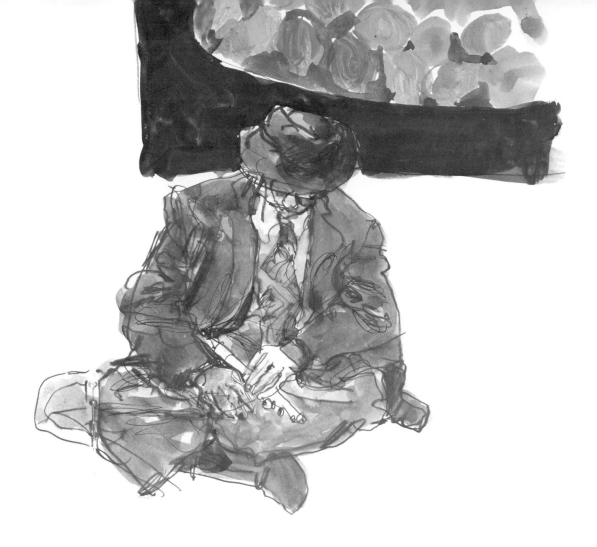

In drawing the camera, I wanted to express its precise, manufactured qualities. I used a straightedge to draw most of the shapes. With a back-and-forth scribble, I began to sense the texture of the camera body. I could see that in order to get the blackness necessary I'd have to build up the tone in layers, overlaying three or four for the darkest shadow areas. To get the pitted look, I began to pepper the surface with the pencil point. To maintain uniform stipple, it was necessary to keep a sharp point so I kept several sharpened pencils on hand. The contrasting textures of the glass viewfinder and chrome trim were approached in the same exploratory manner as the body. The areas left untouched, besides serving as a reminder of the medium, allow viewers to fill in some information themselves. To succeed at this, however, you must make sure that the parts you articulate are juicy and descriptive.

The above drawing was a quick sketch made in a Paris subway station. Here I was interested in the baggy, dishevelled and slightly tragic qualities of the subject — a sleeping flute player. I allowed my felt-tip marker to meander in and out of the folds of the clothing in a careless, almost random manner. After bringing the drawing home, I felt the scribbles were a little overdone and confusing so I floated a grey watercolor wash over the figure, restoring its shape. In effect, I worked here from scribble to shape. The water-soluble marker bled a little into the wash, softening the line.

Loose, scribbly line covered with a flat wash. (Felt-tip marker with watercolor)

Textural inspiration

Once, while traveling on a train, I became interested in the profile of another passenger. The more I observed, the more I realized that what interested me was the pattern of wrinkles around her eyes, mouth, and chin. At the time, I had only a broad-nibbed pen with which to draw — not what I would have chosen for the job. But I was curious to see how it would look so I made the drawing at right. I blame both my pen and the rocking of the train for the coarse, somewhat unrealistic result. Still, I like the textural effect of those wrinkles.

Repetition with variation

If I could offer only one suggestion for drawing surfaces, it would be this: repeat, but vary. Every surface has some kind of texture or pattern which — as we've already seen — can be suggested by any of a number of ways, including strokes, shapes, tones, lines or other marks. The point of varying the stroke is not only that the actual surface probably is varied (however hard you have to look to see it) but is also to make the drawing interesting. When I don't actually see variation in a surface, I invent it.

Repetition with variation is a design principle in both art and in nature. You find it in the cadence of stirring speeches: "We shall fight them on the beaches, we shall fight them on the land . . . " You find it in nursery rhymes: "Pease porridge hot, pease porridge cold . . . " It is in the swirling stroke of van Gogh's cypress trees and in the recurring four notes of Beethoven's Fifth Symphony. In nature, it is proclaimed in every pattern and every texture. It *is* nature. And for us, it is a source of aesthetic pleasure. Being an order-loving animal, we are soothed by repetition, but being also of a restless nature, we like some variation, too.

Tiny stipple dots mixed with small shapes and tonal strokes. (Ballpoint pen)

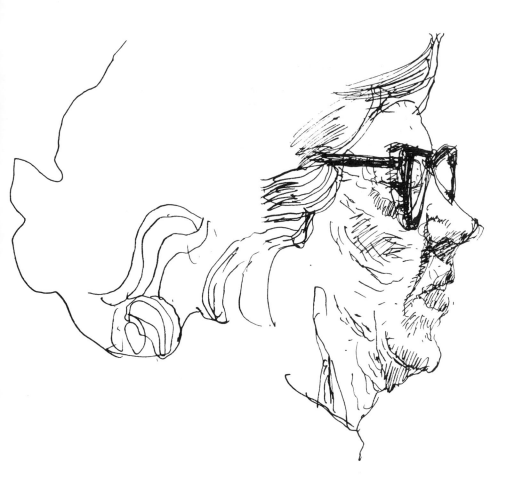

Irregular lines with straight tonal strokes. (Broad-nibbed pen)

Parallel diagonals with scalloped horizontals. (Broad-nibbed pen)

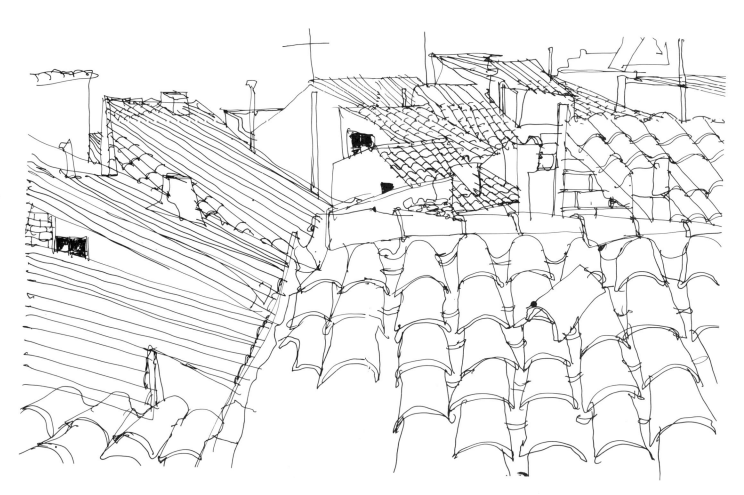

I like to draw odd and elusive textures from nature (smoke or water) or from technology (pushpins or spacemen). Because neither I nor my audience has any deep prejudices about what these things should look like, I feel free to be experimental with them. To repeat but also to vary in such cases usually provides arresting results.

In drawing sand, I used my ball-point pen to pepper the surface with little specks. Thus provided with repetition, I then proceeded to vary it with irregular ridges and little clustered clods.

The rooftops of Spain are surfaces composed of little quasi-geometric shapes. As they receded into the distance, my textural stroke shifted from shape-by-shape articulation to a combination of straight, diagonal, and wavy horizontal line suggestion. At the furthest distance I dropped the horizontals altogether. In this drawing, the repetition was provided by the uniformity of the tiles themselves and the variation by the different angles of the rooftops and the changing textural strokes.

The elephant is an animal made for texture drawing, from the long, hanging folds of the ear, over the relatively smooth surface of the crown, to the explosion of creases in the flexible trunk. Notice here the effect of shadow on texture. Since texture is in large measure revealed by light, it stands to reason that we will see less of it in the shadows.

The two drawings on the right-hand page are some explorations I did on the subjects of texture and technology. The upper picture is the open back of a transistor radio. It looks complex, but it is really just a mixture of various sized rectangles and circles against a background scribble. The ear and the astronaut were cut out from other drawings and

Irregular strokes with varied pressure. Shadow areas smudged with wet finger. (Water soluble felt-tip marker on rough paper)

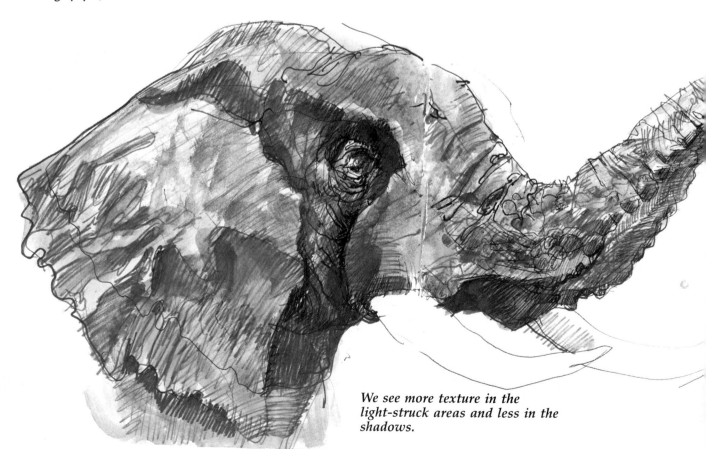

We see more texture in the light-struck areas and less in the shadows.

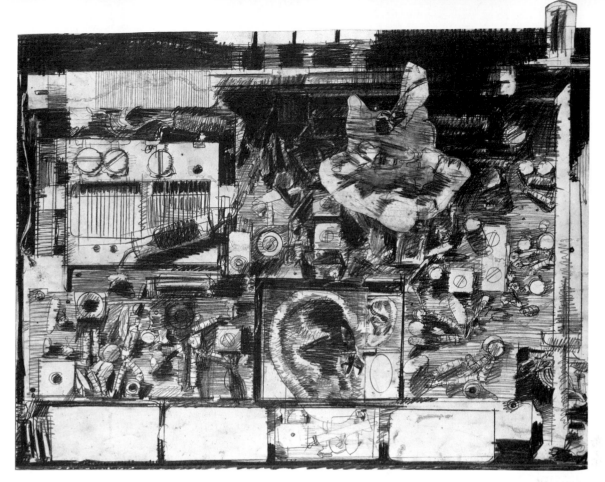

pasted on. The little sketch at the bottom was copied from a photograph of an air-launched missile. The entire drawing is simply a series of shape-and-scribble blobs repeated in a variety of ways.

I like to work from photographs which have an abstract quality and then push that quality even further. This one reminded me of an increasing trend toward abstraction and distance in warfare.

Rectangles and circles with heavy black scribble. (Pencil)

Irregular blobs with loose scribble line. (Pencil on coated paper)

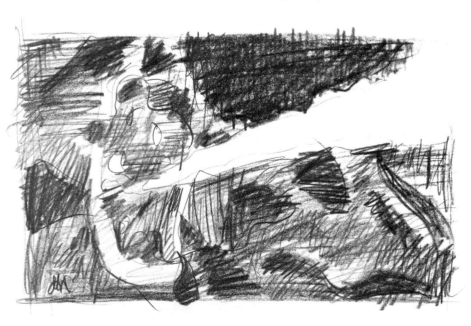

Pigeon: Soft transition between tones, wet-in-wet blending. (Watercolor)

Rooster: Vigorous dab, streak, and spatter brush techniques. Paper damp rather than wet. (Watercolor)

Contrasting textures

One of the ways we appreciate texture is in opposition to another and different texture. Every serious draughtsman recognizes that a drawing is not a group of isolated parts, it is really a set of relationships. Each and every textural area in a drawing relates to the other textural areas around it. They play off each other, and it's actually possible to heighten the sensation of one by working on its neighbor.

Susan Dowley's drawing, *A Closer Look*, which opens the chapter illustrates this idea. The smoothness of the shell owes as much to the rough background as to the exquisite rendering, and the grey of it becomes positively pearly against its dark surroundings.

It still amazes me how masters like Degas and Courbet were able to create the smoothest and softest of portraits using heavy black chalk and rough-toothed paper. Close examination of one of these delicate faces reveals it to be coarse and granular. Judged through a viewfinder, it could be mistaken for used sandpaper or a stucco wall, but in context, surrounded by darker and more textured hair, the pebble skin becomes petal soft.

When you understand drawing as a set of relationships, you grasp the key that things look large or small, coarse or smooth in relation to something else in the picture. Beginning students frequently give up on their work before these

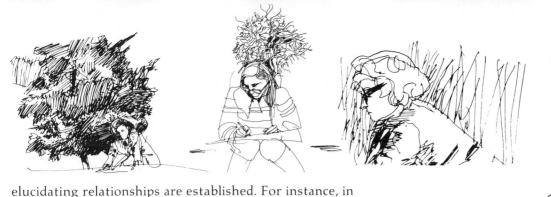

elucidating relationships are established. For instance, in drawing something that is supposed to be light on white paper, do not neglect to include something dark alongside it for comparison. If you don't, you may perceive a problem in your area of interest without realizing that the solution lies in the surrounding area.

If you're new to this idea of relationships, I recommend paying attention to the textural qualities in work you admire. Take a piece of white paper and tear out a coin-size hole through which to isolate the particular textural effect. When you've analyzed it, move it over the surrounding areas and analyze these, too. You'll see how the different illusions were achieved, but you'll be especially struck by how the textures depend upon each other for their effect.

Another exercise which will bring the idea of texture contrasts alive is to make drawings in which you pair opposing textures. I've diagrammed a few possibilities below, and you could think of others. The idea is to deliberately play textures against each other and to use one to support another.

Pod: Thick line with rough-textured tone. (Felt-tip marker, compressed charcoal on heavy newsprint)

Seed: Light linear stroke. (Felt-tip marker)

Project 6 - A — Contrasting Textures

Make a drawing which contrasts two decidedly different textures. Choose one of the suggestions here or use an idea of your own. In either case, draw the subject from observation, not from imagination or memory. Work large — preferrably 18x24 inches — and move in on the objects to capture textural details.

To experience the textures tactilely, stop from time to time to actually feel them. Use triggering words and don't hesitate to intensify. If you have a magnifying glass, study your subject with it now and then. Use any medium. Allow one hour and twenty minutes.

Meandering, connected line with circular shapes. (Felt-tip marker)

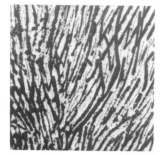

Straight, grassy strokes, built up in clusters. (Etching)

Unifying with texture

The concept of unifying with texture takes us on an opposite tack from that of the previous two pages. We are still exploring relationships, but instead of looking for contrast, we're looking for similarity. Actually, we're not only looking for similarity, we're forcing it. This might mean sacrificing a realistic illusion, but we do this knowingly. If the venerable, weathered face we're drawing is reminiscent of the barn siding in the background, we render them both in such a way as to bring the two textures together. The effect is often arresting, sometimes amusing, and frequently both. In some cases, we may go so far as to treat all of the elements of our drawing as if they were made of the same stuff. This is a highly stylized treatment, but within it there is room for subtle expression. Note the evocative Harold Altman drawing below.

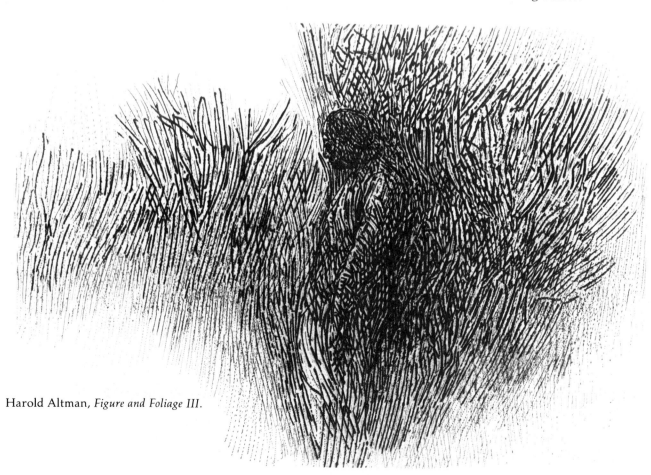

Harold Altman, *Figure and Foliage III*.

158

The picture of the sea shell and fishing boats was really a random exploratory sketchbook page. I began it by drawing the shell, executing it in a light, loose scribble. Later, when I decided to draw the boats and fishermen, I simply continued with the stroke. These were really two separate drawings, but the stroke brought them together.

Textural strokes can become a bridge for establishing connections, or it can make stronger the connections we already sense. In the little sketchbook drawing of the matador and crowd, I was struck by the visual unity between the two. It suggested the inevitable connection between the spectacle and the spectators. I drew this fifteen years ago, long before I realized the lost connection between men and animals that bullfighting represents.

Project 6 - B — Unifying With Texture

Make a drawing, similar to those shown on these pages, which uses a single textural stroke to unify all elements of the picture. The personality of your stroke might be derived from something in your picture, like grass or foliage or water. The textural stroke should pervade all areas of your drawing, but this doesn't mean it should be mechanical or routine. If you can find ways of making little variations in it, so much the better. Draw your scene outdoors, preferably something with buildings and figures. Use any medium. Allow thirty minutes to one hour.

While there are no formulas for drawing textures, in the next few pages some general points are offered to aid your observation. These hints are mostly variations on the shape-and-scribble approach discussed earlier. Also included are some notes on articulation. None of this information is intended to substitute for careful observation which is always the basis for good drawing.

Back-and-forth scribble applied in various directions. (Felt-tip marker)

Strands are subordinate to the shapes that contain them.

Wavy, rope-like groupings.

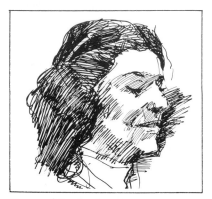

Grouped in simple masses.

Tight curls blend into tonal scribble.

Project 6 - C — Hair

Draw a head from a back three-quarter view, with special emphasis on the hair texture. Take time to actually touch the hair before and at several times during the drawing. Look for the way the hair gathers in clusters and be aware of the overall hair shape. Make many of your textural strokes in the same direction as the hair grows. Note the l/s pattern and show some indication of that as well. Use any medium or combination of mediums. Use appropriate triggering words such as "wavy," "kinky," "shiny," or "wispy." Allow 30 minutes.

Hair — clusters of fine lines

The common error in drawing hair is to start right in drawing the strands. The results are usually textural enough but often formless. For a better hair effect you'll need to employ a more perceptive shape analysis.

The first thing you should notice about hair is its overall shape. For quick sketches, simply drawing that shape and filling it in with a scribble stroke is enough. For a more considered drawing, you'll need to see how the hair is subdivided into smaller shapes either by its styling or by the play of light or both. In its physical arrangement there may be no more than two or three shapes. When there are more, it may be useful to see the hair as a collection of ropes, and clusters of strands. Short curls can be executed in clusters of C-shaped strokes, tapered at the ends. The enrichment shapes provided by light and shadow can be numerous. Sometimes too numerous. Squinting will make them easier to manage.

Finally, a few well-placed wisps and strands will complete the illusion. These will play off nicely against the more tonal scribble. When executing individual strands, make them in the direction that the hair grows and keep your point sharp. Use a light, sensitive touch, and "lift off" at the end of each stroke.

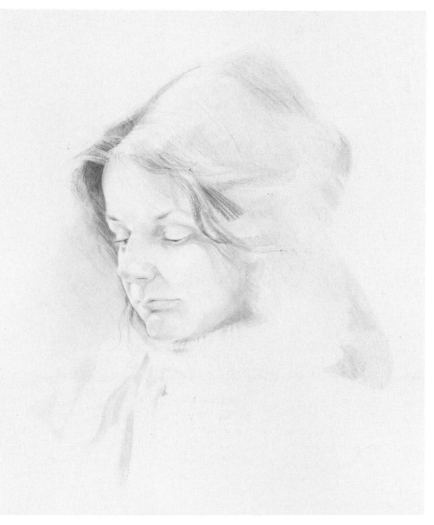

Soft, tonal stroke with finely articulated wisps. (Pencil)

George Dugan, *Portrait of Nina*

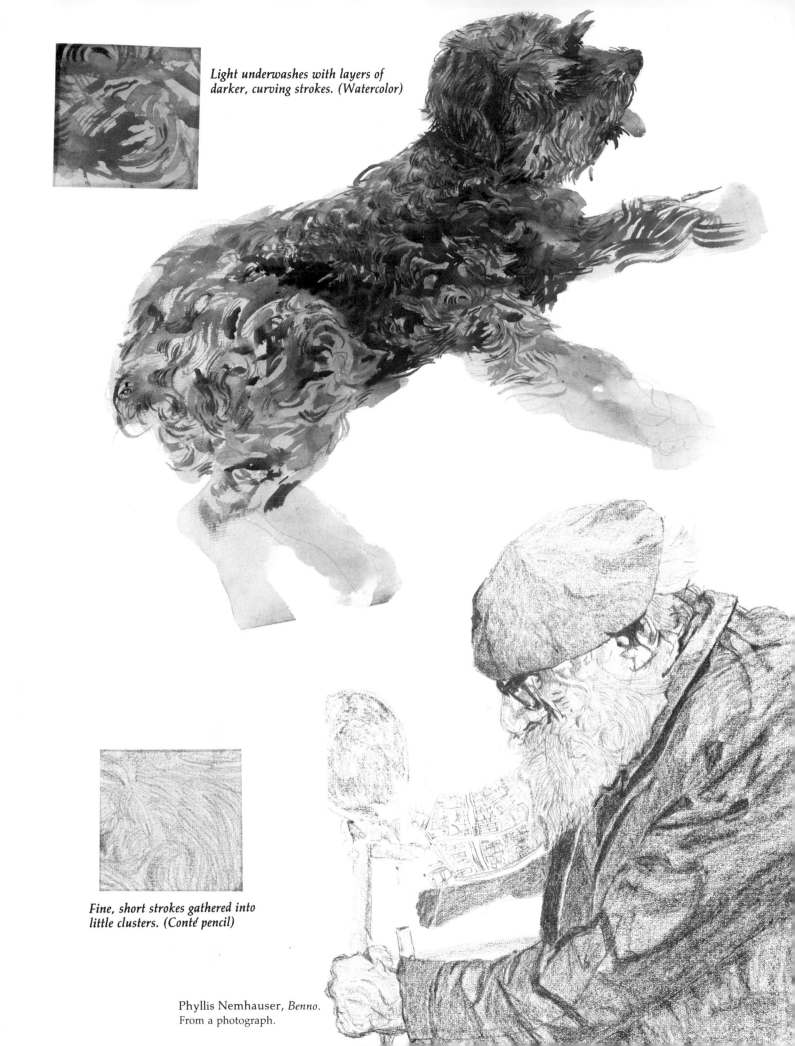

Light underwashes with layers of darker, curving strokes. (Watercolor)

Fine, short strokes gathered into little clusters. (Conté pencil)

Phyllis Nemhauser, *Benno*.
From a photograph.

The foliage stroke is largely dependent on the plant type.

Simple masses with occasionally articulated shapes. (Watercolor with pencil)

Project 6 - D — Foliage

Draw a tree or bush with special emphasis on the foliage masses. Articulate and suggest to capture the character of the foliage. Use appropriate triggering words such as "lacey," "jagged," or "roundish." Use the texture of the tree bark and the linear patterns of the branches to provide interesting contrasts here and there. Show some indication of the l/s pattern as well. Use any medium or combination of mediums. Allow 45 minutes to one hour.

Foliage — masses of scribble, patterns of intricacy

If you do any landscape drawing, you'll be continually confronted with the challenge of rendering leaves. Once again, you'll do well to see them as a problem in shape organization. Look for the main masses first and pay particular attention to the light and dark groupings. It's a good idea to map these areas out. A very simple back-and-forth tonal stroke is often useful in getting the masses established before proceeding to a stroke that reflects the leafy texture.

Repetition with variation should be your guide in handling the complex leafy surface. Your stroke should of course suggest the character of the particular type of foliage you are observing, and that will be much influenced by how close you are. To enhance the illusion, you'll want to articulate some of the leaves here and there as well as some of the branches. In drawing branches, try to move your pencil in the same direction as the branch grows. Trapped shapes of sky-light popping through the leaves will contrast well with the leafy scribble strokes.

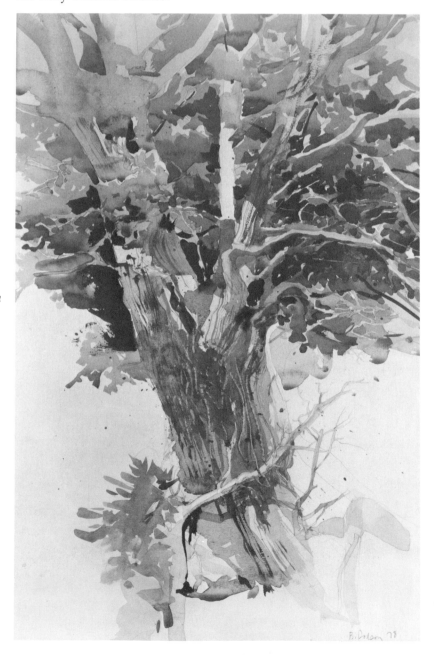

Jagged, overlapping scribbles combined with irregular parallels. (Felt-tip marker)

Intricate, scratchy lines built up in soft masses. (Etching)

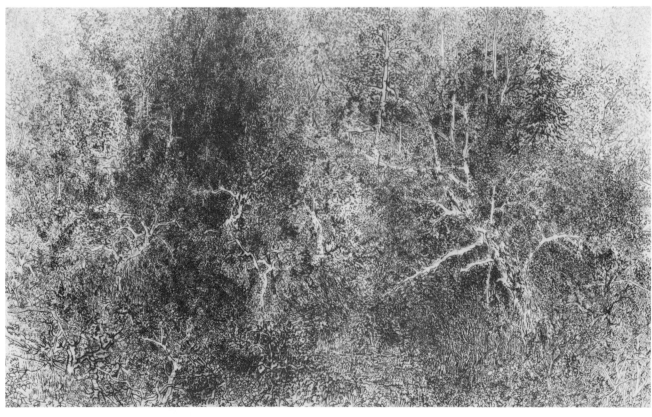

Gabor Peterdi, *The Big Norfolk.*

Project 6 - E — Drapery

Place or hang a cloth so as to create an irregular pattern of folds, perhaps draped over a chair back or dropped casually over the chair seat. Make a drawing of it in any medium or combination of mediums. Map the shapes carefully and, when modelling the tones, be especially sensitive to hard and soft edges. Focus your surface textural strokes in few areas. Use any medium. Allow 45 minutes to an hour.

Crisp, angular shapes with sharp lines. (Graphite and colored pencils)

Drapery — hard and soft edges

In representing drapery, we have the chance to really see how form and texture interact. The whole idea of what is form and what is texture is somewhat arbitrary in the first place. Already in this chapter we have presented as texture such diverse surfaces as rooftops, a crowd of people, an air-launched missile, and a street musician's baggy suit. Such groupings should make us realize that art, like life, is a seamless web, one category tying into another. We only separate things in order to talk about them.

With drapery we are simultaneously drawing the folds and the surface characteristics of the fabric. First, let's consider the folds. Folds are really shapes, but their soft edges can be misleading. We need to reassert that they are shapes by mapping them out. Once you've done this, you can fill in with

tonal strokes, being sensitive to the degree of darkness within each shape and the softness of most of the edges. The edges especially are critical. Whether they are soft, sharp, or amorphous, how well you relate these edges to each other will be a major determinant in how successfully you convey the feeling of drapery. Don't neglect the use of rubbing and erasing techniques shown in Chapter 2. They are liberally applied in these examples.

Capturing sheen, nap, or weave is important but less so than capturing realistic folds. If you squint, you will see that the pattern of folds dominates any characteristics of the fabric itself. This doesn't mean those characteristics are added later. I like to work fold and fabric together, shifting from tonal stroke to textural stroke and back again.

Joan Waltermire, *Leather Jacket*.

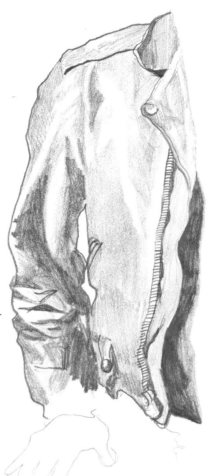

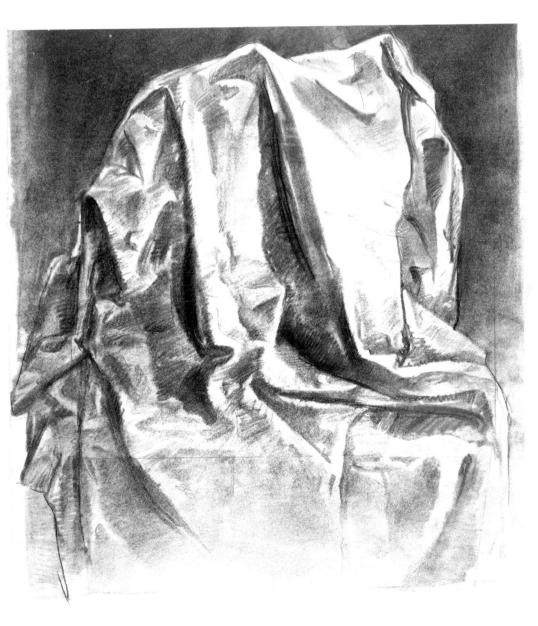

Middle and dark shapes, modified by erasing. (Pencil with kneaded eraser)

Rounded, irregular shapes softened with fingers and paper stump. (Vine charcoal)

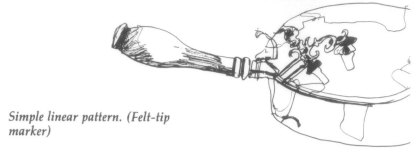

Simple linear pattern. (Felt-tip marker)

Project 6 - F — Reflective Surface

Make a drawing of a polished, reflective object, such as a chrome bumper, a teapot, or a brass musical instrument. Look for and record the complex, irregular shapes reflected in the surface, as well as the hard and soft edges. Capture also the high contrasts and bring out the highlights by surrounding them with dark and middle tones. Use any medium or combination of mediums. Allow 45 minutes to one hour.

Reflective surfaces — blobby shapes and high contrasts

Reflective surfaces are my favorite texture because they are so striking, so alive, and so unpredictable. When we spoke of enrichment shapes in Chapter 1, we could have chosen reflective surfaces as our paradigm example because the shapes involved are so numerous and varied. Sometimes those enrichment shapes are little scenes in themselves, as in the case of the serving dish above or in the astronaut's face-shield below. More often, they are simply irregular, dark- and middle-tone blobs that abruptly change into brilliant white highlights. It is the sudden change from dark to light that is most characteristic of this surface.

The first step in recreating this texture is usually a careful mapping of the dark, middle, and light shapes. Take special care to note the white highlights. In the spirit of John Ruskin's advice, "Look at the white interstices . . . with as much scrupulousness as if they were little estates which you had to survey, and draw maps of, for some important lawsuit, involving heavy penalties if you cut the least bit of a corner off

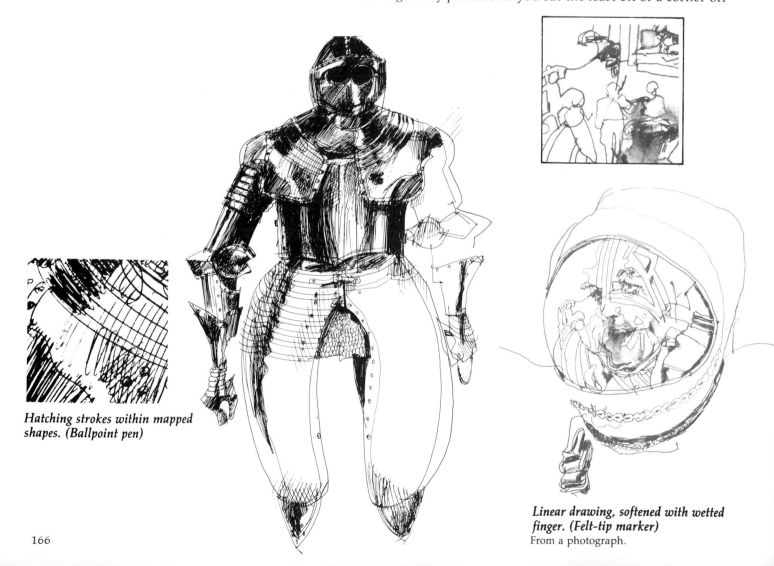

Hatching strokes within mapped shapes. (Ballpoint pen)

Linear drawing, softened with wetted finger. (Felt-tip marker)
From a photograph.

Light-and-dark scribbles within busy shapes. (Ballpoint pen)

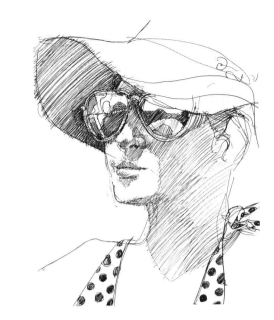

any of them." You may pick them out at the end with your pointed, kneaded eraser. Remember, too, that a highlight will look as bright and shiny as the area surrounding it is dark.

Watch closely the combination of hard and soft edges. In some places, you'll find a sharp, clean division between light and dark, while in others the edge is soft. If you're using pencil or charcoal, rubbing with a paper stump is a good technique for the soft edges. Be alert to the bend and distortion of reflection as it conforms to the surface it's lying on. On something cylindrical, the shapes will tend to stretch out longitudinally, creating a straight and mechanical look as in Michael Mitchell's elegant piece below. On a rounded object, they follow the curvature. In water, the reflections are unpredictable, governed as they are by the action of waves and ripples.

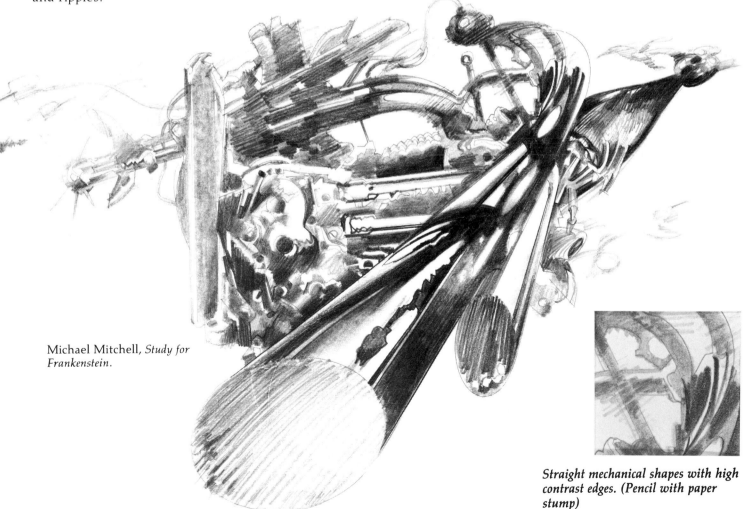

Michael Mitchell, *Study for Frankenstein.*

Straight mechanical shapes with high contrast edges. (Pencil with paper stump)

Texture stroke changes at different distances.

Foreground.

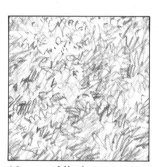

Near-middle distance.

Far-middle distance.

Distant background.

Texture at a distance

You have no doubt noticed that the further you move away from something, the less you see of its texture. This is one of the depth principles listed in Chapter 5. As we move away from the possibility of tactile contact with single objects, we readjust our textural sense to groups of objects. The tactile quality of a building's concrete surface will gradually disappear, the farther we move from it, until the pattern of the windows might appear textural. At an even farther distance, the entire city skyline might evoke a tactile response.

The shift from single to group awareness demands a shift in the stroke used to draw it. Instead of making the same marks smaller and smaller, we must change to an altogether new stroke. You can see several such changes in the landscape drawing at left.

Below is a striking example of the powerful effect of a suggested textural stroke. The painter, Kung Hsien, was one of a group of artists in seventeenth century China with a revolutionary new style. The traditional painters had been super-articulaters. Even distant rocks, mountains, and trees were executed in an elaborate and careful manner. Kung Hsien's brush strokes show no such diligence. The bold, circular brush-work treats the entire land mass as a single simplified texture, one that could in another context represent human hair or a woolen coat.

Kung Hsien, *Mountains and Mist-filled Valley.* 1671.
Ink and light color on paper. The Nelson - Atkins Museum of Art, Kansas City, Missouri (Nelson Fund).

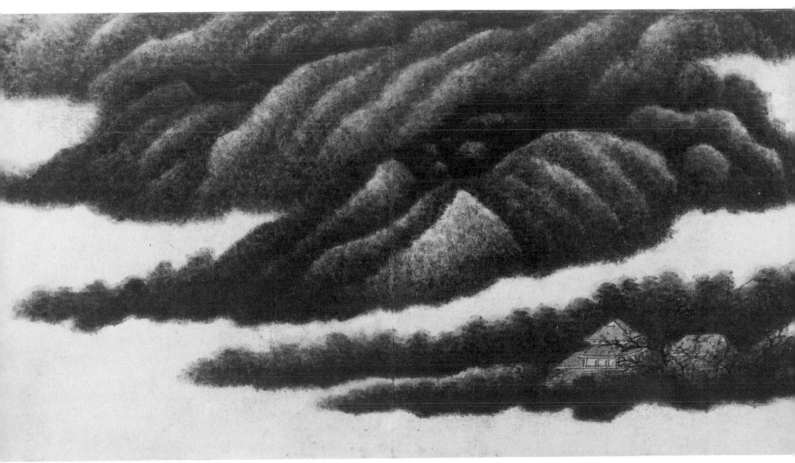

KEYS TO CHAPTER 6
The Illusion of Texture

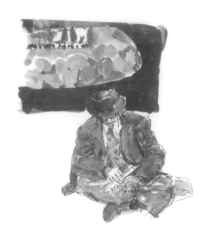

- **Articulate and suggest.** Combine careful rendering of the surface with a stylized textural stroke.

- **Sense the stroke.** Use your tactile sense to "feel out" the surface with your drawing tool.

- **Repeat and vary.** Strive to capture both the recurring patterns and subtle variations that occur in every texture.

- **Contrast textures.** Heighten the sensation of one texture by developing the one next to it.

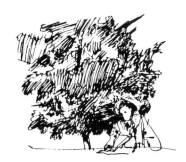

- **Unify with texture.** Use a single textural stroke to strengthen the relationships between picture elements.

- **Shift strokes for distance.** As objects get farther away, change your stroke to reflect the objects' changing visual characteristics.

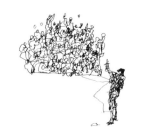

SELF-CRITIQUE OF YOUR PROJECTS

Project 6 - A — Contrasting Textures YES NO

- Did you achieve a strong contrast between the two textures?
- Did you actually touch the surfaces of your objects?
- Did you mix articulation and suggestion in your textural strokes?
- Did you use triggering words?
- Did you intensify?

Project 6 - B — Unifying With Texture YES NO

- Did you use the same basic textural stroke throughout your drawing?
- Did you vary it slightly?
- Does the textural stroke seem to unify your drawing?
- Was your stroke derived from something in your scene?
- Did the stroke feel automatic at a certain point?

Project 6 - C — Hair YES NO

- Did you draw the hair mass more or less as an overall shape?
- Have you mapped the hair mass into its main clusters?
- Have you indicated, however slightly, the l/s pattern?
- Did you use triggering words?
- Did you generally make your textural strokes in the same direction as the hair grows?
- Did you keep your drawing tool very sharp?

Project 6 - D — Foliage YES NO

- Did you draw the main foliage masses as overall shapes?
- Did you articulate and suggest your textural strokes?
- Did you contrast the foliage with the bark texture and the branches?
- Did you use triggering words?

Project 6 - E — Drapery YES NO

- Did you map out the light and shadow shapes?
- Does your drawing contain both hard and soft edges?
- Did you build the tones patiently?
- Did you focus your surface textural strokes in only a few areas?

Project 6 - F — Reflective Surface YES NO

- Did you map out the reflective shapes?
- Does your drawing contain both hard and soft edges?
- Did you intensify some of the contrasts?
- Did you bring out some of the highlights by surrounding them with darker tones?

7
PATTERN AND DESIGN

DESIGNING WITH SHAPE • SENSING PATTERN • FRAMING • CROPPING • STRADDLING OPPOSITES • IDENTIFYING TANGENTS

The difference between sketching and designing is that the former is concerned with *things* while the latter is concerned with the *relationships* between things. Design — or composition, a synonym — goes beyond drawing objects to drawing the whole pattern and considering the entire piece of paper. We all have a sense of what it means to compose in this way, but no one knows exactly. And no one needs to. What we hope to develop in this chapter is a pattern-sensing mode which will help you bring disparate parts together in a formal composition.

Imagine you're part of a play in rehearsal, and you've just been shifted from actor to director. Now you're responsible for more than lines; you're in charge of the whole production. You'll need to step off the stage and come out into the house seats. From here you'll be moving actors, props, and background. You may know exactly what effects you want or you may take an "I'll know-it-when-I-see-it" attitude. Stepping back, taking a whole view, having a plan but being willing to experiment are the essential conditions for compositional drawing.

It is a discipline without rules. The many attempts to formularize compositional laws have given us interesting, subjective, and often contradictory results. I prefer to show you a way *into* design by giving you three basic ideas about the subject:

1. The building blocks of a picture are *shapes* which include those of the subject and those of the background.
2. Good design grows out of a sense of wholeness and is expressed in the relationships of the parts rather than in the skillfulness of rendering any particular part.
3. Picture relationships are invariably based on some form of ambiguity or paradox.

These ideas may seem unfamiliar at first, but their threads have been interwoven throughout the text, and I think you will recognize them when you see them.

Reducing your picture to a simple pattern of shapes will help you organize it. This can be accomplished in your mind or in a little compositional sketch like this.

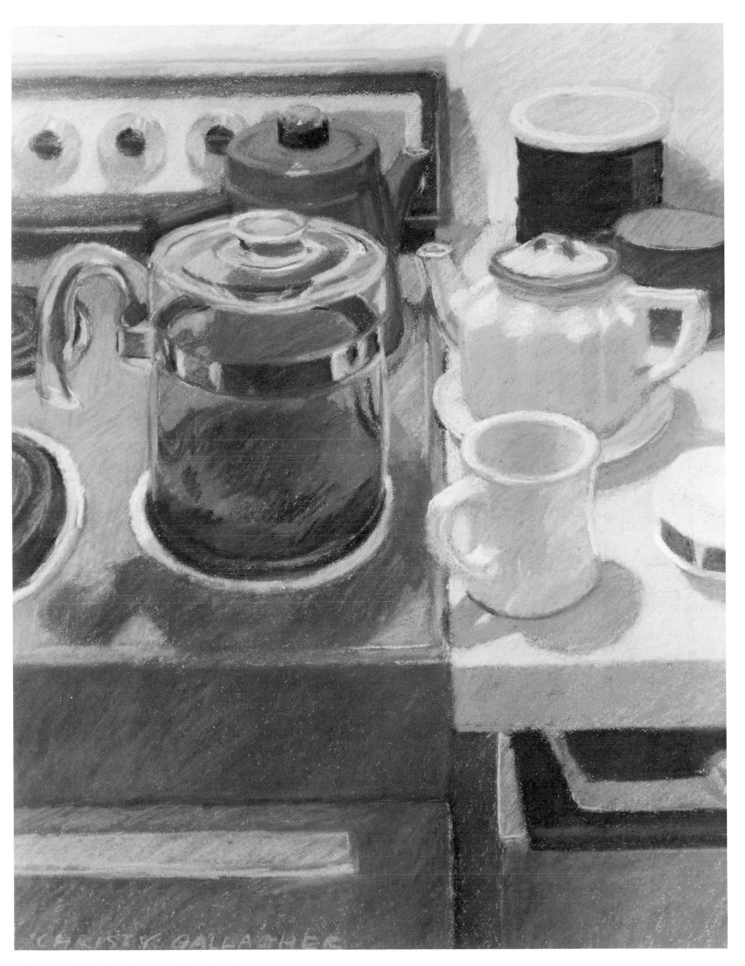

Christy Gallagher, *Coffee and Tea*. Pastel.

This composition is made up of two shapes . . .

1

the silhouette shape of the head and shoulders . . .

2

and the white shape of the background

The Picture Puzzle

The visual world is a vast and unbounded collection of shapes, but a drawing of that world is more like a picture puzzle — a number of shapes within a given border. Some of those shapes are going to be the objects you're drawing, but just as important to your picture are the shapes of the spaces between, behind, and extending to the borders of your paper. These background shapes can easily escape detection. Your alertness in recognizing them, however, will be a measure of your growing sense of design.

Before we go into this aspect of drawing, I want to define the shape terms to be used throughout this section. Generally, I will refer to *positive* and *negative* shapes, but to avoid endless repetition, I will also use the terms "figure and background" shapes, "black and white" shapes, "light and dark" shapes or "spaces." At times distinctions will be made between these terms, but for now consider that they will be used interchangeably. So long as you remember that *everything* is a shape, you'll have no problem in following these definitions.

Recognizing Shapes

In silhouette, a man's head and shoulders are a single shape. Drawn on a piece of paper, a silhouette would actually create a second shape: the shape of the space behind the head and bounded by the paper's outer edges. This, therefore, would be a two-piece puzzle as shown in the example at left. The woman's head, below, is also a single shape. In this case, however, the head touches the top of the paper, leaving a white background shape on either side. The outer edges of the picture comprise the edges of these shapes. In addition, one small white shape is trapped inside the woman's stylish hair-do. In the expanded view, we see each of these shapes separated and numbered as if they were four jigsaw puzzle pieces: three white shapes and one black shape — a total of four shapes. Returning to the left-hand example, let's study the particular character of each of the white shapes. Ignore the black shape altogether. You'll notice that as you draw the white negative shapes, you are also drawing the black positive shapes. Positive and negative shapes share common borders.

Imagine you are looking at the same landscape that Christy Gallagher saw when she made the drawing at right. Further imagine that you are viewing this scene through the cut-out window of your viewfinder which crops the scene the same way it is cropped here. You see, as she did, the dark

This composition is made up of four shapes . . .

. . . the woman's silhouette plus the white shapes on either side of the head and the trapped shape in her hair.

masses of trees cutting across the lighter shapes of field and sky. By squinting, you see the pattern even more strongly, reducing it to the quality of a two-dimensional poster. If you squint enough, you can reduce all trees and shadows to a single dark shape. This shape would normally be a good starting place for your drawing, but let's imagine that you take the opposite tack. Shift your attention to the field and sky shapes. Squint through the cut out window of your viewfinder and note the three large light shapes and then numerous smaller ones.

Now let's pause a moment. Does it really matter whether this landscape is a white-on-black or a black-on-white problem? Why go to all the trouble of seeing it both ways when one way will do? These questions get to the very heart of design.

We stated earlier that to design we have to shift to a pattern-sensing mode so we can see the whole instead of its parts. To understand what this means, let's consider that there is a little struggle going on between figure and background shapes, each one trying to assert itself. Like undisciplined and unruly siblings, they jealously compete for your attention. The design suffers if either sibling wins. Your role is to be an impartial referee, giving each equal treatment and always ruling in favor of the overall design. This means favoring neither figure nor background but using them both to support each other.

Tying shapes together

Thus far we've been discussing figure and background as the two separate entities that comprise the shape world. There is more to the picture, however. When you squint your eyes, you see a pattern of light and dark shapes. While some of these are the physical objects themselves and the background behind them, others are the result of light and shadow play and differences in local value.

Project 7 - A — Three Simplified Landscapes

Look around your outdoor environment and select a view with some good light-and-dark contrasts. Your subject may be trees or buildings or both. Frame your subject through a homemade viewfinder as described in Chapter 4 and squint strongly to reduce all the shapes to either black or white. Omit all details and textures. Assign a black tone to the darker shades of grey and a white tone to the lighter shades. At times, merge like tones into larger shapes. You may outline shapes in order to fill them in but don't leave outlines in your finished drawing. Work rapidly and no larger than 4x5½. When you have completed your first drawing, do two others either from different views or of different subjects altogether. Take about five to ten minutes for each drawing.

The dark shapes are tied together in a single shape almost resembling an alligator's profile. The more numerous white shapes surround and are trapped within it.

Christy Gallagher
Pastel

175

Face and shoulder shadow.

Background shadow.

Both shadows tied together in a single shape.

Project 7 - B — Three Faces

This project is similar to 7 - A except that you will make your studies from three magazine photographs — the larger, the better — of human faces with strong light and dark contrasts. Tape a sheet of tracing paper over each photograph and reduce all the features to either white or black shapes. Fill in the dark areas. Where a tone changes gradually from light to dark, make an arbitrary division between the two. You may outline your shapes before filling them in but, again, don't leave outlines in your final drawing. Keep your drawing simple and allow five to ten minutes for each drawing.

In design, different shapes of the same tone are frequently merged in order to unify the picture. Light, shadow, and local value areas are combined to weave figure and ground together. Darks merge with darks, lights with lights, and middle-tones with middle-tones regardless of their different sources. The new shapes formed by such mergers are little pieces of unified design and are themselves interlocked to form the large connected pattern of the picture as a whole.

We've already seen this interlocking function in shape tie-ins and mergers in Chapters 1 and 4, respectively. By extending this function to all areas of your picture, from center of interest to background shapes, you tend to lock your jigsaw pieces together into a tighter, more cohesive organization. Additionally, you do something else which is essential to design: you introduce paradox.

Let's look at a simple use of paradox in the shape tie-in at left. The first design shows a man's face-shadow running into his shoulder-shadow. The next shows the cast shadow on the wall behind him. In the third example, all the shadows are merged, eliminating the distinctions between them and creating a new, ambiguous shape. This new shape is a combination of form and cast shadows, but it is also simply a flat, black shape. Unconsciously we tend to jump back and forth between seeing it as dimensional and seeing it as flat — as well as seeing it as descriptive and seeing it as abstract. These paradoxes play with our perceptions and allow us to participate in the work. Such viewer participation plays a lively part in a work of art.

Shape tie-ins are but one of the half-dozen paradoxes we'll be looking at in the latter half of this chapter. For now, let's see if you've grasped the basic idea of figure and background tie-ins. Count the black and white shapes in each of the illustrations below. You need not have an exact count if your answers indicate you have a general idea of the concept. Of course, any connected shapes are to be counted as one.

Count the shapes in each picture. (Answers below.)

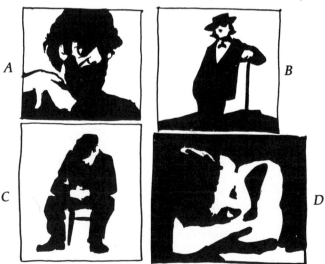

Answers:

D. Three black shapes, four white shapes.

C. One black shape, four white shapes.

B. Two black shapes, five white shapes.

A. One black shape, eight white shapes.

Sensing patterns

Our pattern-sensing mode is a way of perceiving that usually by-passes words. Artists don't necessarily "understand" visual pattern, or know why they like one pattern better than another. They do know from experience, however, that even the murkiest of hunches is likely to produce something worthwhile. Accounts of Willem de Kooning as a young painter in New York have described his intense visual curiosity. While walking down the street, he would suddenly stop and stare as if transfixed at a puddle of oil on the sidewalk. This may seem eccentric until we realize that it's not really any different than stopping to gaze at a sunset. Many unlikely combinations of shape and color can trigger our pattern-sensing mode if we are open to the inspiration.

Your pattern-sensing mode is essentially nonverbal, but you can develop it by playing a little verbal game called "What's the Pattern?" Look in any direction, in all kinds of locations, and describe what you see in a single sentence and in the language of shape. Rather than name objects, use words like "area," "mass," "piece," and "shape." For example, the view outside my window — a distant, tree-covered hill with a stretch of snow-covered field in the foreground and light sky in the background — might be described as a "dark bumpy mass sandwiched between two light shapes."

The wording of your description may at times be awkward, but don't trouble over syntax. "A dark central rectangle with irregular little lights and darks on top and dark curving lines below, against a middle-tone background" describes an ornate end-table with books on top. Even an overburdened sentence like that can be a great help in organizing your seeing.

As summing up and simplifying your subjects becomes a natural part of your seeing, you will be able to drop the use of words altogether. For now, the very act of trying to express such scenes in words can make you want to draw them. It's as if the visual part of your mind were to say to the verbal part, "You haven't quite described it . . . let me show you."

Sometimes the pattern will jump right out at you, but if it's hard to discern, remember to squint. If you have to, squint even to the point where you can barely make out individual objects. The few blurry darks and lights that remain are your pattern.

Massive dark shape with black and white filigree halo.

Black and white stripes in straight and undulating patterns.

Project 7 - C — A Pattern in Reverse

Set up a still life from the list below:
1. a random, looping length of rope on the floor;
2. a close-up arrangement of scattered pushpins, many of them overlapping and touching;
3. a portion of a bicycle or tricycle.

Each of the subjects has strong shape patterns which you are to reveal in pure black and white by drawing the background shapes only. Draw and fill in all the trapped shapes as carefully as you can and leave the figure shapes pure white. Move in close. Make your drawing 8x10 inches and use any drawing medium. Allow 40-60 minutes.

Small rectangular chips arranged in groups of spirals.

Framing

As I write these words, I am looking at my own drawing table in front of me. Canisters of brushes, ink bottles, tubes of paint, scissors, tape dispenser, books, and two coffee cups make up only a partial inventory of the clutter before me. It's a mess to be sure, and typical of the confusion of shapes in the visual world. (Have you noticed that almost any time you begin to draw something, even something simple, it's more complicated than you had anticipated?) When you really look at it, any piece of reality is as complex as my drawing table, which when I attempt to draw it, will present me with the same problems I always confront when beginning a new drawing. What do I include? What will I leave out? How big or small will I make the elements? In short: what will be the arrangement of objects and empty spaces?

I can use my viewfinder (see Chapter 4) to simplify the organizational problem. (If, as often happens, I cannot find my viewfinder, I can use my two hands to frame the area.) The hole of the viewfinder should approximate the proportions of the drawing paper. Scanning my table through the viewfinder enables me to select some objects and crop others. It allows me to focus on one area at a time. This makes the subject understandable to me in design terms.

In these small ink and wash sketches, I considered a variety of compositions. In the horizontal format, I could take in more of the elements, but a vertical design offered some interesting diagonals and unusual croppings. Either works well, but since my subject was generally horizontal, I favored that direction. I tried several different eye levels, viewpoints and distances from the subject. With each new position, the objects and the spaces between them changed shape, and a whole new pattern was created. Notice that the total number of shapes in each case is reduced due to the cropping, shape mergers, and background tie-ins. By simply framing the scene, a complex problem becomes more manageable.

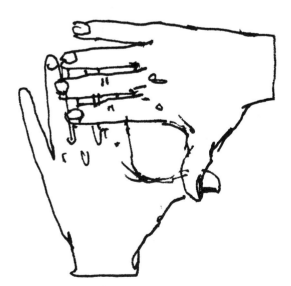

A homemade viewfinder offers an excellent way to preview possible compositions.

Your hands can simulate a viewfinder.

Generally I drew the arrangements as I found them, but on occasion I shifted objects to make a better design. If something looked too confusing, I omitted it. If a space looked too blank, I moved something into it. My decisions were made almost unconsciously — I just played with the shapes until something clicked for me.

I've learned the value in seeing more than one possibility in a subject. Even if I'm only planning to make a single drawing, I scan the subject slowly with my viewfinder for possible approaches before I choose the one most appealing to my own pattern sense. Deciding on a particular arrangement is usually more a matter of, "Hmmm . . . this looks promising, I'll see how it works out," than of, "Ahah, that's exactly what I'm looking for!"

A dramatic overhead view opens up white spaces and makes possible a vertical composition with strong diagonals.

In this view, everything is clustered toward the center. Only a touch of the dark background is showing.

Moving in very close brings out a subject's abstract qualities. Shapes become larger and more mysterious.

The large open area in front gives an added feeling of depth. Cropping is confined to the top border.

179

Tighter cropping adds more background shapes.

Cropping

We can view cropping as something that just happens whenever our background hits the edge of the paper, or we can view it as a radical design device. Cropping helps develop nerve because it requires absolute decisions. Objects are either in or out of the picture. Adventurous cropping will cut right across important aspects of the subject. It brings the viewer in closer and breaks up the background. Revealing only parts of objects, cropping adds an abstract quality to a work of art. The viewer becomes less aware of things and more aware of shapes, angles, and tones. In this way, cropping emphasizes design.

Radical cropping is a recent innovation in the history of Western art, evolving out of the separate influences of Japanese woodblock prints and photography. The eighteenth century woodblocks of Hiroshige, Hokusai, and others featured oblique and obscured figures and buildings cropped at bold angles. The first photographers started out imitating painters by carefully centering their subjects within the picture area, but very soon — either by mistake or by experimentation — began cropping in more daring ways. They moved in for close-ups, let figures walk in and out of frame, and had unidentifiable fragments cut off at the borders. Painters of the late nineteenth century were excited by these innovations and began to incorporate them into their work. The use of a picture's borders to create new shapes has been a part of art ever since.

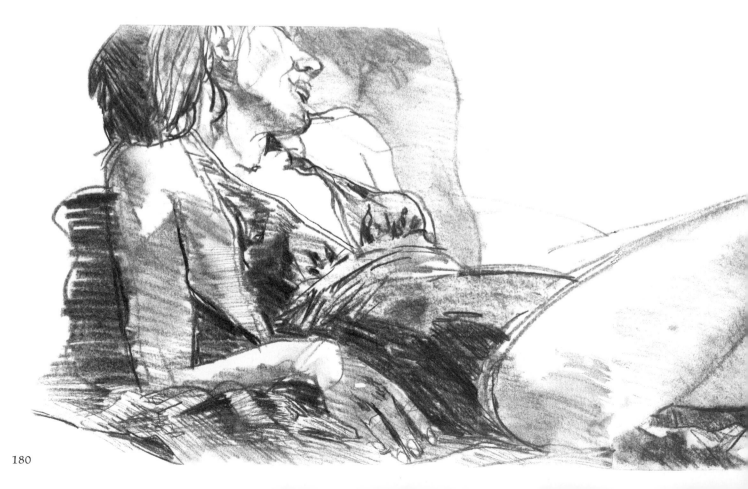

The reasons for cropping may be varied, but they tend to fall into two categories. First, cropping brings the viewer in closer for more intimate contact with the subject. Second, cropping divides one big background into smaller, more numerous, and more distinctive shapes. Notice the diagram of the scissors and bottle on the left-hand page. In the top picture, the objects are placed in the center of the paper. The surrounding white area can be considered a shape, but it is too large and all-encompassing to have any real identity. When we move in and crop, however, as we've done in the second example, we give the background a set of more assertive and muscular shapes. Now there are three or four identifiable shapes, and they play a more active part in the picture's design.

Although there are no rules for cropping, I like to follow a *crop and float* formula. This means that if you crop the top of an object, you let the bottom float or vice versa. If you crop one side of an object, let the other side float. Also, it's best to avoid cropping at narrow junctures. People, for example, should not be cropped at the ankles, wrists, or neck because it suggests amputation. Finally, avoid cropping at tangents, where the edges of the figure or object exactly meets the edge of the paper. Such cropping is confusing to the eye.

Crop decisively but avoid . . .

critical junctures . . .

and tangents.

In composing your picture, generally follow a "crop and float" formula.

Radical cropping forces the design aspects — we are made more aware of the light and dark shape pattern and the edges of the paper. (The ankle crop is less objectionable when the legs are cropped at different places.)

1. Do I want a horizontal or a vertical composition?

2. Do I want more background or more figure?

3. Can I reduce my subject to five shapes or less?

Three compositional decisions

Most design decisions take place in the first few minutes. If you're doing a sketchbook study, you make a few quick decisions in your head, perhaps a few vague strokes on the paper, and then plunge right in. If you're doing a carefully executed piece, you might try a few little compositional studies first. Either way, you make a very early commitment to a plan. Of course, as you draw, you'll continue to make small changes and modifications, but chances are, if any of those changes are major, you'll begin a new drawing.

I place a good deal of emphasis on ways of getting started. Perhaps this is because I remember how often I've sat with sketchbook in hand, pencil poised, subject before me, feeling totally stuck. The problem for me was always the same: pressure. I felt presure because I was afraid I couldn't remember all that I was supposed to know. I felt pressure that I was about to spend a lot of time and effort and might still come up with weak results. And I felt the pressure of wanting to say something artistically and not knowing how. It finally occurred to me that all these concerns were irrelevant if I couldn't get started. From this experience, I derived a strategy which gets my pencil moving. I ask myself three compositional questions which get me quickly involved in the design of my picture:

1. Do I want a vertical or a horizontal composition?
2. Do I want more subject or more background?
3. Can I reduce my subject to five shapes or less?

If you're generally slow to get started, I recommend that you memorize these questions, and make them part of your internal dialogue. Then make your decisions quickly, almost impulsively.

Decision #1 (vertical or horizontal format): Before you start drawing, consider both arrangements, perhaps with the aid of your viewfinder, and then make a quick decision. Usually it will seem an obvious choice. Logic would dictate, for example, that for a standing figure you turn your paper vertically, and for a reclining figure, horizontally. Occasionally, however, you'll want to do the opposite just to keep from getting into conventional habits.

Decision #2 (more figure or more background): In most drawings, you'll probably want your center of interest to dominate, but that doesn't necessarily mean it needs to occupy more space. Sometimes isolated and lonely qualities can be emphasized by making the background shapes larger. (Decision #2 is really just a tricky way to get yourself thinking about the background shapes before you start drawing.)

Decision #3 (five shapes or less): Reducing your subject to a few shapes and getting them down on your paper gives you a basic design to work with. There's nothing magic about the number *five* except that it's just about all the human eye can take in at a single glance. The idea is to force your subject, no matter how complicated, into a simple pattern. Sometimes this entails squinting and perhaps even a value sketch. A strong commitment to the initial plan will make the middle and late stages of your drawing much easier.

Project 7 - D — Four Compositional Studies

Select two still life objects or a sleeping pet and make a series of four compositional studies in pencil. These studies should be simply drawn with a small number of shapes and only three values, not counting the white of the paper. Make these studies no more than 4x5½ inches and do them in the following order:
1. a horizontal composition;
2. a vertical composition;
3. a close-up composition (horizontal or vertical);
4. a distant view (horizontal or vertical).

Use your viewfinder to frame each composition and allow about five to ten minutes each.

Designing with straddles

A number of ideas in this book are based on paradox. I call them *straddles* because they place one foot in each of two opposing camps. Here are some examples:

- Sometimes, as when drawing blind, you draw better when you don't even look at your picture.
- You can discover your own tendencies through copying and emulating someone else.
- You strive to create illusions while simultaneously reminding viewers that they are looking at a drawing.
- Your goal is to draw accurately yet it is also desirable to intensify certain aspects.
- You can tie figure and background together in a common shape that is neither and both at the same time.

Can you recognize the contradiction in each of these statements? Surprisingly, whatever strength these ideas have is a result of that contradiction.

Combining opposing ideas — straddling — is a vital part of design and far more common to both art and life than is generally realized. Too often we approach drawing as a discipline in which there is a right way and a wrong way of doing things. The idea that opposites can exist side by side can be perplexing to those of us brought up to see things as either/or, true or not true, correct or incorrect. This is a Western habit of thinking that sadly inhibits much of our understanding about whole systems in general and art in particular. Eastern thought has a lot to teach us about paradox.

Yin/yang is an ancient Chinese idea in which the world is seen to be comprised of coexisting opposites. Understanding comes not from choosing between opposites but from embracing them. The Zen Buddhists have a particular knack for making a virtue out of contradiciton. Here, as best I can recall it, is a typical Buddhist paradox based on learning and innocence.

> When I was young and knew nothing, a tree was simply a tree, a mountain simply a mountain, and a lake simply a lake.
> When I had studied and learned some, a tree was much more than a tree, a mountain much more than a mountain, and a lake much more than a lake.
> When I became enlightened, a tree was once again just a tree, a mountain just a mountain, and a lake just a lake.

Is the third state of consciousness exactly like the first state? Well, yes and no.

Modern physicists have found that light sometimes acts wave-like and other times acts particle-like. Even though these properties are mutually exclusive, scientists accept that light is both. In effect, they concede that the ancient yin/yang idea of both/and is more applicable here than the traditional scientific notion of either/or.

When you look for them, straddles are everywhere. The opposing characteristics of Sancho Panza and Don Quixote is a straddle. The earthy, realistic, cynical one illuminates the romantic, idealistic, deluded one. And vice versa. They act as foils for each other. In a sense, I've had these two characters, one on each shoulder, advising me during the writing of this

The ancient Chinese yen/yang symbol.

book. Don Quixote encouraged me to present drawing as an adventure, a quest filled with high risks but offering great rewards. Sancho told me to come back down to earth and explain the little tricks, the how-to's, the step-by-step procedures of drawing. It wasn't until I stopped thinking in terms of either/or that I could listen to them both.

The either/or habit is hard to break. It's difficult to imagine that things can be both simple and complex at the same time or that something could be simultaneously rational and emotional or specific and general. When one voice says, "Make your shapes recognizable" and another voice says, "Strive for a what-is-it quality," rather than feeling you must choose between the two, find a way of incorporating both. When you shift from an either/or way of thinking to a both/and mode, you set up the possiblities for creative solutions.

I don't want to convey the idea that a straddle is simply a 50-50 compromise, an average. That would be like saying that if you had one foot in a bucket of ice water and the other in a bucket of scalding water, on the average, you'd be pretty comfortable. We can be sure that Dickens' famous opening line from *A Tale of Two Cities*, "It was the best of times, it was the worst of times," does not translate to, "It was a so-so time." Straddling means getting the most out of each opposing quality. Over the next few pages, we'll look at some of the more important straddles that apply to picture organization.

Repetition and variation

Earlier, repetition and variation were presented as a textural device, but it's really a "whole-systems" principle so ripe with possibilities that it's presented again here as an aspect of picture design. By finding some way of repeating shapes in your drawing, you set up a pleasing visual rhythm. By making those shapes individual and varied, you provide an interesting

Repetition

repetition with variation, a straddle

Variation

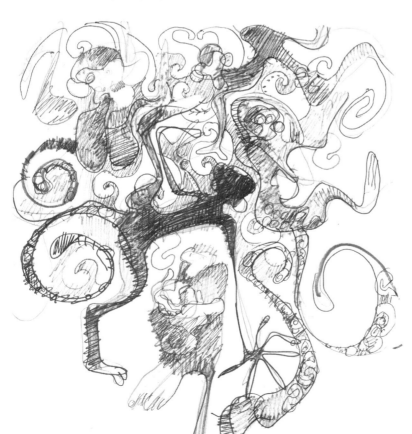

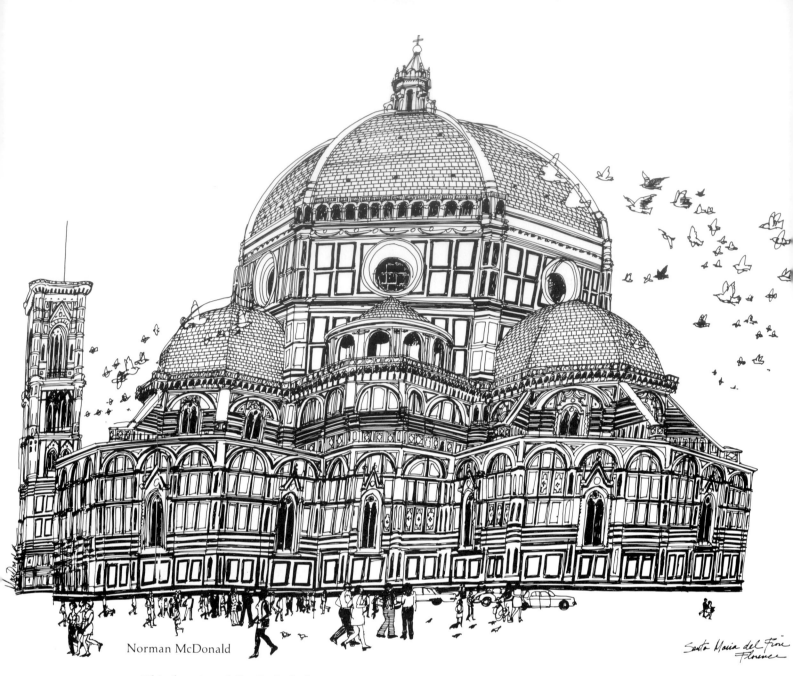

Norman McDonald

Santa Maria del Fiore
Florence

This drawing of the Cathedral in Florence impresses us as intricate, but the plan is quite simple. The single large shape contains a variety of repeated rectangles, circles, and arches. The birds and people are added repetitions.

counterpoint to that rhythm. This is the straddle. The viewer jumps back and forth between seeing the unified whole and seeing the individual part.

There are lots of ways of repeating shapes. The simplest is to draw similar things. A cluster of houses, or a mass of bare tree branches are two such examples. You might lay out a group of soda or beer bottles, some standing, some lying at different angles with irregular spaces in between. If you draw manufactured items in which every object is exactly the same, you'll have to rely on an irregularity of positioning (some side views, some front views, some three-quarter views) and negative shapes in between (some tight spaces, some open spaces) to provide the variation.

Objects of basic shapes like boxes or balls make variation harder to achieve than do objects which are asymmetrical, like shoes, or different from end-to-end, like wood screws. All of these objects make good subject matter, and each one offers a different challenge.

Another way to play with the repetition/variation straddle is to draw a single object or animal either from a photograph or from your imagination, as I did with the

drawing of the monkeys on page 185. Then recopy it, altering it slightly by stretching, twisting, or bending, and fit it tightly near the first object. Continue to do this until you fill the page. The result has almost a wallpaper feeling, only much more personal and imaginative.

Beyond drawing similar things, there are more subtle ways of combining repetition with variation. Shadows, for example, can echo the shape of your center of interest. Negative shapes can do the same thing. Trapped little background spaces within the mass of a houseplant tend to echo the leaf-shapes.

Disparate objects included in the same picture can resonate with one another. I am reminded of an early Dutch still-life which includes a melon cut in half alongside a mandolin. The eye links up these two shapes and makes a satisfying connection.

Seurat's *Sunday Afternoon at the Grande Jatte* represents the bourgeoisie relaxing in the park. All the expected objects are there: playing children, parasols, trees, and boats. What is not so obvious is the way the elements are put together to form a series of curves and circles. Rounded trees, half-round umbrellas, quarter-round bustles, and the curving postures of figures on the grass serve to vary a pattern that is barely discernable. Even the curving tails of dogs and a pet monkey add to the subtle resonance. Although initially inspired by the actual scene, such a composition is ultimately the result of careful organizing and arranging. This bending and reshaping of reality is another example of intensifying. It moves a step beyond merely reproducing what is seen in order to impose a stronger sense of pattern. Often such hidden repetition is the most effective kind and, as you might guess, the hardest to achieve.

Seurat, *Sunday Afternoon at the Grande Jatte*

A variety of moods advance along the bobbing heads like a tune along a progression of musical notes. Drawing based on a painting by R. Levers.

Simplicity and complexity

Although we have said that straddles involve contradictions, they are more a matter of language than reality. In those moments when we experience reality fully, we see through apparent contradictions and find instead complementariness.

A work of art may straddle simplicity and complexity in a number of ways, but for now let's apply it only to patterns and consider the two extremes. In one, your drawing is composed of a very few, orderly shapes. In the other it's broken up into a great diversity of shapes. Straddles introduce complexity into the first example and simplicity into the second.

To impose a straddle on a simple pattern is to find and emphasize the individual shapes and unique textural strokes within your drawing. Imagine a composition of just two shapes; an open meadow and a clear sky. Such a design might not hold our interest without some enrichment details. If the field were sufficiently alive with grasses, clover patches,

A simple overall pattern with complex enrichment shapes.

wildflowers, and perhaps a worn path, the simplicity of the design would take on some complexity. This is the kind of problem that the painter Andrew Wyeth handles so deftly.

When you are drawing a complicated subject, straddles can simplify and standardize shapes or tones. Let's say you are doing a tangle of different junk yard objects. To maintain some sense of organization, you may want to alter the shapes to make them seem somewhat more uniform, or you might want to flatten the tones so the whole pile has more evenness and regularity. You will be eliminating the confusion of enrichment shapes, particularly in the background. In other words, you'll want to strengthen the similarities of the pattern and lessen the disparities. Paul Cézanne was a master at reducing complex irregularities to a unified structural whole.

Complexity invests a picture with diversity and richness while simplicity gives it coherence and unity. The mental "stretching" that occurs when we grasp these two ideas at once is the pleasure of an art experience.

A complex overall pattern with simplified enrichment shapes.

Project 7 - E — Clarity and Ambiguity

Select an object of some complexity to draw. Notice that from certain angles, the identity of the object is very apparent while from others it is almost unrecognizable. For this project, approach your subject from the less descriptive angle, but draw it as carefully and accurately as you can. In this way it is possible to straddle ambiguity and clarity. Strive to balance the two in equal measure. At the end of one hour, try to evaluate whether or not you succeeded. If you feel your drawing is too weighted on the ambiguity side, intensify the identifying textures and details of the object. If weighted on the other, make some changes in the lighting to allow part of the object to fade into obscuring darkness. Allow 20 minutes more to complete this second phase.

Clarity and ambiguity

A drawing which holds our interest is one which asks the questions as well as provides answers. Sometimes it's the question that invites the audience in ("What is it?") and it's the answer that satisfies ("Ah, I see, an old pair of workman's gloves"). Just as often, the audience's interest is provoked by a recognizable object ("That looks just like my old gloves") and the questions follow ("Why put them on an elegant Oriental rug?").

The tendency toward opening (questions) and toward closure (answers) is the basis of this straddle. The idea is to present tantalizing clues without providing full disclosure, offering something that, at first glance, is vaguely recognizable but not altogether discernable.

One simple way of captivating a viewer is to draw your subject from an unusual view such as an extremely foreshortened perspective, or you might interweave your subject with strong light and dark shapes going the other way, as in the watercolor sketch by Ann Toulmin-Rothe.

The clarity/ambiguity straddle is more easily made any time you draw objects which are themselves hardly recognizable, such as an antique apple corer or the gears of a cement mixer. Finally, you can place familiar objects in unusual settings, such as an egg in a baseball glove.

The motive behind such drawings is not merely to tease or frustrate but to allow your audience to make some discoveries. Perhaps, as a result, they will regard the objects in a new light. Maybe you can coax them, if only for a moment, out of the world of things and into the world of shape and design. This may seem like a small achievement, but it represents the gift of lifting others out of old habits of seeing. As an artist, you set the example by lifting yourself out first.

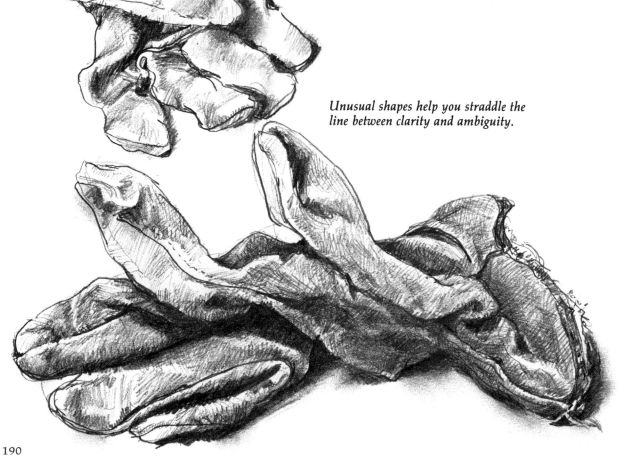

Unusual shapes help you straddle the line between clarity and ambiguity.

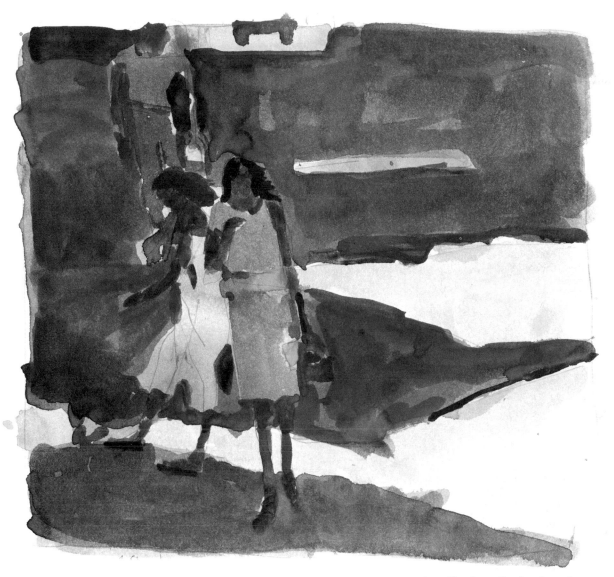

Ann Toulmin-Rothe, *In and Out of Shadows*. Watercolor.

These elements are unrecognizable to most people as fishing gear.

Balance and imbalance

"Motion or change," wrote Ralph Waldo Emerson, "and identity or rest are the first and second secrets of nature." Emerson's secrets apply to art as well. We are drawn to order, stability, and symmetry at the same time that we are attracted by freedom, dynamism, and mobility. The difficulty of formulating perdurable rules about composition arises from the opposing nature of these attractions. Our challenge in composition is to find some specific way of satisfying both of these needs simultaneously. In other words, while we can recognize that no specific rule of design applies in all cases, we find in every good picture a creative tension (or *balance*, if you prefer) between Emerson's first and second secrets.

Every student is cautioned against placing the center of interest in the center of the paper. Too static. What students are not generally told is that a center placement is fine if you can find some other way of introducing disequilibrium. Similarly, you've probably been warned about placing a focal point near the edge of the paper. Too unbalanced. But if you can inventively pull the viewer's eye back into the picture, satisfying the need for order, you can go ahead and do it.

Shapes near the edges are precarious . . . *unless you bring them back into the picture.*

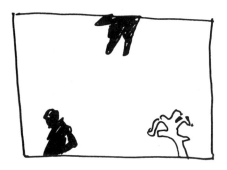 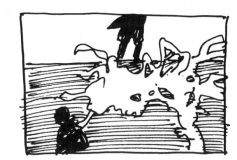

Admittedly, few compositions are based on such extreme placements, but you need to try this to experience the push and pull of picture design.

As a practical matter we can say that (1) we want to keep the viewer's eye within the picture area, and (2) we want to keep it moving. Usually creative tension takes place between elements of different sizes and shapes. Small shapes can balance larger ones by means of their location, contrast, or emotional associations. Higher contrasts catch our eye more readily than lower, and isolated elements carry more significance than the same elements closely grouped together. Some objects are simply more interesting to us than others — like the human face or form.

Symmetry/asymmetry, order/disorder, balance/imbalance — the same basic logic underlies each of these pairs of words. You can push one half of the equation as long as you realize that, as forces build in one direction, you must counter with forces in the opposite direction. By experimenting with placement, you expose yourself to a little risk and sometimes considerable uncertainty. But a little precariousness is good for design.

Project 7 - F — Balancing Extreme Compositions

Make a full tonal drawing of a still life in any medium you choose and place the center of interest in one of two locations on your paper:
1. in the true center of your paper; or
2. near the outside edge of your paper.

The point of this project is to see if you can keep the center of interest in these uncomfortable places yet make them work by the introduction of light, shadow, texture, pattern, or other objects. Try to introduce some excitement into Problem #1 or some stability into Problem #2. Make a few preliminary sketches of possible solutions. Then, select your best solution and do a full tonal drawing in the medium of your choice. Allow approximately one hour.

Equally divided pictures areas and centered subjects are generally avoided as being too static . . .

. . . unless you find a way to introduce disequilibrium.

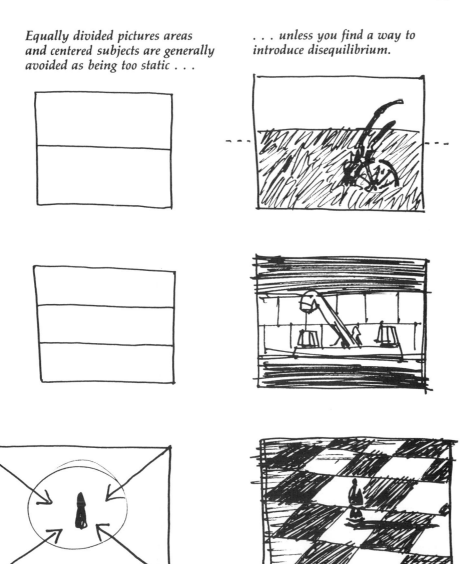

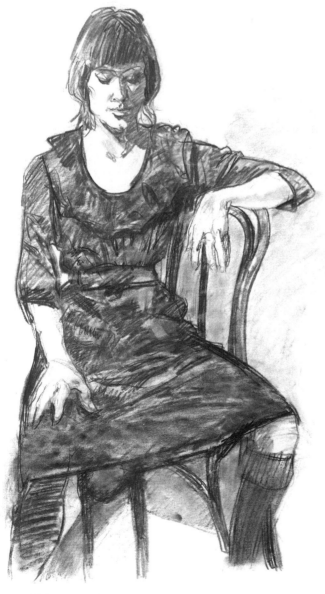

The left side of the shape is simple and serene. The right side is angular and active.

Active and passive shapes

This straddle is particularly suited to drawing the figure. Although the human body is symmetrical, even in repose, we usually want to present it in a way that illustrates its dynamic qualities as well. This suggests, if not a rule, certainly a useful device: if you make one side of the figure simple, contained, and passive, make the other complex, protrusive, and active.

One way you can do this, developed by the classical Greeks, is to present the standing figure as a set of counterbalances. The weight on one leg creates an out-thrust hip and a lowered shoulder. With the addition of a jutting elbow or an extended hand, you have a lot of action going down one side. The other side of the figure is a simple, curving stretch. The two complement each other.

Another way to accomplish this active/passive straddle is to draw the hands differently — one open and the other closed. The open one is more convoluted and therefore more active in terms of shape. In comparison, the closed hand is passive.

Clothing can accomplish a similar effect, as can hair. A loose garment can be bunched up on one side and hanging limply on the other. When handling a hair silhouette, the more active side might have more wisps and curls emerging from the mass. Accessories like a fringed shawl or the knot of a scarf can add to the busyness of the active side. On the passive side — in addition to keeping the shapes simple — lowering contrasts, blurring edges, or even merging with a background rectangle can help to subdue the shape.

Working with opposite sides of the figure will help you see how balance is obtained through the equilibrium of opposing forces. You can probably see that this straddle is a first cousin to balance/imbalance and also to simplicity/complexity. Actually, all of the categories of straddles we've looked at are related, and frequently they fold into one another. You needn't try to keep them all in your head. If you remember to look for and develop opposites, appropriate straddles will be suggested by what you see.

Tangents

A tangent occurs where one shape just touches but does not overlap another shape. I hesitate to say anything is bad in drawing, but tangents are such attention-getters that you will probably want to avoid them. Occasionally, they are a deliberate design device, but usually they are a visual coincidence that the artist has failed to notice.

In the example at top right, the one woman's elbow, instead of resting on the ledge, seems to be leaning against the other woman's head. In the second example, the tangent is at the point where the woman's nose appears to touch the window. Is the rectangular shape a window in the background or some other object actually touching the woman's nose? These tangents become a distracting focus for our attention.

Another sort of tangent occurs when the straight edge of one of the elements in a picture runs into and connects with the straight edge of another element so that they share a common border. The extent to which such tangents can mislead is illustrated in the examples at lower right.

In the matter of tangents, you will want to consider the edge of your paper as one of the elements in your drawing, too. Avoid letting the edge of any object end there, whether in a point like the elbow or in a line like the car roof. At times tangents may be interesting, even comical, but they are only desirable insofar as it is the artist's intention to use them

M. C. Escher, a Dutch artist with a scientific bent of mind, was one of the few who regularly used tangents to good effect. Background and foreground objects, particularly in his flocks of birds or schools of fish, share boundaries to the extent that one cannot say which is which. When you look at many of Escher's drawings, your mind flips back and forth between positive and negative, foreground and background as the shared borders are perceived first as one and then as the other.

Unless you are doing something deliberate, you can easily correct a tangent by separating, overlapping, or otherwise jogging the arrangement of picture elements. If it occurs in nature, you will want to change your position.

One is less likely to let tangents slip in if one deliberately makes a few and experiences the results. When you're sketching, stick two objects up against each other, or end some object at the edge of your paper. In a short while you'll have developed your consciousness of tangents and will not accidentally create them.

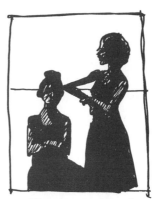

Elbow against head.

Nose touching window.

Car supporting mountain.

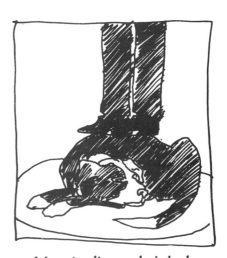

Man standing on dog's back.

Window resembles hat.

KEYS TO CHAPTER 7
Pattern and Design

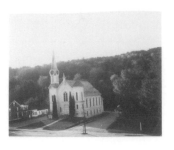

- **Design with shape.** Use shapes as building blocks for composing your picture.

- **Sense pattern.** Look for the abstract arrangement of lights and darks in your scene. Reinforce this pattern in your mind by describing it in words.

- **Frame the scene.** Use your viewfinder to put boundaries around the scene you are about to draw.

- **Crop the scene.** Cut off parts of your subject at the borders to create more background shapes and a more intimate composition.

- **Straddle contradictions.** Establish creative tension by embracing opposing ideas in a single picture.

- **Identify tangents.** Avoid unwanted coincidences where picture elements just touch but do not decisively overlap.

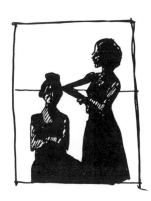

SELF-CRITIQUE OF YOUR PROJECTS

Project 7 - A — Three Simplified Landscapes

YES NO

- Are all the shapes in each of your pictures either black or white?
- Are your drawings bold and simple with a minimum of detail?
- Did you succeed in eliminating all outlines from your finished drawing?
- Even though your composition is simplified, does it convey at least a vague idea of the actual subject?
- Did you stay in the language of shape, giving equal attention to black shapes and white shapes, figure and background?
- How many shapes are in your picture?

Project 7 - B — Three Simplified Photographs

YES NO

- Are all the shapes in each of your pictures either black or white?
- Are your drawings bold and simple with a minimum of detail?
- Did you succeed in eliminating all outlines from your finished drawing?
- Even though your composition is simplified, does it convey at least a vague idea of the actual subject?
- Were you able to treat features as shapes rather than things?
- How many shapes are in your picture?

Project 7 - C — A Pattern in Reverse

YES NO

- Are all the shapes in your picture either solid white or solid black?
- Were you generally able to concentrate on drawing the background shapes and not the figure shapes?
- Were you able to capture the character of the figure shapes even though you only drew the background shapes?
- Looking at your picture from a distance, is an overall pattern readily apparent?

Project 7 - D — Four Compositional Studies

YES NO

- Did you make your studies simple and use only three tonal values?
- Did you consider the size and characteristics of the figure shapes as well as the background shapes?
- Did you use your viewfinder to frame each composition?
- For the close-up, were you able to create additional background shapes by cropping?
- In each of the four studies, did you manage to create a distinctly different composition?

Project 7 - E — Clarity and Ambiguity

YES NO

- Did you render your subject in careful and accurate detail?
- Make a simple outline of your drawing. Is it unrecognizable as an object?
- After your evaluation at the end of the first phase, did you feel the need to intensify either quality?
- Do you feel your final drawing effectively straddles clarity/ambiguity and exerts pull in *both* directions?

Project 7 - F — Balancing Extreme Compositions

YES NO

- Does your drawing have a definite center of interest, and is it placed either in the center or near one edge of your paper?
- Have you introduced other elements to counterbalance your center of interest?
- Did you try out more than one solution in your preliminary compositional sketches?
- Are your shapes, tones, and textures carefully executed?
- Do you feel your picture effectively straddles balance/imbalance and exerts pull in both directions?

8

DRAWING AND IMAGINATION

JOINING TWO BAGS • CREATIVE PLAYING • MAKING THE FAMILIAR STRANGE • WORKING IN SEQUENCE • DRAWING ON DIVERSE SOURCES • EXPLORING THEMES

"The mind," wrote surgeon and philosopher Wilfred Trotter, "likes a strange idea as little as the body likes a strange protein and resists it with similar energy. If we watch ourselves honestly, we shall find that we have begun to argue against a new idea even before it has been completely stated."

Notice that Trotter doesn't say we don't have strange ideas — merely that we resist them. Poets, musicians, scientists, artists — in fact, all of us — have enriched our lives from time to time with strange ideas. It was a strange idea for Einstein to imagine he was riding a beam of light away from the clock tower in Berne, Switzerland, which led to the theory of relativity. It was a strange idea for the Impressionists to imagine they were painting bits of pure light with each brush stroke. Franz Kafka's fantasizing in "Metamorphosis" what it would be like to wake up as an insect was more than a little strange. Then there was Buddha's "realization" that our concepts of reality are largely based on illusion.

If we examine each of these "strange ideas," we quickly realize that all are quite simple. None required "genius" to imagine. Each and every one of us has fantasized in similar fashion. None of us need ever fear that we don't have an active imagination, because imagination is mostly a willingness to entertain a strange idea now and then.

For now, let's not make any distinctions between fantasies, daydreams, dreams, free association, creative thoughts, and strange ideas. Let's agree that they are all mental grist for our creative mill, and let's also agree to put them all under the one heading, "imagination."

Steve Guarnaccia

By definition, everyone has imagination. More to the point, how can the imagination help us in drawing? A clue might be found in Steven Guarnaccia's drawing, *Happy Birthday*. With the addition of a little airplane, the birthday cake becomes huge, even monumental. It also becomes humorous and provocative. The artist's "strange idea" in this case comes from playing with scale and with the way pastry writing resembles skywriting.

Joining two bags

Every creative thought, imagining, or strange idea involves putting together at least two elements in a novel way. We can think of it as taking a bag containing one idea and joining it to a bag containing a completely unrelated idea. A "strange idea" inevitably results.

Obvious to us now, the idea that the heart acts as a

Harvey's idea of blood circulation.

Archimedes' idea of displacement theory.

pump was a novel one to the Western world in the seventeenth century. Variously thought of as the soul, the seat of emotions, and the generator for new blood, the heart's true function was understood by William Harvey only after examining the pulsating heart of a fish. Harvey's "strange idea" was his recognition of the similarities between this throbbing organ and the action of a mechanical water pump. In his mind, he put together a bag marked "fish heart" with a bag marked "water pump" and, *Eureka* — he found a truth.

Robert Louis Stevenson's interest in writing a story about the struggle between good and evil in each of us provides another example. He had a dream about a man who was chased by police, and drank a potion which changed his identity. On waking, Stevenson put together the bag marked "good and evil" with the bag marked "identity potion," and he wrote *Dr. Jekyll and Mr. Hyde*.

You may recall one of the most famous "strange ideas" of all. Given a beautifully ornate crown, the King of Syracuse asked Archimedes to ascertain if the crown was indeed made of gold as the donor claimed. The only way of determining gold content was by comparative weight. However, that would necessitate melting the crown down to a lump equal to the gold weights on hand — a method unacceptable to the king. Archimedes pondered this problem while stepping into his bath. As the water rose, he realized that the volume of water he displaced was equal to his own, and thus he had the mechanism for measuring the volume of the crown. He put the bag marked "crown of gold" together with the bag marked "bath water displacement." The two seemingly unrelated ideas yielded important creative results. Some accounts have it that he ran naked through the streets shouting, "Eureka! I found it!"

Creative play

The spirit of creative play is the spirit of "joining two bags." It requires a loose and friendly attitude.

I drew this dead crab on the beach with no particular "idea" in mind. As I drew, I began to see more clearly its human-like face. This prompted another sketch in which the face became more prominent. The old, angry features began to take on more life for me, and I could sense how the word "crab" came to be applied to an embittered, aged person.

I made a separate study of just the face, giving it even more human-like qualities. The three drawings became a process of discovery. I had not started out to emphasize the human-like face. The idea began to grow on me as I drew. I

A playful attitude helps you make connections between separate things.

was merely ready to be affected by what I saw, hence the joining of the "crab bag" with the "old person's face bag."

Incidentally, sketchbook drawing provides the best vehicle for creative play. Free of the pressures of serious work, the sketchbook will provide a record of your private thoughts and observations. At these moments, creative play is the most active.

The mountains of Monserrat in northeastern Spain are striking in their verticality and large rounded forms. As with the crab, I began to see human resemblances as I drew them. Heads, shoulders, breasts — the mountains became female forms to an uncanny degree.

English tombs and caskets of deceased knights, ladies, and nobles were frequently decorated with the owner's effigy. I drew a few of these and then thought how odd it would be if this custom were still observed. I pictured the effigies of businessmen in three-piece suits, and I drew a tourist standing nearby as if he adorned his own casket. A morbid idea perhaps, but one animated by a spirit of play.

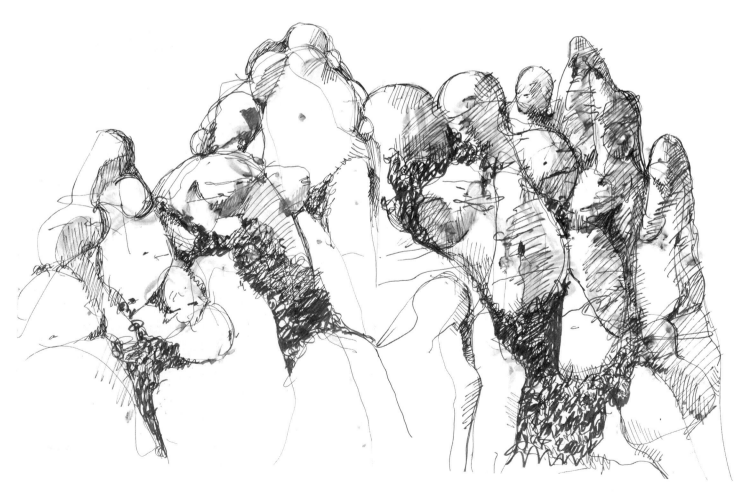

Monserrat Mountains and female forms.

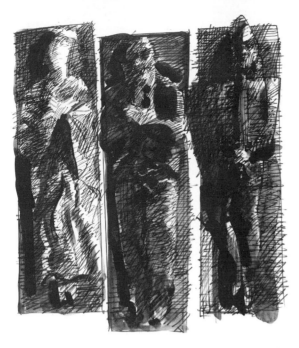

Old English tombs and modern effigy.

The drawing of Laurel and Hardy below was done in a wax museum. The actual figures, while closely resembling the two comedians, also had a strong, waxy quality which I began to emphasize as I got into the drawing. I ended up drawing them as if they were soft and beginning to melt.

It's important to realize that such ideas grow out of an *experimental* attitude. Often they will occur to you *as you draw*, not before. By being curious about your subject and refusing to be too "result oriented," you obtain the best results. A sense of humor helps, too.

Droodles: Commonplace symbols in odd situations.

Reprinted from *Droodles* by permission of Price/Stern/Sloan Publishers, Inc., Los Angeles.

Making the familiar strange

Cartoonist Roger Price invented an art form called the "Droodle", which looks at commonplace things in unusual ways. As he put it, "A Droodle is a sort of drawing that doesn't make any sense until you know the correct title." Price often achieves his effect by looking at something from an unorthodox angle, say, from directly above. At other times, he puts elements together in odd or absurd combinations. The two Droodles above are titled "Bear Climbing a Tree" and "Man Playing Trombone in a Phone Booth." The alternative title to the second Droodle is found by turning the drawing upside down. In that case, it is titled, "Midget Playing a Trombone in a Phone Booth." If you turn the picture on its side counterclockwise, it is subject to a third interpretation: "Deceased Trombone Player." Price claims that Droodles are the greatest invention since the coloring for margarine. I agree. They remind us of the creative possibilities in mixing a playful spirit with an unorthodox point of view.

Anything that makes us see reality in a fresh or unusual way, reawakens our eyes. Odd tangents, overlapping forms, and distorted reflections are but a part of our daily experience with visual strangeness. Making the familiar strange means being alert to such phenomena. It requires three things: luck, nerve, and a little faith in process. People who think you can't do anything about luck are wrong. You can improve your luck by one simple act — carrying a sketchbook. Even when you don't use it, it makes you look at things more intently as possible subject matter. Nerve only requires an irreverent attitude about results. If you don't really care how the drawing turns out, you'll try anything. My sketchbooks are as filled with little fragments that never materialized as they are with completed drawings. Faith in process simply means you don't have to know where you're going when you set out. Each of these three sketchbook studies was started in just such a relaxed and accepting mood.

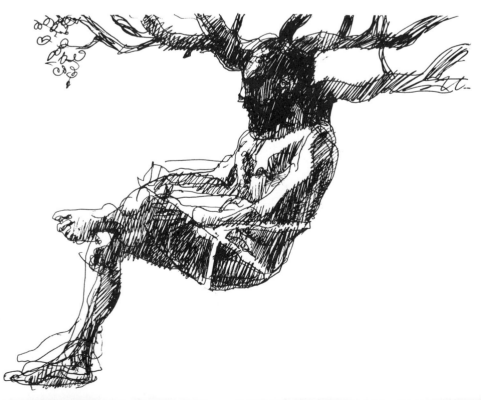

Tangents: A visual coincidence. I originally intended to put in the rest of the tree trunk and the chair, but the merged man and tree had such an organic feel that I deliberately played it this way instead.

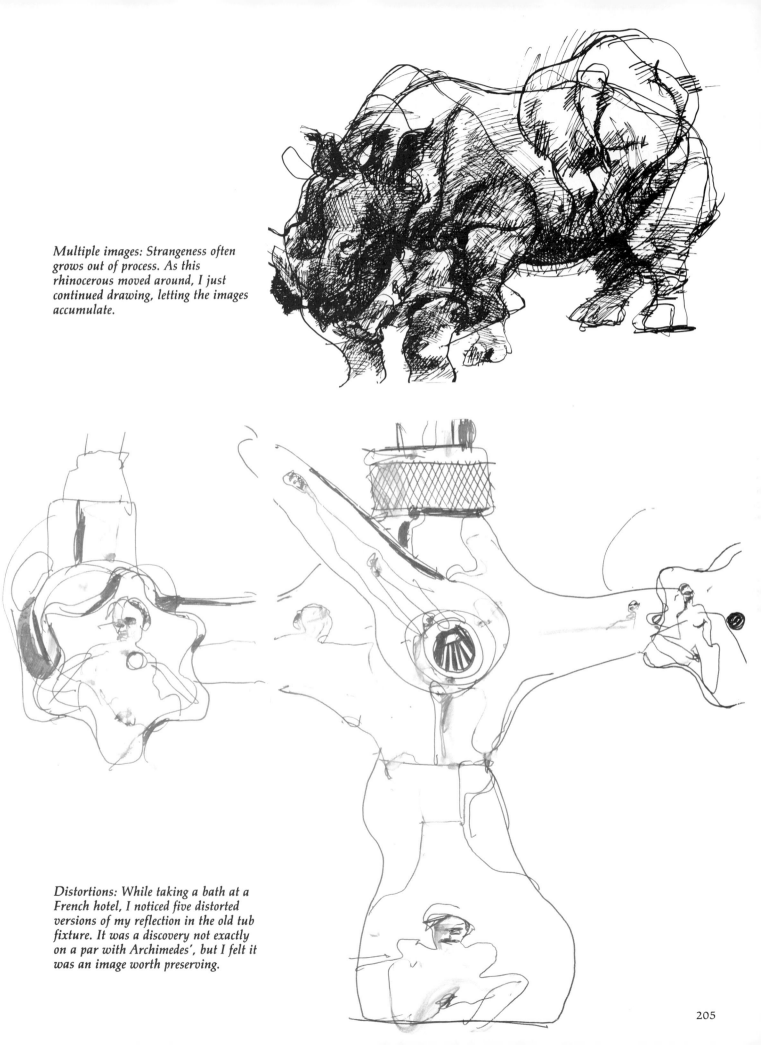

Multiple images: Strangeness often grows out of process. As this rhinocerous moved around, I just continued drawing, letting the images accumulate.

Distortions: While taking a bath at a French hotel, I noticed five distorted versions of my reflection in the old tub fixture. It was a discovery not exactly on a par with Archimedes', but I felt it was an image worth preserving.

Stop sign: It means only one thing.

Inkblot: It means whatever you think it means.

Cohesive and objective: A drawing of Moroccan musicians, emphasizing details of dress and instruments.

The stop sign and the ink blot

A red and white hexagonal sign with the word STOP on it means only one thing, and automobile drivers across the United States know what that is. The Rorschach "inkblot" used in psychological testing, however, is another matter. It means whatever the viewer thinks it means.

The stop sign and the inkblot are twin aspects of communication in art. Objects realistically rendered to the last detail are examples of stop sign communication in that nothing is left to the viewer's imagination. Objects partially obscured, distorted, or suggested possess inkblot qualities where viewer participation is required.

Most of our training in communications has been of the stop sign variety. "Be rational, be logical, explain yourself clearly." These were our early messages. The elusive, the metaphorical, and the incomplete were not thought of as communication skills. It's ironic that we haven't legitimized these forms when they provide us with some of our most intriguing experiences.

You drive along a highway and see a small object on the road ahead. You experience that momentary jolt of uneasiness, thinking perhaps it's a dead animal. You realize as you get closer, that the object is only a battered, corrugated box. A coat that looks like a human figure in a darkened room, the gnarled tree root that suggests an old man's hand, these are inkblot experiences, suggesting as much as they reveal.

An appreciation of the value of inkblot communication is part of the fun of being an artist. ("Hey, I don't have to explain this. I'm an artist.") Art actually happens somewhere in the space between clarity and ambiguity, concept and intuition, thought and feeling. Usually, you have to bring your audience "into your tent" first by making something clear and recognizable to them. Once inside however, they are eager to

participate with you in being tantalized, intrigued, and left to their own interpretations. In the following poem by Ira Ginsberg we catch this mixture of specific, recognizable imagery and tantalizing, mysterious overtones.

Many of the ideas we've discussed previously — such as individualization, focusing, controlling, sighting, and articulating — contribute to stop sign drawing; while restating, shape merging, suggesting, intensifying, and straddling, as well as the keys in this chapter, all contribute to inkblot drawing.

The two drawings of musical groups on these pages illustrate a slight drift from a stop sign drawing to an inkblot drawing. In the drawing of the Moroccans at left, I tried to indicate as clearly as I could (in the short time available) the type of dress, musical instruments, and ethnic mixture of this interesting assembly. The other drawing is of a wedding band in the Montmartre section of Paris. Here I wanted a more vague, loose feeling. Some areas are left undone, details omitted, and proportions are intensified.

I don't say that one is better than the other, but in our culture, the stop sign mentality is strongly reinforced, often to the detriment of the inkblot. I push the inkblot as an antidote to our "too literal" view of things.

Disconnected and ambiguous: A drawing of a Parisian wedding band, emphasizing the mismatch of musical types.

THE BOX
by
Ira Ginsberg

There is a brown cardboard box
in the basement:
water-stained,
torn,
and rather tenuously tied
with tattered twine.

The box holds something precious,
I am sure,
but I can't remember what,

though an inventory,
hurriedly scrawled upon a side
long ago,
should tell me
all there is to know.

I might open it of course,
and would,
could it withstand one more untying;

and were it certain
I'd not find
the box was lying.

© 1984 by Ira Ginsberg

207

A man and a monument: Random play with sizes and shapes.

Working in sequence

The imagination is never stifled for lack of raw materials. There are enough ideas, images, symbols, and experiences in your head already to work with for a lifetime. It's a little like having a car with an unpredictable battery, though. Sometimes you get in and it starts right up. Other times, especially if it has been sitting idle for awhile, you turn the key and nothing happens.

One method for getting a charge on those slow starting days is to work in sequence. Rather than do one drawing, plan to do a series of three or four. Choose a subject and alter it incrementally for each subsequent drawing. If I choose a tube of toothpaste, I will draw it, squeeze some toothpaste out into a jar, draw the tube again, roll the bottom up, and draw it a third time. A tube of toothpaste gains character as it is used up — just like the rest of us. The increased angular wrinkles, the distortion of letters on the label, and the rolled up end can transform a commonplace manufactured item into something with a personality. Documenting that transformation can be the basis for a series.

Another simple object/sequence idea is to draw the same subject matter in different situations. You might draw a hat on a chair with the light and breezy quality of a Palm Beach hotel lobby. Next, possibly with a change of hats, you might do something sinister with dark tones and disappearing edges. You might substitute a tattered chair, include a backdrop of florid wallpaper, or insert a handwritten note, to convey a different mood.

Imagination cannot be forced, it must be coaxed. Working in sequence removes the pressure that can paralyze you on a single drawing by breaking down the problem into increments. After drawing the same basic subject a time or two, your mind is freer to experiment a little. As Dr. Edwin Land, inventor of the Polaroid camera wrote, "True creativity is characterized by a succession of acts, each dependent on the one before and suggesting the one after." Working in sequence places you squarely in this continuum and provides your imagination with a structure and direction in which to begin moving. Each drawing leads to further discoveries that can be applied to the next drawing.

A drawing by a friend . . .

. . . is the basis for Steve Guarnaccia's play with body length and hat sizes.

209

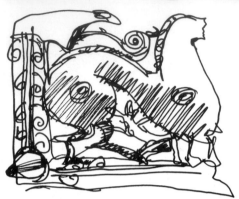

Sixth century Anatolian pendants . . .

. . . with a thirteenth century Aztec sculpture . . .

. . . combine as sources for an experimental drawing

Using sources

Nothing is wholly original. All anyone ever does is put together new combinations. Once you realize this, you can get right to work, sketching, copying and *combining* the things that interest you. Your sources can be profound or trivial. Remember that Freud got the idea for sublimation from a magazine cartoon and Fleming discovered penicillin when mucus from his nose dripped into a petrie dish.

Inspiration should be as diverse as your experience and interests. Mine have been art, history, and movies, so I've connected these elements in illustrative and personal ways. At the Metropolitan Museum of Art, I sketched the Anatolian pendants at left. I liked the cut-out negative shapes and the way they decoratively link up to the center animal. Another people with a lively shape consciousness were the pre-Columbians. I drew this Aztec goddess — Coatlicue, goddess of the earth and creator of man, patron of life and death — in the Mexican National Museum. I loved the creative combination of human and nonhuman animal forms. Now, from time to time, I experiment with little drawings like the one at bottom left, combining the cut-off shapes of the Anatolians with the anatomical experimentation of the Aztecs.

I made a drawing of Henry VIII after reading a book on the history of the Tudors. I began somewhat randomly with some imaginary drawings of the king and one of his beheaded wives. I then began surrounding him with some of the pivotal figures in his life. I copied two of my favorite portraits, Sebastiano del Piombo's portrait of Clement VII (the Pope who refused to grant Henry a divorce) and Hans Holbein's portrait of Thomas Moore (the man for all seasons who was beheaded for his silence on the matter). The wrestling figures along the side represent vague memories of an old Charles Laughton movie, *The Life of Henry the Eighth*.

When my son was a small child, I used to emulate his drawing style in an attempt to get his boldness and assertiveness into my own handwriting. I found that when I drew the way he did, I actually felt freer and more open. Now I deliberately shift to this mode when I feel I'm getting too cautious or timid in my work.

Childlike handwriting qualities . . .

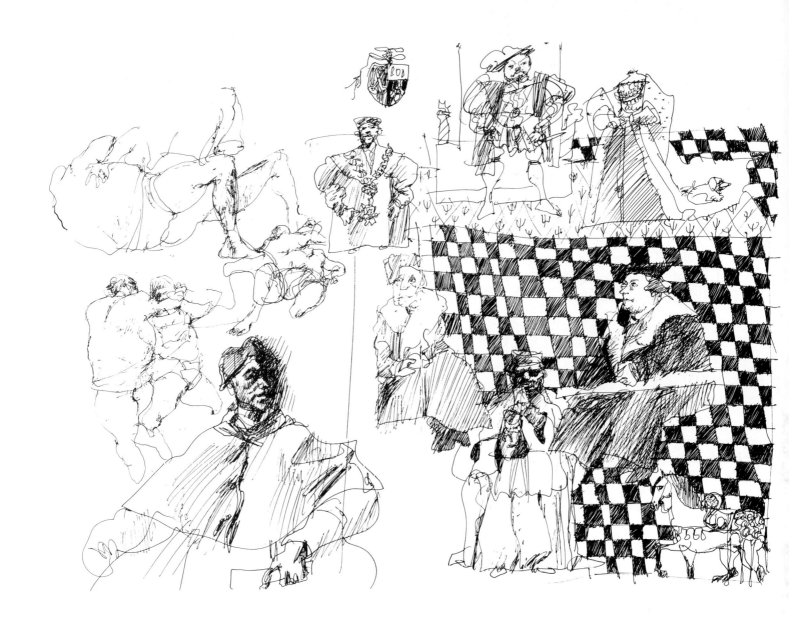

. . . imitated in adult drawing.

Integrating personal experience

Part of your job as an artist is to intensify your connection with your subject and to break down the distance between you and what you draw. This means sticking your neck out a bit and drawing things with which you have an intimate relationship, transforming personal experience to reveal something of your true self. I am talking about making some lifetime longing or hidden fear the subject of your drawing. You might deal with your attitude toward your body, or toward death, your family, your home, your friends, or your past. This can be exhilarating and scary at the same time. Imagine returning to your old neighborhood and drawing the house you lived in as a small child, standing before a mirror and drawing your naked body, collecting together and drawing some objects that remind you of someone that you have lost. If you've always feared being alone, imagine expressing that fear in a drawing, perhaps doing a series of empty rooms. This kind of relationship with your subject is several steps beyond any we've discussed so far. It means playing for higher stakes and making yourself more vulnerable. It means taking more responsibility and more credit for being an artist than you may be used to. It means admitting to yourself that you might be more of an artist than you've dared acknowledge. This can be a very empowering experience, but it's also risky.

Decorative tiles and lattice-work from the Alhambra, a Moorish palace in Spain.

Illustration for **The Rubaiyat.**

What if people don't like what you draw? What if your ideas seem shallow and obvious? What if you're really not much of an artist anyway and this is going to prove it? If critical dialogue like that emerges, I hope you've learned to control it by now. Maybe with your added sense of craft and control, you have more confidence in yourself. Maybe drawing has already helped you get in touch with deep feelings and now you're ready to risk more.

Some years ago, I suffered a severe automobile accident which left me with permanent injuries. During my long recovery period, I went over and over it. I felt profoundly changed, more emotionally than physically. I obsessively asked the question, "Why me?" Through drawing, I was able to turn much of my despair into creative energy. I drew my back brace, I drew my x-rays, I made imaginary drawings of people who were injured. When I found my young son's toy Volkswagen partially melted in the back seat of our car, I made numerous studies of it because it reminded me of the accident.

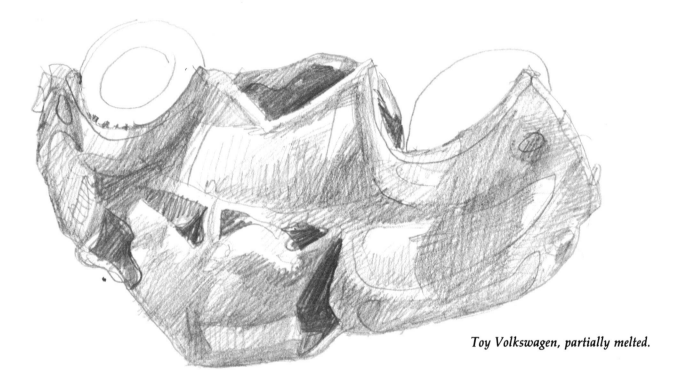

Toy Volkswagen, partially melted.

During a year in southern Spain, I read and reread Omar Khayyám's *Rubaiyat*, the epic poem about life, death, and fate. I made a series of drawings, putting together the verses of the poem with the decorative tile, wrought iron, and fabric motifs of the region.

The drawing at left illustrates some of its best known lines:

> The Moving Finger Writes; and, having writ,
> Moves on: nor all your Piety nor Wit
> Shall lure it back to cancel half a Line,
> Nor all your Tears wash out a Word of it.

The realism and acceptance of this poem comforted me, and it was a rich source of artistic inspiration as well.

Snapshot

Photographs

Throughout this book I have attempted to keep you working from what I call *primary sources*, drawing from real objects and real people, because I believe this fresh contact is the best way to improve drawing skills. However, we live in a world filled with secondary sources. Images in newspapers, magazines, and movies offer us something we can't always get in the real world. They can take us places we've never been — to the moon, under the ocean, or inside the body. They can freeze or speed up motion and time, and they allow us to work in the convenience of our own homes.

But like every modern convenience, they can also make us lazy and spoiled. Some artists become so dependent on projecting and tracing photographs, they completely lose confidence in their ability to draw from life. With this in mind, I suggest two simple criteria for the use of photographs:

1. As a way of exercising — for example, copying tonality or analyzing proportions; or
2. As a point of creative departure — changing, intensifying, or combining them to make something new.

We've seen their use as exercise tools in Chapters 2 and 4. The examples shown here illustrate their creative potential.

Initial sketch

Final drawing: Gary Hamel's drawing was done from an old family photo. One enjoyable feature of this work is the way Hamel incorporated the blurred, awkward aspects of the snapshot. The dog seems unreal, almost other-worldly, in this arresting piece.

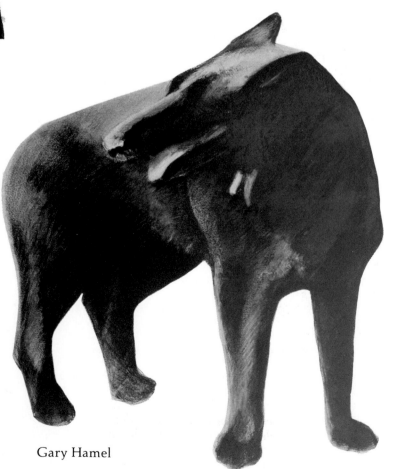

Gary Hamel

214

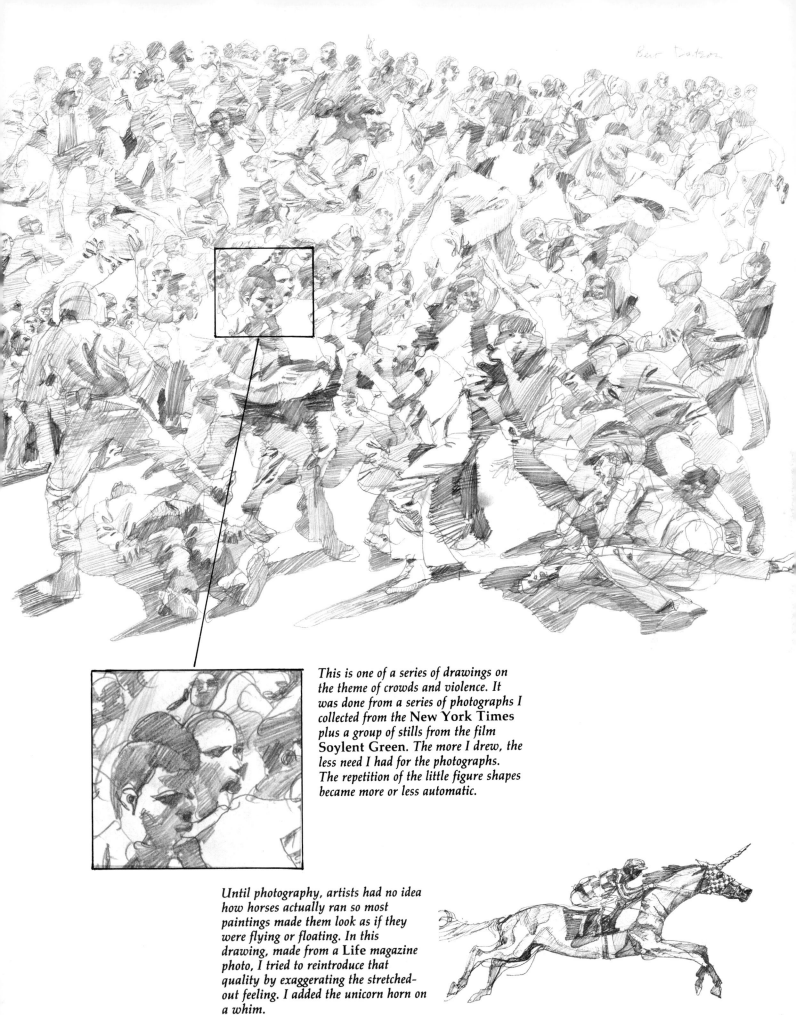

This is one of a series of drawings on the theme of crowds and violence. It was done from a series of photographs I collected from the New York Times plus a group of stills from the film Soylent Green. The more I drew, the less need I had for the photographs. The repetition of the little figure shapes became more or less automatic.

Until photography, artists had no idea how horses actually ran so most paintings made them look as if they were flying or floating. In this drawing, made from a Life magazine photo, I tried to reintroduce that quality by exaggerating the stretched-out feeling. I added the unicorn horn on a whim.

Boxing match on blurry TV.

Television

Drawing from TV is excellent practice for the free hand. The images speed by in such rapid succession that you're lucky to catch just a fleeting impression. I find it's a good eye/hand/ memory exercise that helps me draw live, moving subjects. The best programs are those that repeat shots over a period of time such as speeches and panel discussions, sports, and most network music programming. MTV offers more exciting images, but they generally move *too* quickly.

The freeze-frame feature of the videotape recorder is making things a lot easier for the artist. Lynn Sweat, with a longtime interest in painting the figure in motion, has made good use of this device. By replaying and stopping the action he made dozens of sketches from the film *Flashdance*. He then went through them and selected these three as the basis for the final painting reproduced below.

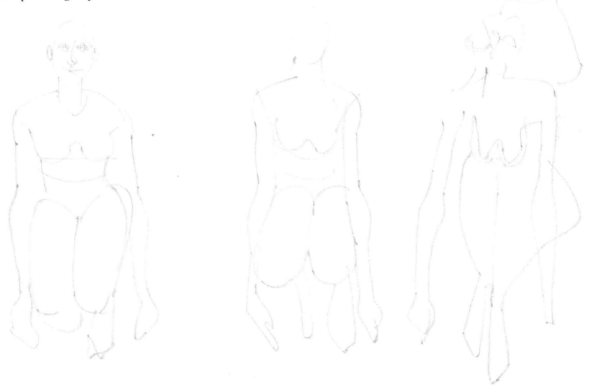

Freeze-frame drawings from the movie
Flashdance.

Final painting

Lynn Sweat

Exploring themes

Sooner or later, every artist concentrates on a particular area of interest to the point where it becomes a theme. The painter Claude Monet, for example, spent a lifetime exploring the effects of light on objects. Kathe Kollwitz took human suffering and social struggle as her major themes, and we find these represented in nearly everything she did. Andrew Wyeth draws on recurring themes of loneliness and isolation. For the painter Richard Estes, the theme is the landscape of city buildings, commercial signs, and reflections in plate glass windows.

Frequently, artists will work through one theme over a period of time and then move on to another. In his 92 years, Picasso worked on dozens of themes, including mythology, African art, still life, portraiture, and circus performers. The bull appears frequently in Picasso's work. Often a symbol of maleness and brutish power, at other times the bull was simply an interesting form used for cubist experiments with line and shape.

The nineteenth century Japanese master Hokusai chose as a theme "Thirty-Six Views of Fuji," a project he worked on for six years. This series depicts the ubiquitous Mount Fuji in a dazzling variety of compositions, at times only as a distant background element. "Disasters of War" was a theme of Francisco Goya. He produced a large body of etchings on the subject during the French occupation of Spain.

In each of these examples, the theme provided the depth of involvement and exploration that no single picture could supply. Each drawing led to further discoveries to be applied to the next drawing. The term for this is "heuristic" — a type of discovery that stimulates further investigation. The following six themes have strong heuristic possibilities:

Theme exploration — The empty environment
Environments designed for people but which contain none set up a strong evocative resonance. Romantic feelings associated with loneliness, isolation, and mystery are key aspects of the empty environment. This theme greatly rewards those who feel that creating depth, building up tone, and reproducing architectural details are well worth the patience generally required. Empty rooms at home, bus stations, offices, and diners are a few examples.

Theme exploration — "A hundred of anything"
This theme has its origins in a remark an artist friend once made: "If you put a hundred of anything of the same type together, it will be visually interesting." The idea is based on the design principle of shape repeats or recurrence. These are "all-over" drawings. No one part has more importance than another. You might draw a tree's leaf mass or a mass demonstration of people filling the paper. There is no focus. Same-sized tin cans can be seen and drawn from different views. You don't really need 100 of anything, just take one and draw and redraw it from different angles. Pushpins, spools, shoes, spoons, hands, or crumpled dollar bills all make excellent *objets d'art*.

Theme exploration — Decorative motif

Most of us have an impulse to decorate. We often doodle by repeating and embellishing shapes, making little curliques or intricate linear patterns. Weaving ordinary subjects — people, animals, and plants — into decorative motifs has intriguing theme possibilities. A good approach is to organize your drawing like an Oriental rug. Make an outer decorative border, an inside center of interest, and add clusters of pictures and decorations throughout. Look at Persian and Islamic art for ideas. Wallpaper, tile, and fabric designs are also good sources of inspiration.

Theme exploration — The distorted reflection

The fun house mirror takes our own familiar image and rearranges it, squashing the body, separating and elongating the head, lowering the eyes, and stretching out the ears; yet, however distorted, we still recognize ourselves. Reflections make excellent subjects for drawing, particularly for self-portraits. I have found drawing distortions to be very liberating. One can be looser, free of the restraints of having to "get it right."

Chrome bumpers or coffee pots are good reflective objects, as are distorted mirrors if you're lucky enough to find one. Drawing your reflection in puddles offers the added interest of including various puddle shapes and details.

Theme exploration — The blow-up

To take a small object and blow it up to a very large scale combines the stop sign and the inkblot. The viewer recognizes the object, but, because it is magnified, is forced to see it in an entirely new way. When an object is grossly out of scale, sensitive handling of shapes, tones and edges is critical to keep the object recognizable. Use a magnifying glass to capture the smallest nuances of texture and detail. For best effect, these drawings should be done large, at least 18x24 inches, and the cropping should be extreme to fill the page with only a part of the object. A milkweed pod, an opened pomegranate, a toothpaste tube, a walnut, or an insect are all good macro-drawing subjects.

Theme exploration — Broken or hidden images

Revealing some parts of an image and concealing others makes a drawing more compelling. The combining of elements so as to partially obscure them adds a sense of mystery and surprise. It's another way to make the familiar strange by creating "gaps" which the viewer must fill in. These situations may seem unusual, but they occur more often than many realize.

A person partially obscured in a window or doorway, a dog whose body lies in bright sunlight but whose head disappears into a dark shadow, or a child sleeping under a sheet with only an arm or leg sticking out are all examples. Sometimes you can deliberately set up this sort of situation. Other times, you'll just come upon it. Either way, it's an imaginative approach to your subject.

Project 8 — Explore a Theme in Six Drawings

For this project, make a series of drawings based on one of the themes listed here or on another of your own choosing. These drawings should be well considered, so make a few little preparatory notes and sketches ahead of time to get some direction clear in your mind. This doesn't mean you should plan each drawing in detail, though, because a willingness to explore and an openness to possibility are essential. Invest some time in this project, perhaps completing it over a period of several weeks. Make all your drawings the same size and think of them as a unified group. They should all be connected by a common thread, however invisible.

When you've completed your six drawings, rather than rushing into a self-critique, set them up as a group and live with them for a while. Let your evaluation of these drawings come gradually. Since you will need to set your own criteria for this project, you'll want to evaluate it by those same criteria. No self-critique questions are provided.

KEYS TO CHAPTER 8
Drawing and Imagination

Imagination, the ability to conceive strange ideas, is part of everyone's mental makeup. Each day, whether we recognize it or not, all of us are actively manufacturing strange ideas in our heads. The only difference between creative people and so-called non-creative people is that creative people welcome their strange ideas.

- **Join two bags.** The creative process is the act of joining two unrelated bags. In drawing, that means combining at least two different ideas on the same piece of paper. These ideas may have only a remote connection with each other.

- **Be playful.** Adopt an attitude of looseness, friendliness, and sense of humor toward your subject and yourself. Rather than worry about how your drawing will turn out, get into the spirit of the moment. It's not necessary and it's probably not wise to know exactly where you're going when you start. If a strange idea occurs to you in the middle of a drawing, go with it.

- **Make the familiar strange.** Seeing the familiar and the commonplace in a new way is the basis for imaginative drawing. This could mean drawing something from an unusual or obscured view, combining unrelated elements, changing the relative sizes of the elements, distorting, rearranging, or symbolizing.

- **Work in sequence.** By doing a series of drawings with small changes in between each one, you create the healthiest environment for the imagination. Each drawing leads to further discoveries that can be applied to the next drawing. It has the effect of coaxing your creative abilities into play.

- **Use diverse sources.** Visuals and non-visuals alike are rich sources of inspiration. In your work, incorporate influences from art, photography, and television, as well as from poetry, literature, and music. Especially try to incorporate the most powerful of sources: your own intimate and personal experiences.

- **Explore themes.** Make lots of drawings over a period of time on a particular subject or a particular approach to a subject. Paradoxically, when you narrow your focus this way, you widen the potential for discovery.

CONCLUSION

I have, in these last few chapters, placed a good deal of emphasis on creativity and the associative qualities of imagination, curiosity, open-mindedness, spontaneity, and sense of humor. I do so because I believe that these qualities represent the very best parts of ourselves in both art and life. They allow us to live in an ever-unfolding present rather than in the past or the future. They help to keep us free of inhibiting rules and positions, letting us experience the pleasure of making our own discoveries.

I hope that I have clearly presented to you my conviction that drawing is a means, not only of self-discovery but discovery of the interconnectedness of things. When this happens to us, we experience drawing's purest pleasures.

Yes, drawing can also be frustrating and difficult — a common experience for most of us. It may be reassuring to consider the cases of Mozart and Beethoven. Mozart's gifts seemed to be at his fingertips. He wrote forty-eight symphonies, two symphonic movements, and over forty concertos in his short (35 years) life. He could, by all accounts, dash off concertos at a moment's notice. He was said to have written one concerto while playing a game of croquet.

Ludwig van Beethoven was a struggler. In a lifespan of fifty-six years, he wrote only nine symphonies and less than half as many works as did Mozart. He seemed to labor torturously over all of them, writing, changing, crossing out, starting over. Friends reported that his study was littered with crumpled pieces of paper.

Given a choice, I think we'd all like to be like Mozart — flawless and beautiful images dancing off our pencil points with effortless grace. But although I believe there is genius in everyone, for most of us it will be the Beethoven kind. It will take a lot of crumpled drawings to bring out the best in us.

Best wishes,

Bert Dodson

BIBLIOGRAPHY

Arthur, John. *Realist Drawings and Watercolors: Contemporary American Works on Paper.* Boston: New York Graphic Society Books, 1980.

Canaday, John. *What Is Art? An Introduction to Painting, Sculpture, and Architecture.* New York: Random House, Alfred A. Knopf, 1980.

Capra, Fritjof. *The Tao of Physics.* New York: Bantam Books, 1977.

Chaet, Bernard. *The Art of Drawing.* 3rd ed. New York: Holt, Rinehart & Winston, 1983.

D'Amelio, Joseph. *Perspective Drawing Handbook.* New York: Van Nostrand Reinhold Co., 1984.

Edwards, Betty. *Drawing on the Right Side of the Brain.* Los Angeles: Houghton Mifflin Co., J. P. Tarcher, 1979.

Elbow, Peter. Writing with Power: *Techniques for Mastering the Writing Process.* New York: Oxford University Press, 1981.

Ghiselin, Brewster, ed. *The Creative Process.* New York: New American Library, 1952.

Hampden-Turner, Charles. *Maps of the Mind.* New York: Macmillan Publishing Co., 1982.

Henning, Fritz. *Concept and Composition: The Basics of Successful Art.* Fairfield, Conn.: F&W Publications, North Light Books, 1983.

Henri, Robert. *The Art Spirit.* Edited by Margery A. Ryerson. Harper & Row, Publishers, 1984.

Jaynes, Julian. *The Origin of Consciousness in the Breakdown of the Bicameral Mind.* Boston: Houghton Mifflin Co., 1977.

Maurois, Andre. *Illusions.* New York: Columbia University Press, 1968.

Nicolaides, Kimon. *The Natural Way to Draw: A Working Plan for Art Study.* Boston: Houghton Mifflin, 1941.

Pirsig, Robert. *Zen and the Art of Motorcycle Maintenance: An Inquiry into Values.* New York: William Morrow & Co., 1974.

Price, Roger. *Droodles.* Los Angeles: Price, Stern, Sloan, Publishers, 1965.

Richards, Mary C. *Centering in Pottery, Poetry, and the Person.* Middletown, Conn.: Wesleyan University Press, 1969.

Rico, Gabriele L. *Writing the Natural Way: Using Right-Brain Techniques to Release Your Expressive Powers.* Los Angeles: Houghton Mifflin Co., J. P. Tarcher, 1983.

INDEX